THE FRANKLIN D. MURPHY LECTURE SERIES

Established in 1979 through the Kansas University Endowment Association in honor of former chancellor Dr. Franklin D. Murphy, the Murphy Lectureship in Art brings distinguished art historians, critics, and artists to the University of Kansas, where they participate in the teaching of a graduate seminar in the Kress Foundation Department of Art History and deliver two public lectures, one at the Spencer Museum of Art and one at the Nelson-Atkins Museum of Art, the published versions of which are presented in this series.

THE FRANKLIN D. MURPHY LECTURERS IN ART

1979	Pierre Rosenberg	1994	John Szarkowski
1980	Brian O'Doherty	1996	Karal Ann Marling
1981	Xia Nai	1996	John M. Rosenfield
1982	Richard Field	1998	Serafín Moralejo
1983	Robert G. Calkins	1999	Helmut Brinker
1983	Svetlana Alpers	2001	Yi Sŏng-mi
1984	Nubuo Tsuji	2001	Wanda M. Corn
1986	David Rosand	2003	Donald McCallum
1987	James Cahill	2004	Roberta Smith
1987	William Vaughan	2005	Tamar Garb
1988	Walter S. Gibson	2007	Okwui Enwezor
1989	Thomas Lawton	2008	David M. Lubin
1990	Johei Sasaki	2009	Christopher M. S. Johns
1992	Marilyn Aronberg Lavin and Irving Lavin	2010	Toshio Watanabe
		2012	Michael Brenson
1994	Lothar Ledderose	2014	Cynthia Hahn

David Cateforis, Series Editor (2014–)

China and the Church

China and the Church

Chinoiserie in Global Context

CHRISTOPHER M. S. JOHNS

UNIVERSITY OF CALIFORNIA PRESS

University of California Press, one of the most
distinguished university presses in the United
States, enriches lives around the world by
advancing scholarship in the humanities, social
sciences, and natural sciences. Its activities are
supported by the UC Press Foundation and by
philanthropic contributions from individuals
and institutions. For more information, visit
www.ucpress.edu.

University of California Press
Oakland, California

Library of Congress Cataloging-in-Publication Data

Johns, Christopher M. S., author.
 China and the church : Chinoiserie in global
context / Christopher M. S. Johns. — First edition.
 pages cm. — (Franklin D. Murphy Lectures)
 Includes bibliographical references and index.
 ISBN 978-0-520-28465-4 (cloth : alk. paper)
 1. Chinoiserie (Art). 2. Catholic Church—
Influence. 3. China—Church history—18th
century. 4. Catholic Church—Oriental rites—
History—18th century. 5. Chinese in art—18th
century. 6. Men in art—18th century. I. Title.
II. Series: University of Kansas Franklin D. Murphy
lecture series.
 N7429.J64 2016
 709.03′3—dc23

 2015031984

Printed in China

24 23 22 21 20 19 18 17 16
10 9 8 7 6 5 4 3 2 1

The paper used in this publication meets the
minimum requirements of ANSI/NISO Z39.48–1992
(R 2002) (Permanence of Paper).

For Marsha S. Haufler
Scholar, colleaque, and friend

CONTENTS

Acknowledgments ix

Introduction *1*

1. China and the Church: From Matteo Ricci to the Chinese Rites
 Controversy *15*

2. Chinoiserie and Chinese Art: The Seventeenth and Eighteenth
 Centuries *43*

3. Chinoiserie and the Chinese Body *91*

 Conclusion: Chinoiserie and the Enlightenment *139*

Notes 143

Selected Bibliography 163

List of Illustrations 175

Index 179

ACKNOWLEDGMENTS

The seed of the present project was planted in the gorgeous gardens of the Schönbrunn Palace in Vienna in 2007. While touring this famed imperial residence of the Habsburg dynasty with Marsha Haufler, we both noticed the omnipresence of East Asian art works and of objects produced in Europe but inspired by the Chinese and Japanese originals available to Western artists from a wide variety of sources. Sitting in a shady copse near the Neptune fountain, we continued to talk about what we had seen, and later we renewed our discussions over delicious Viennese pastries and coffee. With her enviable command of the art and visual culture of China, Marsha was able to explain many things that I had only imperfectly understood, or of which I was completely ignorant, and she posed several provocative questions about European chinoiserie seen from the East Asian perspective. These discussions continued long after we left Vienna and led to an invitation to help direct a seminar at the University of Kansas, which I had the honor to do in spring 2009.

As the Franklin Murphy Visiting Professor, I came to Lawrence for two weeks to present material on baroque and eighteenth-century chinoiserie to twelve highly talented and interested students. These six seminar meetings, paired with one public lecture at the Spencer Museum of Art at the University

of Kansas and another at the Nelson-Atkins Museum of Art in Kansas City, formed the basis of the present book. I am deeply appreciative of the opportunities given me by the Franklin Murphy fund and I am above all indebted to Marsha Haufler (art history) and Diane Fourny (French), treasured colleagues who directed the seminar with me. In my long career, I have never been in a more sympathetic and stimulating intellectual environment.

The graduate students in the Murphy seminar presented their research projects and wrote term papers of exceptional quality. I learned a great deal from these young scholars and the present book has benefited from their expertise. I would like to thank them individually: Yen-yi Chan, Janet Chen, Elizabeth A. Williams, Wenrui Zhong, Nancy Schneider, Shuli Han, Shuyun Ho, Sooa Im, Takaaki Kumagai, Yingju Lan, Nian Xiyao, and Junghwa Park. For months after the conclusion of our course, these generous individuals continued to send me bibliographic references and to offer encouragement for the present project, for which I am deeply grateful.

The field of global cultural studies has flowered in recent years, and I have benefited from the advice, conversation, and scholarship of several remarkable scholars in the vanguard of that development. In particular, I would like to thank my colleague at Vanderbilt, Tracy Miller, who has patiently fielded countless questions about China and Chinese art. Diane Fourny was a great help on a number of issues related to China and the Enlightenment and to the role of those eighteenth-century scholars, writers, and *philosophes* who did so much to frame the western discourse on China during the Enlightenment. Elizabeth A. Williams generously shared her wide-ranging knowledge of eighteenth-century silver, lacquer, and porcelain. I also thank Thomas DaCosta Kaufmann for talking to me about the broader theoretical context of cultural commodity exchange. Maureen Cassidy-Geiger has been an authoritative source on Meissen porcelain and the collecting of soapstone sculpture in eighteenth-century Dresden, and her collegial generosity has done much to improve my book. Dawn Odell

shared her pioneering research on cultural exchange between China and the United Provinces in the seventeenth and eighteenth centuries and helped me to locate a number of publications and images that have greatly aided my argument. Perrin Stein also generously shared her great knowledge of French eighteenth-century art in general and chinoiserie in particular, even allowing me to read and cite an unpublished manuscript, for which I am most grateful.

A number of other individuals and institutions were of enormous help in a wide variety of ways, and I would like to acknowledge them here: Stacey Sloboda, Michael Yonan, Kris Ercums, Christopher Strasbaugh, Jeffrey Collins, Peter Björn Kerber, Bruce Robertson, Mark Ledbury, Stephanie Fay, Patrick Gilbreath, Meredith Martin, David Cateforis, Linda Stone-Ferrier, Karin E. Wolfe, Cristina Mossetti, Tommaso Manfredi, Sherry Fowler, Kristina Kleutghen, Elizabeth J. Moodey, Robin Jensen, and Christine Horner. It has been a great pleasure to work with the University of California Press, and I would like to thank Rachel Berchten, Karen Levine, Jack Young, and Caroline Knapp for their patience, sage advice, and support. For research assistance, I am appreciative of the tireless efforts of Fay Renardson and Riley Shwab. The staff of the Staatsbibliothek and the Zentralinstitut in Munich were always courteous and helpful when confronted with my numerous questions and requests. I also thank Jim Toplon and Yvonne Boyer of the Vanderbilt University Central Library for much practical assistance and many professional courtesies. The Nelson-Atkins Museum of Art, the Metropolitan Museum of Art, the J. Paul Getty Museum, the Walters Art Gallery, the Cleveland Museum of Art, the Royal Collection by Courtesy of Her Majesty Queen Elizabeth II, the University of Utrecht Library, the Arnhold Collection in New York, and the National Gallery of Art in Washington, D.C., allowed me the free use of digital images of works in their collections.

For those individuals I have forgotten to mention, I offer my apologies and sincere thanks for your efforts on my behalf.

Introduction

When Father Joachim Bouvet, S.J. (1656–1732), returned to Europe in 1697 from the Jesuit mission in Qing dynasty China, he brought with him a luxurious series of forty-three plates that he had had engraved and colored that year by Pierre Giffart (1638–1723). Giffart took great pains to replicate the details of the Chinese originals. The images included the Kangxi emperor (reigned 1662–1722) and members of the imperial family, prominent men and women of the Manchu elite, bonzes (Buddhist monks), soldiers, and scholar officials (figure 1), wearing either ceremonial robes or clothing appropriate to their rank and occupation. Many viewers admired the svelte elegance of the portraits of Chinese ladies with their exquisite coifs (figure 2), and European women were advised to emulate the appealing modesty and virtue of their East Asian counterparts. Bouvet's book with Giffart's images was published as *L'État présent de la Chine en figures* (The Present State of China in Images), dedicated to the duke and duchess of Burgundy. It was intended to demonstrate the cultural sophistication of China, which many felt compared favorably to "the happy reign of Louis XIV."[1] Indeed, Catholic France was the major market for the publication, and the Sun King himself was more than a little curious about his Chinese counterpart and the distant empire over

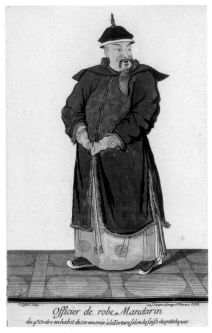 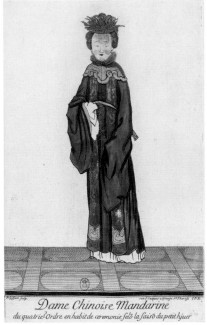

1. Pierre Giffart, *Officier de Robe Mandarin [Mandarin Official]*, from Joachim Bouvet, *L'état présent de la Chine en figures*, colored engraving, 1697.

2. Pierre Giffart, *Dame Chinoise Mandarine [Chinese Lady]*, from Joachim Bouvet, *L'état présent de la Chine en figures*, colored engraving, 1697.

which he reigned. Bouvet visited the French court to raise funds and recruit additional volunteers for the China mission. Although the results of his effort were less satisfactory than the Jesuit fathers had hoped, Bouvet's descriptions of the Qing empire served to increase an interest in China that was already evident. European knowledge of East Asia had been growing exponentially since the late sixteenth century, most of it owing to Catholic publications and a vast epistolary network of missionaries, scholars, ecclesiastical administrators, merchants, and diplomats. Even so eminent a philosopher

as Gottfried Wilhelm Leibniz (1646–1716) so valued information about China that in 1705 he could write: "It is impossible for even a bare but accurate description of their practices not to give us very considerable enlightenment, and one that is much more useful in my view than the knowledge of the rites and furniture of the Greeks and Romans to which so many scholars devote themselves."[2] Leibniz's telling challenge to the paradigm of civilization in ancien régime Europe—Greco-Roman antiquity—indicates the intellectual esteem in which many of his contemporaries held the emerging discipline of Sinology.

The enthusiasm in France and throughout Europe that greeted *L'Etat présent de la Chine en figures* was characteristic of the highly positive view of the Qing Empire that pervaded the Western consciousness from the arrival of Jesuit missionaries in China in the last quarter of the sixteenth century until the imperial edict banning proselytization was promulgated by the Kangxi emperor in 1722. Initially optimistic about prospects for the conversion of the emperor and his court to Catholic Christianity, Western observers found that such hopes had dimmed considerably by the second decade of the eighteenth century and were virtually extinguished soon afterwards. China's immensity and remoteness from Europe precluded any colonial or military intervention, and because the Chinese refused to trade with the West on an equal footing, there was little recourse but to tolerate an exchange imbalance, given European demand for tea, lacquer, paper, porcelain, and other products for which the Chinese demanded payment in silver, only occasionally agreeing to accept woolen cloth, clocks, and astronomical instruments. The only avenue open for the expression of European frustration at what was viewed as an intolerable and humiliating situation was through culture, both textual and visual, an idea to which I shall return in due course.

Chinoiserie, a Western artistic style that adapted Chinese originals for its own purposes, was originally invested in more or less authentic depictions

of the Eastern empire, but beginning in the early eighteenth century, authenticity and humanized depictions of Chinese bodies, architecture, leisure pastimes, and performances of social rank gave way to a grotesque, dehumanized, and, in the case of male bodies especially, a remarkable degree of feminization. Chinese architecture, rather than being rendered as intriguingly exotic and the product of an old and venerable civilization, was visualized in eighteenth-century chinoiserie as flimsy, insubstantial, and hopelessly antiquated. Similarly, distinctions of rank, so important in both Western and Asian cultures, were blurred, a means of both denigrating and mocking authentic Chinese social practices. This book will examine the history of contact between the Roman Catholic Church and Catholic courts and late Ming and early Qing China, in the context of the role of the latter in the Western imagination. My argument centers on the notion that perceptions of China were favorable, often extravagantly so, until the collapse of the Catholic missions there in the last years of Kangxi's reign. Although some Westerners continued to praise China, most began to disparage it as a corrupt empire ruled by a feminized and decadent court. European chinoiserie was a key player in this dramatic change in tack, and I consider it as a form of political and cultural expression, in opposition to traditional interpretations of the phenomenon as merely a flight of Rococo fantasy indulged in by artists in the middle decades of the eighteenth century. A reconsideration of chinoiserie as an intellectual change agent in the alteration of Western thinking about China in the seventeenth and eighteenth centuries is the goal of this book.

+ + + +

Matteo Ricci (1552–1610), the founder of the Jesuit mission in China, was arguably the first prominent European Sinologist. His letters and the works published by his followers did much to transmit a realistic image of China to Europe. Ricci's high praise of the late Ming emperors with whom he had

contact helped create favorable comparison of East Asian monarchs to Catholic European rulers. Of the Chinese political structure, Ricci wrote: "If of this kingdom [China] one cannot say that philosophers are kings, at least with truth one will say that the kings are ruled by philosophers."[3] Such a statement helped promote a flattering view of the imperial administration, as did the description of the requirement that those seeking to occupy important public offices in China take civil service exams, a practice that some argued the European polities should adopt. Although the Jesuits recommended the wise rule of scholar officials to their readers back home, in practice the imperial system was far from ideal, as many merchants and other missionaries who had to deal with it could (and did) testify.

A map of Beijing, published in 1662 and preserved in the Bibliothèque Nationale in Paris (figure 3), shows the Chinese administration to great advantage. In the image, two seated Chinese worthies flank a cartouche bearing the text *Pecheli sive Peking Imperii Sinarum Provincia Prima* (Pecheli or Peking, First Province of the Chinese Empire). The cartouche is decorated with a pair of large exotic birds. Each of the officials, their feet resting on ample cushions, is shaded from the sun by a standing servant who holds a gold sunshade with cloth flaps. The more richly dressed official has a fabric panel on his torso decorated with two cranes, auspicious birds that also indicate high rank. Both officials and attendants are represented in naturalistic proportions, and the distinctions of rank between them are obvious, even to a European audience. Western representations of Chinese men and the imaging of niceties of social and political rank, phenomena that change through the period considered here , are a major theme of chapter 3.

The notion of Chinese exceptionalism, developed in tandem with the rise of Sinophilia during the middle decades of the seventeenth century, was fomented in part by the laudatory accounts of the Jesuits and in part by the widespread enthusiasm for the Chinese luxury objects coming into Europe in enormous quantities. Porcelain and lacquer especially encouraged the

3. Map of the province of Beijing, with figures, colored engraving, 1662. Paris, Bibliothèque Nationale.

exceptionalist argument, because Europeans were still ignorant of the actual processes that created such exquisite, and to them mysterious, objects. Louis-Daniel Le Comte articulates the exceptionalist claim most clearly in his *Nouveaux mémoires sur l'état présent de la Chine* (New Observations on the Present State of China), published in 1696, a book much indebted to earlier publications, in particular Father Athanasius Kircher's *China monumentis, qua sacris qua profanis illustrata* (The Monuments of China, Both Sacred and

Profane Illustrated; usually called simply *China illustrata*), of 1667.[4] By the end of the seventeenth century, both economic and political exchanges between France and the Qing court in Beijing were well developed, and European chinoiserie, which was then extremely fashionable, was largely positive in its characterization of East Asia. The cultural, political, and scientific admiration of China, however, would soon veer dramatically in a negative direction.

The historian Nicholas Dew has aptly characterized European Sinophilia in the age of Louis XIV as "baroque orientalism," a phrase that also suggests a helpful way to think of the exoticized but admiring attitude toward China visualized in chinoiserie.[5] The study of global history in this period was dominated by a universalizing gaze that welcomed Chinese chronicles, many of them undeniably ancient, as contributions to the scholarly reconstruction of the past. But when the eighteenth-century Enlightenment rejected universal history in favor of discrete national narratives, Chinese sources were increasingly viewed with suspicion, their august pedigree impugned. In addition, baroque orientalism, as a highly developed phenomenon that predated European colonialist adventures in East Asia, not only situated China beyond European control, but also placed it on an equal footing with the Ottoman, Persian, and Mughal empires, which had stood outside Western power dynamics long before the eighteenth century. This is a crucial point, because when the Qing emperors definitively rejected Christianity and free trade with the West in the 1720s, Europeans could do very little to counter them.

Throughout the eighteenth century, however, Europe used chinoiserie increasingly to feminize and trivialize the "Celestial Empire" in the popular imagination, so that by 1800 China had been transformed from the baroque orientalist society of philosopher-kings, able administrators, and producers of modern luxury marvels to a squalid, corrupt, and backward despotism in which a tottering throne oppressed the populace. The lingering Jesuit view

of an exemplary China was slowly extinguished.[6] It was even suggested that Chinese "frivolity" was caused by a lack of the virility necessarily associated with a vibrant civilization, and progressives claimed that Qing society had much in common with the louche aristocracy of the ancien régime, a censorious characterization also brought to bear on the rococo during its period of decline.[7] When the Qianlong emperor died in 1799, the European colonial project had developed sufficiently to bring China to heel, as it did during the First Opium War (1839–42), and the Western colonial powers neither forgot nor forgave their earlier impotence vis-à-vis the Beijing court.

+ + + +

This book makes three arguments about the history of European chinoiserie from about 1600 to the end of the eighteenth century.

First, it introduces the vital importance of the Christian mission in China to both social and artistic developments in Europe. My narrative focuses especially on the Catholic courts, where fervent hopes of converting the Ming and Qing emperors to Roman Catholicism waxed until they collapsed utterly over the fraught issue of the Chinese rites, which are discussed in chapter 1. Although the Western desire to convert China to Christianity was probably sincere, the mission was also promoted as a means to open lucrative markets in East Asian goods, which were much in demand. Art histories of chinoiserie have largely ignored the role of the Church and its efforts to convert the East, except as a source of the images that appeared in missionary publications and as a resource for visual material. The Church's role in cultural and artistic exchange, however, extended well beyond providing an image database for artists. Decisions made by the Curia in Rome and by a series of popes had a direct impact on the China mission, as well as on European attitudes toward the Chinese Empire through time.

Second, the book argues that a fundamental change occurred in the chinoiserie aesthetic in the early years of the eighteenth century, a widely rec-

ognized phenomenon that has been attributed almost exclusively to the rise of the rococo style, with its whimsical fantasies, some of which just happened to have a vague association with East Asia. The command by the Kangxi emperor and his successors, the Yongzheng (reigned 1722-35) and Qianlong (reigned 1735-99) emperors, that missionary activities cease played a vital role in the aesthetic shift in chinoiserie in the mid-eighteenth century, giving a highly negative charge to images of Chinese people, architecture, clothing, and even social practices. (It should be noted that Kangxi, Yongzheng, and Qianlong are not personal names but designations for periods of reign. Because of their relative familiarity, they are often used to refer to the emperors themselves, and I shall use the terms interchangeably for persons and periods.)

Third, the shift from appreciating China as a venerable, well-governed realm to disdaining it as an entity that was decadent, rickety, unthreatening, feminized, and on the verge of collapse is seen most clearly in the gross distortions and feminization of the Chinese male body, a phenomenon that lays the foundation for later visualizations and characterizations of East Asians. Ancien régime chinoiserie transformed the Western conception of China, from the promotion of it as fundamentally similar—and for many equal—to the West into a denigration that underscored difference and reimagined the East as utterly alien and indubitably inferior.

I begin my argument by examining the role of the Church, from the Middle Ages on, in exchanges between Catholic Europe and East Asia. This discussion culminates in the definitive establishment of the Jesuit mission under the leadership of Matteo Ricci, one of the most influential champions of China in the early modern era. Ricci and his small band of brothers made fundamental contributions to the emerging discipline of Sinology, and provided the most trusted sources of knowledge about China until their claims began to be seriously interrogated during the Enlightenment. After arguing for the importance of Jesuit ideas in the development of the more positive

forms of European chinoiserie characteristic of the seventeenth century, I turn to the mania for chinoiserie from about 1600 to its remarkable transformation during the 1720s, precisely the decade in which the Manchu emperors forbade further Christian proselytizing. I see this development as a vicarious punishment by the West of a previously admired polity that had haughtily rejected Catholic Europe's most precious commodity—the "true" religion. Because China was impervious to military coercion and unyielding to Western attempts to establish free trade (reducing the West to sending silver to purchase Chinese goods), one of the few venues remaining in which to assert European superiority was visual culture. It has long been recognized that an effective way to create hierarchy is to feminize rivals, and that is exactly what happened in much chinoiserie of the middle and later decades of the eighteenth century.

It is standard practice in the history of art as a discipline to make works of art and material culture the chief category of evidence in an argument, but if the millions of objects imported into Europe from East Asia during the seventeenth and eighteenth centuries are taken into account, it is also problematic. I must necessarily severely restrict my examples, and even though quantities of chinoiserie objects do not support my argument, I make no apology for selecting those that do. Still, the widely acknowledged shift from "good China" to "bad China" in chinoiserie that took place in the second quarter of the eighteenth century cannot have materialized only from artistic choices and changes in taste. It is too widespread, too sudden, and too decisive.

Confining my arguments to Catholic courts and elites has helped me focus more closely on the Church's role in the development of chinoiserie in a global context, but it has the disadvantage of presenting relatively little evidence from the United Provinces (now known as the Netherlands) and the British Isles, which were both hugely important emporia for East Asian goods that also made significant contributions to chinoiserie. With few

exceptions, I base my narrative on objects produced in Catholic states for Catholic patrons, juxtaposed to works of East Asian art available in Europe and including evidence from the Protestant maritime powers only for purposes of comparison. The study of global chinoiserie has been more deeply developed in the British and Dutch contexts than in the context of Catholic Europe, thanks to the work of scholars such as Christiaan Jörg, Dawn Odell, Julie Hochstrasser, and Stacey Sloboda, among others. I hope that this book helps expand the discourse.

In addition to the challenges presented by the almost unfathomable quantity of East Asian works of art and material culture available as artistic inspiration for chinoiserie, there is an additional problem in the broad range of objects. Europeans imported from China (and sometimes Japan) printed and unprinted fabrics that served as points of departure in chinoiserie designs for wallpaper, clothing, folding screens, fans, endpapers for books, and many other utilitarian and decorative objects. Hugh Honour's pioneering study, *Chinoiserie: The Vision of Cathay*, provides myriad examples of such objects.[8] Lacquer furniture from Japan and later China became popular as early as the sixteenth century, and by the 1700s, antique lacquer panels imported from the East were being cannibalized from earlier pieces of furniture and incorporated into new ones of Western manufacture. A stunning example of such hybrid furniture is a *commode à vantaux* (chest of drawers with doors), circa 1780, by the celebrated Parisian cabinetmaker *(ébéniste)* Adam Weisweiler (1744–1820), now in the Nelson-Atkins Museum in Kansas City (figure 4). In it, five antique Japanese lacquer panels are incorporated into a modern construction of ebony, mahogany, marble, and gilt copper alloy. Indeed, many *ébénistes* adapted the Asian forms seen in imported lacquer to decorate furniture of entirely European production. Chinese silver was also admired and its deployment in chinoiserie parallels that of lacquer, especially in Great Britain. There, a spectacular silver epergne, made in 1761 and attributed to Thomas Pitts (active 1744–93) and also preserved in Kansas

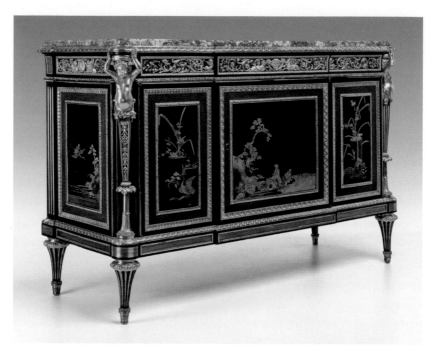

4. Adam Weisweiler, commode *à vantaux*, ebony, marble, mahogany, lacquer, and gilt copper, ca. 1780. Kansas City, Nelson-Atkins Museum of Art.

City, imitates figural and architectural forms ultimately derived from Chinese art and architecture (figure 5).

By far the most important Chinese luxury import, however, was porcelain, a substance whose polished, radiant surfaces and great durability fascinated Europeans, often to the point of obsession. Although my narrative includes works in a variety of media, I privilege porcelain, for it was without question the most ubiquitous East Asian art encountered in Europe. Western attempts to manufacture porcelain whose quality compared to that produced by the Chinese were realized only in the eighteenth century, despite sustained and determined efforts. Asian porcelain was also the most impor-

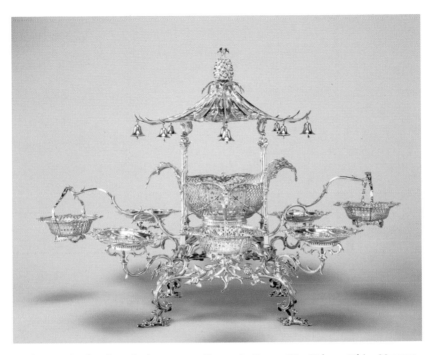

5. Thomas Pitts (attributed to), epergne, silver, 1761. Kansas City, Nelson-Atkins Museum of Art.

tant single source of authentic motifs, although woodblock prints included in books and produced by Chinese artists were also highly influential.[9] In European porcelain, however, one sees the earliest indications of the dismissive, feminized image of China that came to dominate chinoiserie in the second and third quarters of the eighteenth century, a perception that permeated the Western imaginary until the relatively recent emergence of China as an economic powerhouse and a global military presence.

China and the Church

From Matteo Ricci to the Chinese Rites Controversy

The *Nestorian Stele* in Xian (figure 6), an oolitic limestone monolith ten feet high erected by Nestorian missionaries in 781, documents the presence of Christians in China from 635, during the Tang dynasty (618–906). It has both Chinese and Syriac characters, and lists the names of the Assyrian missionaries who had come eastward over the Silk Road to convert China. Early Chinese sources are virtually silent about the original Nestorian enterprise, and without the evidence of the monument it is likely that awareness of the earliest presence of Christians in China would have remained obscure or would even have been lost to historical memory. The Nestorian mission left few traces, but it was only the first of many attempts by Christians to proselytize the eastern empire. Western efforts to evangelize in the East have a surer historical basis during the Yuan dynasty (1271–1368), inaugurated by the Mongol conqueror Kublai Khan (1215–1294) after he defeated the remnants of the Song dynasty (960–1279) that had controlled southern China since 1127.

The *Pax mongolica* established by the Mongols made travel between Europe and East Asia considerably less dangerous than in earlier times, and caravans laden with goods traveled in both directions. A few Europeans are documented at the Mongol court during this time, including the Parisian

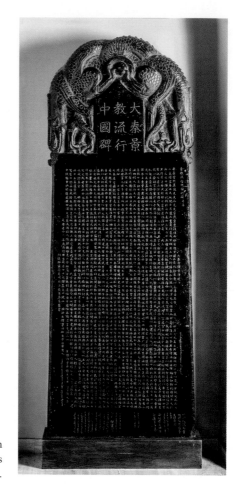

6. Nestorian stele, limestone, seventh century CE. Xian, Beilin Forest of Steles Museum.

goldsmith Guillaume Boucher. The most celebrated Western tourist of the era was the Venetian Marco Polo (1254–1324), who claimed to have gone to China and later published a widely influential memoir, a text so fantastical that it raises the question of his ever having really visited the empire. In any event, Polo's account of the land he called Cathay made a profound

China and the Church

impression on the European imagination and was generally believed until eyewitness accounts by missionaries and merchants proved much of it to be fictional.

The tranquility the Mongols imposed on most of Central and East Asia also encouraged the Roman Catholic Church to send missionaries to China. Innocent IV Fieschi (reigned 1243–54) dispatched an informal embassy to the peripatetic Mongol court in Karakorum, in Outer Mongolia, led by the Franciscan Giovanni da Pian del Carpine (ca. 1180–1252), but he probably never visited China. In 1294, the year of Kublai Khan's death, Giovanni da Montecorvino (1246–1328), a papal envoy sent to China by Nicholas IV Masci (reigned 1288–92), actually reached Beijing, but it is unclear what his contacts were with the court in a time of official mourning and imperial succession. While in China, he translated Christian texts (but not the Bible) into Chinese and was named bishop of Beijing by Boniface VIII Caetani (reigned 1294–1303). Father Andrea da Perugia (d. 1332), who joined Giovanni da Montecorvino in 1309, was consecrated bishop of Quanzhou, the ancient port city described by Polo as "the Alexandria of the East," in 1323. Unlike the Nestorian effort, the Roman Catholic mission established in the late thirteenth century left its mark in Chinese accounts of the Yuan dynasty and was apparently of sufficient importance for Benedict XII Fournier (reigned 1334–42) to send Giovanni de' Marignolli (ca. 1290–ca. 1365) to oversee it in 1342. In the first documented instance of a formal papal diplomatic embassy to China, Marignolli brought presents from Pope Benedict to the Yuan emperor, Toghon Temür (reigned 1333–70), the last of the dynasty to rule China.[1] Chinese sources mention as a component of the papal offering some large black European horses that astonished the emperor.

Marignolli's presentation of pontifical diplomatic gifts was the first of a long series of such gestures, and many East Asian objects were sent as presents to various popes in return. Thus Rome (and Avignon for a time) became important centers for collecting Chinese art. In particular, a number of now

untraced portraits of Chinese emperors and other worthies appeared in the papal cities, giving Westerners a better indication than the textual descriptions of merchant adventurers like Marco Polo of how East Asians actually looked.[2] When a small group of members of the Society of Jesus (the Jesuits) arrived in China in 1579, the mission church established under the Yuan was only a distant historical memory. That church probably did not survive the tremendous upheavals that accompanied the expulsion of the Mongols and the establishment of the Han Chinese Ming dynasty in 1368. The Ming in any event expelled any Christians who remained. Ricci's Jesuits, in the last quarter of the sixteenth century, encountered a radically different China than did their medieval forebears. It was immediately apparent that the Ming Empire rivaled late Renaissance Europe in sophistication and cultural flowering, the Ming's "heathen" religions excepted. As the Jesuit missionary in Japan Francis Xavier (1506–1552) recognized, East Asia could not be overawed by Western technology or force of arms; only intellectual accomplishment and personal virtue would allow Christians to make evangelical inroads in China.[3] Indeed, Xavier died on an island off the coast of southern China while on his way to help proselytize the empire (figure 7). The Jesuits were not only predisposed to admire Chinese civilization, but even began to detect parallels between Christianity and many elements of Confucian philosophy, which was the preferred thinking of the Chinese upper classes.

This fortuitous development led to a rash of publications claiming that China was ripe for conversion, chief among them Niccolò Longobardi's *Breve relatione del regno della Cina* (Brief Account of the Kingdom of China), published in Rome in 1601. This important text was quickly translated into French, German, and Latin. If all the accounts of late Ming China that reached Europe were not so optimistic or laudatory, neither did they have much impact on Western attitudes.[4] Following a period of initial struggle, the Jesuits were making influential friends among the Chinese scholar official and merchant classes by 1610, when Ricci died.

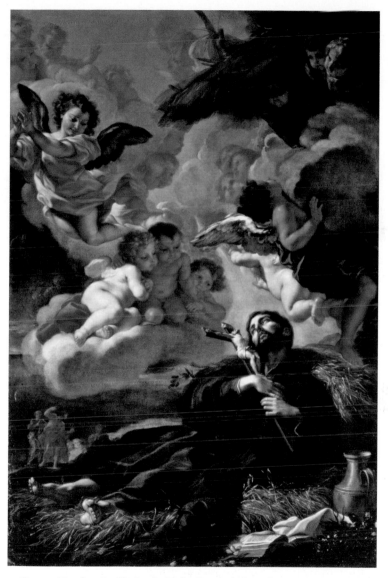

7. Giovanni Battista Gaulli, *Death of Saint Francis Xavier*, oil on canvas, 1675. Rome, Church of Sant'Andrea al Quirinale.

Although few Chinese notables converted to Catholicism, many were interested in Western ideas, especially those related to technology. The last Ming emperors feared the Manchu menace in the north, and they were also wary of possible Dutch, Spanish, and Portuguese designs on the Chinese seaboard. Indeed, the Portuguese were already ensconced in the trading colony of Macao on the southern coast of China, albeit with imperial permission. The Ming government welcomed the practical advice of the Jesuits on how to build better fortifications and improve the range and accuracy of cannon, as well as their counsel on military issues in general. Late Ming China was obsessed by novelty in the scientific and cultural arenas, so the Jesuits were in the right place at the right time.[5] Clocks, maps, books, astronomical instruments, and mathematical implements became the gifts of choice for the Chinese court, catering to an interest that continued far beyond the Ming and even persisting after the end of Christian evangelization in the early 1720s.

European rulers, including the popes, were eager to respond to Jesuit requests for Western books and scientific instruments to present to the emperors in Beijing. In return, the Chinese rulers dispatched quantities of luxury goods such as lacquer, silk, porcelain, tea, silver ornaments, and paper from China to Europe, especially Rome and Lisbon and, later, Madrid, Dresden, and Versailles. The Jesuits were reluctant to inform European audiences of the more "pagan" aspects of Chinese belief systems, because their agenda was to promote the compatibility of Confucian (and neo-Confucian) ethics and Christian morals. Many of the works of art that arrived in Europe, however, represented East and South Asian divinities, something the missionaries must certainly have comprehended. Perhaps they chose to downplay such knowledge as detrimental to their goal of presenting the Chinese in as favorable a light as possible to the Christian West.

Chinese soapstone carvings, highly collectible objects in Europe, are a case in point. The 143 soapstone sculptures collected in the late seventeenth

China and the Church

and eighteenth centuries and preserved in the Ethnographical Museum in Dresden are figural, many representing Buddhist and Daoist divinities, as Maureen Cassidy-Geiger has recognized.[6] The Daoist Immortal Li Tieguai, forced to inhabit a beggar's mortal body, is depicted with a crippled leg, accompanied by his usual attributes—a gourd bottle full of magical potions and an iron crutch—but curators in the Saxon capital did not mention that these objects identified him as a divinity. Cao Guojiu, another Immortal, is represented holding castanets, but the cataloguers in eighteenth-century Dresden interpreted them as a cat-o'-nine-tails, indicating they had little or no knowledge of their bearer's identity. Jesuit publications were crucial to the formation of European ideas about China, but their dearth of information on the variety and iconographical richness of East Asian religions encouraged Westerners to view such figures as either engagingly exotic or superstitiously absurd.[7] By the early Enlightenment, the latter attitude was in the ascendant. My point is that even though Europeans were familiar with the actual appearance of Chinese people, many of them dismissed Chinese religion as signifying cultural fatuity and spiritual decadence because of the distorted physiognomies of some Chinese divinities and the "nonsensical" objects they held. One wonders what a court scholar in Beijing would have made of an image of Saint Cecilia holding a miniature pipe organ, Saint Lucy bearing a tray on which her eyeballs rest, or John the Baptist eating a bug.

Porcelain and book illustrations were the primary media that transmitted a reasonably accurate image of China to artists and audiences in the West. This context underscores the importance of recognizing the dramatic increase in figural narratives in Chinese porcelain and printed books during the early and middle decades of the seventeenth century—precisely the type of ceramic vessels and books Jesuit missionaries would have seen in the houses of the scholar literati and rich merchants to which they were admitted. These same figurative objects were being sent to Europe in increasing numbers during the political crisis of the late Ming dynasty and especially

under the Wanli emperor (reigned 1572–1620). Wanli abruptly ended imperial patronage of the great Jingdezhen porcelain manufactory in southern China, most likely owing to the dramatic rise in expenditures for the army to meet the military threat from Manchuria. The Jingdezhen producers then looked to other markets, including Europe. Many of the narratives decorating Chinese porcelain of this period reference political and religious themes, as did many texts illustrated with woodblock prints that also found their way to Europe.[8] The missionaries' failure to address substantive issues of iconography in the works of art being sent to Europe encouraged a slippage between the original intention and the ultimate reception, and when enthusiasm for China began to wane, such narratives lost their status as intriguing curiosities and came to be seen as evidence of a debased and impotent society mired in superstition.

+ + + +

As European knowledge of Chinese history grew, a troubling paradox emerged. By the seventeenth century, Western scholars, able now to read the chronicles of the empire, realized that China was a much older civilization than Europe, predating even Noah's Flood. China is not mentioned in the Bible, however, with the possible exception of the land of Nod, east of Eden, whose daughters wed Adam's sons, as described in the book of Genesis. Those favorably disposed to China went to great lengths to reconcile biblical history with the Chinese texts. Language was a possible explanation. If one accepted the proposition that Chinese characters were a form of hieroglyphics, it seemed reasonable to assert that China was founded as an Egyptian colony, thus resolving the chronological dilemma, though certainly not to the satisfaction of most scholars.[9] The fact that Egyptian hieroglyphics have no visual similarity to the characters of the Chinese language was conveniently set aside by those who argued for China's Egyptian origin.

China and the Church

A prominent group of European divines called the Figurists gleaned from the moral philosophy of Confucius and other early Chinese sages what they took to be indications that the Chinese had been aware of pre-Christian revelation. The German Protestant historian Georg Horn (1620–1670) was also a major advocate of this position, going so far as to equate ancient Chinese rulers and philosophers with the patriarchs of the Old Testament.[10] Horn and his adherents also believed that their explanation had solved the problem of reconciling the chronology of Chinese texts with that of the Bible, but questions remained: How had China become aware of pre-Christian revelation in the first place, and why do Chinese sources, then widely respected by Western scholars, not mention a universal flood? As Martino Martini (1614–1661) pointed out in *Sinicae historiae decas prima* (History of China, Volume One), published in Munich in 1658, seven Chinese emperors had reigned before the Deluge, an event most Christian scholars dated to the year 2349 BCE. Chinese chronicles mention a major flood that occurred in about 3000 BCE but do not indicate that it destroyed either East Asia or the rest of the world. European accommodationists decided to move back the accepted date for the disaster described in Genesis about six and a half centuries, believing that the Chinese flood must have been the biblical Deluge, although to most traditionalists this claim was anathema.[11] Moreover, to explain the parallels between Chinese morality and pre-Christian revelation, many writers imagined that after the Noadic flood the Old Testament patriarch's son Shem had actually gone to China to establish a civilization based on the teachings of the universal Logos, thus giving the empire a privileged place in the history of Christian salvation.[12] Jesuit Figurists and others knowledgeable about China were part of a broader group of universalizing scholars whose work was largely discredited during the eighteenth century. Their earnest attempts to trumpet the commonalities between Chinese and Judeo-Christian theology in the context of divine revelation demonstrate vividly what was at stake in the China debate. If China were indeed a pre-Christian, antediluvian

culture that somehow had lost knowledge of its biblical origins, then the evangelizing mission itself should be intensified and "true" believers had all the more reason to support it.

The intellectual rejection of universal histories and their undiscerning use of textual sources during the Enlightenment brought Figurist thinking and biblical accommodation with Chinese history into disrepute. Most eighteenth-century intellectuals were highly critical of China, decrying the traditional Jesuit position as prejudiced and self-serving. This seismic shift in European attitudes happened in precisely the same years that the Society of Jesus, which had become the whipping boy for an obscurantist approach to religion, was castigated as a major impediment to social and cultural progress. Four of the five mid-eighteenth-century popes were either ambivalent or hostile to the Jesuits: Benedict XIII Orsini (reigned 1724-30), Clement XII Corsini (reigned 1730-40), Benedict XIV Lambertini (reigned 1740-58), and especially Clement XIV Ganganelli (reigned 1769-74). It was the last of these pontiffs who abolished the society in 1773 with the bull *Dominus ac Redemptor*, much to the delight of progressive Catholics, Protestants, anticlericals, and, above all, Portugal and the Catholic Bourbon courts.

A few voices were heard defending China during the Enlightenment, but some of these apologists used earlier Jesuit texts perversely, to discredit biblical history and the notion of Christian revealed religion. Major reasons for the great interest of some Enlightenment scholars in Chinese historical sources were their virtually unbroken chronology and the near absence in them of the miraculous and apparitional tales that made biblical narratives so suspect to progressive thinkers.[13] Voltaire (François-Marie Arouet, 1694-1778) was the best known of these cynical Sinophiles. Although he often praised the lack of "allegorical fables" in the Chinese texts, he wrote about them in a flattering way to attack indirectly what he viewed as the retrograde mysticism of the Jesuits. In 1765 he wrote: "If any annals bear a character of certitude they are those of the Chinese, which have joined . . .

the history of the heavens with that of the earth. Alone of all the peoples, they have constantly marked their eras by eclipses, by conjunctions of planets, and our astronomers who have examined their calculations have been astonished to find them almost all true. The other nations invented their allegorical fables and the Chinese wrote their history, pen and astrolabe in hand, with a simplicity of which there is found no example in the rest of Asia."[14] By the mid-eighteenth century, Chinese scholarship, culture, and even art were most often defended only as a pretext for attacking ancien régime institutions or "feminized" rococo aesthetics. (Denis Diderot, 1713–1784, was highly contemptuous of East Asian art, disparaging it savagely in the *Encyclopédie*, which he coedited with Jean le Rond d'Alembert, 1717–1783.) How had the paeans of praise lavished on almost all things Chinese in the sixteenth and seventeenth centuries been all but silenced in the eighteenth? The history of the Christian mission in China, from its origin in 1579 to its virtual destruction in 1722, may shed some light on the issue.

+ + + +

Of all the late Ming and early Qing emperors who showed favor to the Catholic missionaries, it was the Kangxi emperor who inspired the most admiration and who seemed to the Jesuits most likely to accept Christianity and thus facilitate the conversion of the empire from the top. There were many reasons for optimism. As a young man, Kangxi had been an ardent student of Jesuit tutors, receiving instruction in mathematics, music, astronomy, hydraulics, and military science for up to four hours a day.[15] His great mentor was a German Jesuit, Johann Adam Schall von Bell (1591–1666), one of the most notable astronomers of the seventeenth century. A print portrait of Bell shows the priest dressed in mandarin robes with a rank badge that displays a bird, a signifier of imperial favor (figure 8). After Bell's death, his place was taken by Ferdinand Verbiest (1623–1688), a Flemish Jesuit whom the emperor appointed head of the Imperial Astronomical Bureau in 1669. Both were men

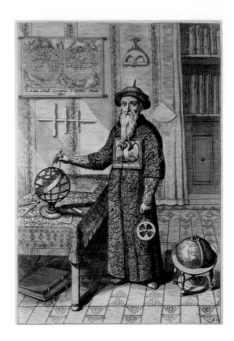

8. Anonymous, *Portrait of Johann Schall von Bell*, engraving, from Athanasius Kircher, *China illustrata*, 1667.

of the Beijing court, and their service to the Kangxi emperor allowed some of their brothers to conduct actual missionary work in the capital and provinces. In 1670 Verbiest introduced the sixteen-year-old monarch to Matteo Ricci's translation of Euclid's *Treatise on Geometry*, a monument to Jesuit intellectual prowess and mastery of the Chinese language.[16] A portrait of Kangxi executed about this time shows the learned ruler seated at a desk in a room defined by Western perspective, perhaps a reference to his study of Euclid under Verbiest.

When Ricci died in 1610, the Wanli emperor commissioned a tomb for him in the imperial capital, an extraordinary honor for a "barbarian." Ricci's successful efforts to bring the mission to the court's attention indicate the ultimate Jesuit strategy—to win over the monarch and members of his family and court so that conversion of the entire empire could be accomplished

China and the Church

more easily and quickly. The collapse of the Ming dynasty, however, put this plan in considerable jeopardy. During the 1640s and 1650s, the triumphant Manchus went to considerable lengths to silence philosophical discussions between the missionaries and their patrons among the scholarly gentry and merchant elite.[17] Missionary efforts dwindled amid the dynastic chaos, especially in southern China, where most of the Christian evangelical establishments were located. The Manchu recognized the important role the Jesuits and a few missionaries from other Catholic orders could play in promoting science and technology at court, so the best among them were brought to the capital, much to the detriment of the mission in the rest of the empire. At first this seemed an auspicious development because the most learned of the Fathers would have direct access to the throne. In the long run, however, it proved to be the mission's undoing.

The Kangxi emperor employed the Jesuits in Beijing as scientists, physicians, cartographers (a vital function in so large an empire), botanists, artists, and translators. The Fathers understood that their service would ensure the emperor's protection, in return, of the Church's missionary interests in the rest of the country, localized persecution of Christians being not uncommon. Given that the actual number of missionaries was small, the government had little to fear from evangelization. The Jesuits saw in imperial favor an indication of Kangxi's genuine concern for Christianity, when in fact his personal interest was relatively limited. He was willing to let the Christians proselytize wherever they liked as long as he could select the most talented among them for court service.[18] Before the 1680s, the China mission was composed primarily of Jesuits, with a few Franciscans, Dominicans, and Augustinians also participating. Most came from Spain, Portugal, Italy, and the Catholic areas of Germany and the Netherlands; very few were French. This national dynamic changed dramatically when Louis XIV (reigned 1643–1715) sent six of his Jesuit subjects to Beijing in defiance of long-standing Portuguese pretensions to exclusive rights (the *padroado*) over which

missionaries were allowed to proselytize in East Asia. The Sun King's reception of Michael Shen (Shen Fuzong), a Chinese convert who visited France in 1684–86, may have influenced his decision.[19] Moreover, collecting East Asian luxury objects was all the rage at the Versailles court, and French merchants exhibited a growing interest in establishing direct trade between France and China instead of relying on Dutch and English middlemen, which made imported goods more expensive. There was every reason to believe that China was ripe for conversion, if even half of what the French monarch heard about his Eastern counterpart were true. Louis's enthusiasm for playing the role of Most Christian King was genuine and should not be underestimated. The group of six he sent to the Kangxi emperor included Joachim Bouvet (1656–1732) and Jean-François Gerbillon (1654–1707), both of whom became major players at the imperial court, especially in the diplomatic arena.

The growing presence of Russian traders on his northern frontier was among the Chinese sovereign's many diplomatic problems. Sino-Russian contact and conflict were frequent after about 1650, and both the lucrative trade in furs and the possible presence of precious metals in the border region were at stake. Cossacks raided Chinese villages, and the construction of two Russian forts in the disputed territories led to open hostilities in the early 1680s. Rather than risk a wider war, the Qing and the Romanovs decided to negotiate, and the Treaty of Nerchinsk (1689) was the result. The challenges of such diplomatic endeavors were greater than they may appear at first glance, for subtlety of language was paramount and the linguistic obstacles were daunting. The Kangxi emperor sent a Chinese delegation, accompanied by two of the court Jesuits—Gerbillon and Tomás Pereira (1645–1708)—to negotiate. The resulting treaty was highly favorable to China. It was published in Manchu, Chinese, Mongol, Russian, and Latin, the last being the language of widest global currency.[20] A large swath of territory north of the Amur River and extending to the Pacific Ocean was recognized as Chinese, and the Russian forts there were to be dismantled. In

China and the Church

return, a "Russian hostel" was created in Beijing to handle affairs of trade and diplomacy between the empires.[21] Eleven Russian embassies were sent to the Qing court during the eighteenth century, more than to any other foreign capital. Kangxi was cognizant of the pivotal role the Jesuits had played in the negotiations and showed them even greater favor than before. Three years later, he was able to demonstrate his appreciation in a spectacular way that the missionaries and the European Catholic powers misinterpreted, with deeply unfortunate consequences.

In 1691 an unusually severe persecution of Christians had been initiated in Hangzhou, with the support of local officials who saw Christianity as a threat to traditional Chinese values and Confucian teaching. The local Jesuit superior, Prospero Intorcetta (1626–1696), wrote to his brothers in Beijing begging for help. The Kangxi emperor was not slow to act on their behalf. In edicts of March 17 and March 19, 1692, he forbade the persecution of Christians throughout the empire and insisted they were no threat to the state. In addition, he acknowledged their contributions to court life and scientific progress. The Hangzhou persecution immediately ceased. The Fathers in Beijing were ecstatic and wrote letters to Innocent XII Pignatelli (reigned 1691–1700) and other Catholic rulers claiming that what they called the Edict of Toleration was tantamount to an imperial profession of faith. In fact, Kangxi was only rewarding the Jesuits for past service, and the edict was no more than a statement of "positive neutrality," as the historian Liam Matthew Brockey has accurately characterized it. Widespread evangelization and a dramatic increase in the number of Chinese Christians were not the emperor's intent, and in any event the small number of missionaries in the provinces precluded any serious alteration in the empire's confessional configuration. From the proclamation of the Edict of Toleration until 1704, when the mission began to be seriously imperiled by the Chinese Rites Controversy, Christianity expanded only modestly, in both new converts and additional missionaries sent from Europe.[22] The flush of success, and anticipation

that the edicts of 1692 would occasion a miraculous mass conversion, blinded Christians to the reality of the situation. Kangxi continued to favor them, and his generosity increased after a Jesuit doctor cured him of a fever by dosing him with quinine. Chinese texts indicate that the monarch often talked to missionaries in the provinces during his frequent progresses, especially in southern China, and that he entertained them in his far-flung palaces, a kindness especially in evidence in the years around 1700. The Kangxi emperor's reputation was at its apex in Europe in the fifteen years following the Edict of Toleration. He was lionized as an outstanding ruler and administrator who curbed corruption, expanded his empire, and brought peace, prosperity, and security to his subjects.[23] The favor he extended to the missionaries and China's adoption of papal calendar reforms that many parts of Europe still refused to recognize were cited as evidence of the emperor's Christian leanings and progressive leadership. But these years of optimism and hope also witnessed the events that were ultimately to be the mission's undoing. As national and ecclesiastical rivalries among the missionaries and their supporters in Europe intensified, many came to resent the Jesuits' dominance of the Catholic missions in China and to disapprove of their accommodationist conversion practices, above all their tolerance for the rites. Doctrinal controversies about the proper conduct of missionary work confused things even more and also annoyed the emperor. Ironically, the positive view of China seen in much chinoiserie blossomed at the very time it was becoming apparent that the mission's inherent contradictions rendered the chances of a mass conversion of the Qing Empire virtually nil.[24]

At the height of their influence, from about 1690 to the end of active evangelization, the Jesuits administered three establishments in Beijing. The Portuguese College, called the Church of the South, was the oldest and housed the Tribunal of Mathematics. This government bureau, with more than two hundred members, was universally respected for its efforts to reform the calendar and make more accurate predictions of eclipses. These

rare astronomical events had helped to mark eras in Chinese history from time out of mind. The tribunal continued to operate freely even after prose-lytization efforts were prohibited. The Bavarian Jesuit Ignaz Kögler (1680–1746) directed the tribunal from 1717 until his death. The Portuguese also administered the Residence of Saint Joseph, the epicenter of missionary efforts in the Qing capital. The French Jesuits were relative latecomers, and their church and residence, together called the Temple of the North, were constructed at the joint expense of Louis XIV and the Kangxi emperor. When the Manchu ruler died in 1722, eight priests and a novice were living there, including the aged Joachim Bouvet.[25] From the Church's point of view, the destruction of such promising prospects—because the institution could nei-ther reconcile differences in missionary methods nor understand Chinese sensibilities on the issue of the rites—was unfortunate. The Kangxi emperor sent Jesuit after Jesuit back to Europe to explain the situation in China, hop-ing to establish peace among the various orders and demanding that Rome acknowledge his authority over the mission. Papal prevarication and increasing animosity among the missionaries only made the emperor more and more suspicious of Christian motives. When Clement XI Albani (reigned 1700–21) finally ruled against toleration of the Chinese rites, Kangxi still tried to negotiate, not really understanding how distant doctrine could trump imperial power. By the last years of his reign, the monarch's patience had been exhausted and the mission had run out of time. On November 18, 1720, the Kangxi emperor published the Decree Concerning Foreigners, whose impact on the mission was catastrophic. The text began by praising the missionary practices of Matteo Ricci, which Clement XI had forbidden, declaring that Chinese Christians had practiced their religion for over a cen-tury without trouble or violating the law. The emperor's real views of Chris-tianity, however, were revealed in the following statement from the decree: "The Church you propagate is neither good nor bad for China, and whether you remain or leave will make no difference."[26] Such aloofness, the product

of years of frustration with the Christians, could not be misunderstood. If the mission could not accommodate the Kangxi emperor, then the mission would have to go.

+ + + +

Although I have mentioned the Chinese Rites Controversy only in passing, it had dragged on for decades and was the chief cause of the Catholic shipwreck in the Manchu Empire. Confucian rituals of profound importance to Chinese society were the primary challenge to Jesuit conversion practices in China. They are fundamental to understanding why Christianity foundered in China in the third decade of the eighteenth century and why European attitudes toward China altered markedly for the worse.

The Jesuits' standard practice, in the books they published and the letters they wrote, was to whitewash Chinese religious, social, and sexual behavior in order to encourage the positive view of China they assiduously promoted. Although Ricci championed China fully, he did condemn many aspects of late Ming sexuality, including prostitution, pederasty, homosexuality, and polygamy, but these censures were largely expunged from his *Storia dell'introduzione del Cristianesimo in Cina* (History of the Introduction of Christianity into China), a foundational text edited and published in Rome after its author's death by the Flemish Jesuit Nicolas Trigault (1577–1628). Trigault was responsible for the Latin translation of the book. It first appeared in 1615 and within a decade had also been translated into French, German, Spanish, and English.

It became customary among the mission Fathers in their writings to avoid any reference to Chinese practices that could not be interpreted positively or that were unequivocally contrary to Christian morality, and this carefully managed view of the East dominated Western perceptions, especially in the Catholic world.[27] What the missionaries actually meant to conceal, however, was their own tolerance of certain ritual practices (the Chi-

nese rites) that were ubiquitous in China, most notably ancestor worship, the sexual practices decried by Ricci being hardly unknown in Europe. The Jesuits and some other missionaries understood that rejecting the Chinese rites would create an enormous obstacle to evangelization, and once it became clear that some Christians, particularly many of the non-Jesuit missionaries, would not allow the indigenous practices, the Fathers became advocates of accommodation.[28] Those who favored tolerating the Chinese ritual practices argued that they were primarily social and civic in nature; others thought them idolatrous. The ritual use of ancestor portraits and tablets with the names of individuals inscribed on them was the major source of interpretive dissension.

Anyone looking at an image of a Chinese family posed before an array of ancestor portraits and tablets (figure 9), can instantly comprehend why the ancestor rites disturbed many non-Jesuit missionaries. Roman Catholics of the time instinctively and correctly understood images and ritual acts in a religious context, and the ancestor portraits seen here are placed on tables that look suspiciously like the altars in Christian churches. In addition, they are often labeled with the phrase "Seat of the Spirit." Moreover, the ritual respect paid to the images included the koutou (even more obeisant than Catholic genuflection), the use of incense to purify the tablets and to help connect the physical world to the divine, offerings of food and wine, and even the burning of paper money to send it symbolically to the world of the spirits. In many Confucian ancestor rites, an animal was also sacrificed. "Altar" tables for displaying offerings, inscriptions of the word spirit, physical prostration, incense, offerings, and the idea of sacrifice all accorded well with what most Catholics would consider a religious performance. The Jesuits must initially have reacted in a similar way, but their deeper knowledge of Confucian ritual practices and their importance to Chinese society enabled the Fathers to interpret them differently in order to promote their own proselytizing. They made a judgment call on the spot as to whether

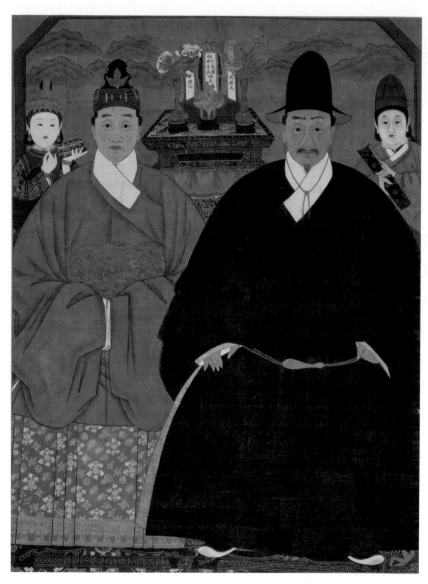

9. Anonymous, *Portrait of Father Zhang and Mother Zhao*, ink and colors on silk, late Ming or early Qing. Washington, D.C., Freer Gallery of Art and Arthur M. Sackler Gallery, S1991.73.

Chinese converts to Catholicism could participate in ancestor rites, and their accommodation of Confucian rituals is a typical example of the Jesuits' pragmatism. Even the Society of Jesus knew, however, that the rites would ultimately be judged in Rome, not China.[29]

The Chinese Rites Controversy plagued the China mission throughout the seventeenth century. Both sides complained to the Roman Curia, and occasionally a pope would make a general statement supporting one side or the other but would not commit to a dogmatic pronouncement. In 1700 the court Jesuits, confident of their favored status in Beijing, composed a statement outlining the purely honorific and filial aspects of the Confucian rites, quoting Ricci and offering in evidence a century of missionary practice. They submitted it to the Kangxi emperor to see if he understood the situation in the same way or wished to correct the text. He said that it reflected perfectly his understanding of the rites and that the Jesuit document required no imperial emendation. The Fathers then forwarded the text to Rome, hoping their position would be vindicated. This was clearly naïve on their part, considering the traditional papal resistance to interference in doctrinal questions by secular rulers. The Roman reaction was predictable: the Curia deeply resented Jesuit collusion with the emperor of China and the emperor's interference in what they considered a strictly ecclesiastical matter.[30] Clement XI was appalled by what the Beijing Jesuits had done. There can be little doubt that this Jesuit miscalculation hastened a definitive papal decision that was diametrically opposed to their interests and, in the event, to their ability to continue the China mission.

The same year that the Jesuits appealed to Rome for toleration of the Chinese rites, the clerical faculty of the Sorbonne in Paris condemned them. The issue split the religious orders. Some Franciscans, almost all Dominicans, and every Augustinian condemned the worship of ancestor tablets, while almost all Jesuits and several Franciscans argued in favor of toleration.[31] Four years later, Clement XI issued the bull *Ex illa die*, definitively condemning

the Chinese rites, but it was officially promulgated only in 1715, to allow time to communicate the decision to the missionaries, inform the imperial court, and ensure obedience. It is certain, however, that Pope Clement had decided as early as 1702 to forbid the Confucian rituals. In July of that year he dispatched the Piedmontese aristocrat Charles Thomas Maillard de Tournon (1668–1710) to Beijing. Tournon was consecrated bishop and patriarch of Antioch, apostolic visitor to the East Indies, and papal plenipotentiary *ex latere* to negotiate with the Kangxi emperor over the rites, but in reality his mission was meant to square the emperor with the forthcoming papal pronouncement. *Ex illa die* was drafted while the pontifical emissary was en route to China.

It would be seven years before Kangxi learned the bull's precise contents, but he was aware that Clement XI was unsympathetic to his views. On December 4, 1705, Tournon was given a sumptuous imperial reception and was showered with honors and presents. But subsequent audiences proved contentious and unproductive. Kangxi ordered the ambassador from court while he considered a response. In fact, the emperor was waiting for the return of the two Jesuits he had sent to Rome to negotiate, but the pair perished in a shipwreck on the return trip. I have not been able to ascertain what instructions they received in Rome, but it seems likely that they had been commanded to inform the emperor that the negative decision concerning the rites was final. Finally convinced that the Albani pope would not yield, the Kangxi emperor decreed that only those missionaries who tolerated the rites as Ricci had would be allowed to stay in China. Tournon, in temporary exile in Nanjing, responded in 1707, requiring all missionaries to take an oath to uphold the papal condemnation. For this act of insolence, the emperor expelled him to Macao, where he was kept under house arrest by the Portuguese authorities, who did not recognize his status as a papal representative because he had been sent to China without the placet of King John V (reigned 1706–50), who still claimed the prerogatives associated with

the *padroado*. Ill and discouraged, Tournon was named a cardinal a few months before his death in Macao, on June 8, 1710.[32] The Kangxi emperor was deeply offended by Tournon's attitude and the Roman refusal to acknowledge his jurisdiction over the mission, and in response to Tournon's directive, he ordered all missionaries to obtain residence permits *(piao)*, to promise to maintain the practices of Ricci, and to remain in China for the rest of their lives. This last stipulation may indicate the emperor's concern that the pope might compel the Fathers in Beijing, so valuable to the court for their technical and scientific expertise, to return to Europe. The emperor personally examined many of the missionaries to enforce compliance to the *piao* rule; by 1708 forty-three of them had been expelled and six were under arrest in Guangzhou (Canton). Fifty-seven either defied Tournon and were allowed to stay in China or went into hiding.[33] Slightly more than half the missionaries who had been in China prior to the Tournon embassy remained, at least for the time being. Although the Kangxi emperor dispatched another Jesuit embassy to Rome to appeal to the pope for the nullification of the bull, the remaining priests understood that unless Pope Clement could be persuaded to relent, the mission was doomed.[34] Negotiations with the papacy were fruitless, and Clement XI confirmed *Ex illa die* in 1715 and formally published it the next year.[35] Rejection of the Chinese rites was now an article of faith.

It is not difficult to sympathize with Kangxi in his initial bewilderment and ultimate anger against the Church, given the many favors and honors he had accorded it in his realm. In particular he was dismissive of Clement XI's pronouncements, characterizing them as ignorant, unlearned, and risible, given that none of the Western principals involved in writing the bull *Ex illa die* could even read Chinese. After his final audience with Tournon, he wrote: "Today I saw the papal legate and the Decree; he is really like Buddhist or Taoist priests and the superstitions mentioned are those of unimportant religions. This sort of wild talk could not be more extreme. Hereafter, foreigners

are not to preach in China. It should be prohibited; it will avoid trouble."[36] Although the threat to ban foreign preaching was not enacted immediately, it was an ill omen for the mission's future.

The Kangxi emperor's attitude toward *Ex illa die* doubtless must have puzzled Clement XI, who believed that only the supreme pontiff could make decisions about Catholic doctrine. In 1719 he sent another embassy to Beijing to try to reason with the emperor. It was led by Carlo Ambrogio Mezzabarba (1685–1741), an able canon lawyer and priest from Pavia. During audiences in late 1720 and early 1721, Mezzabarba simply reiterated the papal position, offering a few minor concessions. His dismissal from Beijing was much more polite than his predecessor's, but Kangxi was still determined to forbid any evangelization that contradicted Ricci's missionary practices. He decided that only Jesuits well versed in scientific and technological matters and those too old to travel to Europe could remain. As far as Kangxi and Clement XI were concerned, there was nothing left to discuss. The mission, moribund for more than a hundred years, would be renewed only in the mid-nineteenth century, in vastly altered circumstances.

The collapse of the Catholic mission in China was discussed widely in Europe. The Chinese Rites Controversy poisoned relations between China and the Catholic powers for most of the eighteenth century. Only France and, to a more limited degree, Portugal continued formal contacts with the Qing court, but these were confined to issues of trade, like those of the British and Dutch. A handful of Jesuits continued to work in Beijing, but their activities were circumscribed to scientific endeavors and to providing works of art (especially portraits) and architectural designs for the imperial family. The most famous of all the Jesuit artists who served in China, Giuseppe Castiglione (1668–1766), arrived in Beijing in 1715, accompanied by the physician Giuseppe Giovanni da Costa (1679–1747). In a letter to Rome, Castiglione detailed the intensely uncomfortable position of the missionaries in the wake of the pontifical rejection of the Chinese rites and the unmitigated

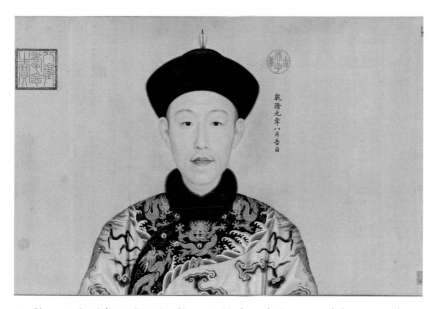

10. Giuseppe Castiglione, *Portraits of Emperor Qianlong, the Empress, and Eleven Imperial Consorts,* handscroll, ink and color on silk, 1736–ca. 1770s. Cleveland Museum of Art, John L. Severance Fund 1969.31. Detail.

debacle of the Tournon embassy. Because of his talent in painting, however, Castiglione enjoyed the favor of three emperors. His impressive *Portrait of the Qianlong Emperor,* circa 1734–35 (figure 10), indicates his ability to adapt Western techniques to Chinese traditions. In addition to portraits, the Jesuit artist painted Manchu hunting scenes, landscapes, and still lifes. Castiglione also executed architectural designs for the Yuanming Yuan (Garden of Perfect Brightness) imperial summer residence, built by the Qianlong emperor at immense expense. It was destroyed during a European punitive expedition in 1860, near the end of the Second Opium (or Arrow) War (1856–60). Kangxi, impressed by Western enamel painting, ordered Castiglione's colleague the artist Matteo Ripa (1682–1745) to produce works in this medium, introduced to China by the Jesuits, but they were not of high

quality, possibly owing to an intentional lack of effort on Ripa's part.[37] The European enamel technique, however, was adapted to Chinese porcelain with great success. Jesuit artists were also responsible for the introduction of copper plate engraving to China. Although the Kangxi, Yongzheng, and Qianlong emperors wanted nothing to do with Christian evangelization, the Jesuits' value to the court in their various areas of expertise could still occasion remarkable tokens of imperial favor.

In 1724 the Yongzheng emperor, implementing his father's decrees, ordered that all provincial churches be closed and that any remaining missionaries be deported or face imprisonment. It was "the death knell for the Vice-Province of China."[38] Three years later, with some justice, the emperor remarked to a Portuguese envoy: "If I sent bonzes to your European provinces, your princes would not allow it," underscoring the relatively liberal attitude of his dynasty toward Western missionary efforts.[39] The reliance of the Jesuits on the favor of the imperial elite they had so assiduously courted in the seventeenth century worked against them once they had lost the emperor's good opinion.

The virtual disintegration of the China mission must have come as a shock to many in Catholic Europe who had eagerly anticipated the Kangxi emperor and his family's conversion to Christianity and the Church's ultimate triumph in the East. Catholicism, however, had never really taken deep root in China, despite the Society of Jesus's claims to the contrary, and implacable opposition from Buddhist monks, the bonzes Yongzhen later mentioned to the Portuguese envoy, may have encouraged Kangxi to take a hard line. His sympathies with Tibetan Buddhism were in all likelihood considerably more significant than many Christians recognized.[40] A print by Edme Jeaurat (1688–1738) of 1731 after a lost painting by Antoine Watteau (1684–1721) dated about 1710–15, *Bonze des Tartares Mongous ou Mongols*, is prescient of changing attitudes in this context (figure 11). Unlike the figural

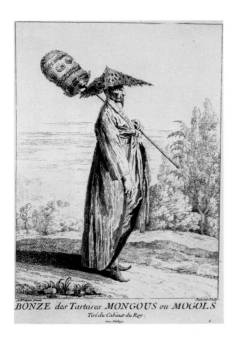

BONZE des Tartares MONGOUS ou MOGOLS
Tiré du Cabinet du Roy.

11. Edme Jeaurat (after Antoine
Watteau), *Bonze des Tartares Mongous ou
Mongols*, engraving, 1731. Private
collection.

and cultural hybridity characteristic of the generally positive image of China
in early rococo chinoiserie, seen to advantage in several other Watteau
designs for interior decorations at the Château de la Muette, *Bonze des Tartares*
has a far more explicit "Otherness," as the art historian Katie Scott has rec-
ognized. The monk's portly appearance is derived from the popular Chinese
figurine known as a *magot*, described in the next chapter, and probably visu-
alizes missionary prejudice against the Buddhist clergy—viewed as "hea-
thens," obstructing conversion to the "true" religion. The monk in *Bonze des
Tartares* literally guards China against religious interlopers, carrying his
folded umbrella as a sentry totes a gun.[41]

Although the end of European evangelization in China was not accom-
panied by the mass martyrdoms and horrendous violence that destroyed the

Japanese mission in the early seventeenth century, it was just as definitive. It also had a major impact on the reputation of China in the European consciousness, as Watteau's image of the second decade of the century anticipates. The profundity of that impact on Catholic Europe's visual culture is the subject of the chapter that follows.

Chinoiserie and Chinese Art

The Seventeenth and Eighteenth Centuries

Chinese silk was present in Europe from Roman times, and in the early centuries of Christianity it was the most important East Asian import. Because such fabric was sometimes used to wrap holy relics, a surprising number of pieces survive in church treasuries, enclosed in reliquaries that helped protect them from sunlight, moisture, and human touch. The vestments of Benedict XI Boccasini (reigned 1303–4) are preserved in the Church of San Domenico in Perugia, and the death inventory of his immediate predecessor, Boniface VIII, lists a large number of Chinese silk vestments, but it is uncertain how they came to Rome. Chinese silk present in Europe was usually decorated with floral motifs, which were soon absorbed into the visual vocabulary of such prominent late medieval artists as the Sienese Simone Martini (ca. 1284–1344) and the Florentine Giotto di Bondone (ca. 1267–1337).[1] The Archangel Gabriel's patterned mantle in Martini's celebrated *Annunciation* of 1333 is a remarkable example of how European artists adapted the dense compositions articulated in Yuan textiles to their own purposes (figures 12a and 12b).

As I noted in the preceding chapter, by the end of the twelfth century the papacy had succeeded in establishing fairly continuous diplomatic contact with the Chinese Empire; Rome and Avignon (the latter from 1309 to 1377,

12a–b. Simone Martini,
Annunciation, tempera and gold
on wood panel, 1333. Florence,
Galleria degli Uffizi. *Right:* Detail.

when seven successive popes resided there instead of Rome, under the protection and domination of the French crown) were the primary European destinations for works of art and other luxury products from the Far East, often sent as presents for the pope or as curiosities brought back to Europe by missionaries. Christian hopes for the conversion of China were always present, but another reason the Church looked eastward was its hope of securing a powerful ally against the Turks, who constantly threatened Christian Europe generally and the shrinking Byzantine Empire particularly. And the ultimate goal was to thwart the spread of Islam.

Chinese scroll paintings arrived in Europe as early as the thirteenth century, brought back by Franciscan friars from the China mission. Many scholars have suggested that because their naturalism may have influenced progressive artists like Giotto, such Chinese works may have played a significant role in the development of early Italian Renaissance painting. But none of these fragile objects has been identified. Archduke Ferdinand II of Tyrol (reigned 1564–95) also collected Chinese paintings at Schloss Ambras, near Innsbruck, but that activity is known only from generic descriptions in inventories of his possessions, the oldest surviving documents to enumerate such objects. By 1623 the library of the University of Copenhagen owned Chinese books illustrated with woodblock prints. In addition, an unnamed English Jesuit mentioned by the Stuart-era diarist John Evelyn (1620–1706) owned Chinese landscape paintings, portraits, pagods (images of deities), and other East Asian "curiosities."[2] Such examples, which indicate the widespread presence of works of Chinese art in Europe, also serve as precedents for the vastly increased number of collections of such objects in the West after about 1650. Until then the major European assemblages of Chinese paintings were found in Rome, which became, not coincidentally, the first seat of the emerging scholarly discipline of Sinology.

Portraits of both Chinese and Japanese notables, in considerable numbers, could be found in Rome, the product of occasional diplomatic

exchanges. Important assemblages arrived in the Eternal City from Japan in 1585 and 1616 (the latter shipment most likely dispatched in 1615, the year before the mass martyrdom of Christians in Nagasaki), and from China in 1652.[3] The presence of Chinese paintings in a variety of genres in the West has been seriously underestimated in histories of chinoiserie, doubtless because so few survive—few, at least, that can now be identified. The provenance of extant East Asian works of art in European collections rarely goes back to the era of the China mission. Nonetheless, there can be little doubt that these objects were sources for those European chinoiserie artists who sought to portray "good China" and the basis of the near caricatures produced by later promoters of "bad China."

Chinese paintings in Europe were probably of considerable importance to the early development of chinoiserie during the Renaissance, but porcelain provided the most extensive visual source material for Western artists. China dominated the global production of porcelain in the early modern era, selling it, from at least the seventh century, throughout East Asia and South Asia, Japan, Egypt, the eastern coast of Africa, and the Persian Empire. A small number of ceramic vessels came to the pontifical court in Rome in the baggage of missionaries and as imperial presents from China, but most arrived as diplomatic gifts from Egypt and Persia. There is little evidence of porcelain's reception in Europe until the late fifteenth century, before which time it was most likely considered only a curiosity. By about 1500, however, it was treasured, in some instances literally, being housed in church or state repositories in many parts of Italy, Germany, Portugal, and Spain. Ming blue-and-white bowls and cups appear prominently in *The Feast of the Gods* (1514) by Giovanni Bellini (ca. 1430–1516), executed for the studiolo of Duke Alfonso d'Este (reigned 1559–97) of Ferrara (figures 13a and 13b). Porcelains in the Venetian doge's collection, which had been a present from the Persian court, may have inspired Bellini's vessels. In any event, the rarity and value of the pieces are indicated by the painter's use of expensive

13a–b. Giovanni Bellini, *Feast of the Gods*, oil on canvas, 1514. Washington, D.C., National Gallery of Art. *Left:* Detail.

materials such as lapis lazuli and ultramarine to replicate Ming blue.⁴ Bellini's noble patron would necessarily have agreed to pay extra for these pigments, so it is reasonable to assume that the d'Este duke appreciated porcelain's rarity and social cachet. Anyone looking at Bellini's sumptuous painting in the National Gallery in Washington, D.C., would immediately comprehend its aesthetic appeal.

Bellini's *Feast of the Gods* is an early example of the enthusiasm for Chinese blue-and-white porcelain in the West, demand for which increased tremendously during the sixteenth and seventeenth centuries. Later, even though more varied chromatic schemes in Asian porcelain gained popularity, especially after the introduction of European enamel, blue and white remained (and still remains) the quintessential colors of Chinese ceramics. The China missionaries were involved, almost from the beginning, in the porcelain trade with Europe, because they were also necessarily agents of the Portuguese *padroado,* the controversial agreement by which the Holy See gave the court in Lisbon control over ecclesiastical appointments in East and South Asia and the authority, in theory, to deny any cleric entry into its jurisdiction if it saw fit. Portugal was slowly losing its traditional privileges by the mid-seventeenth century, both in the mission and in global trade, and by the 1680s the increased presence of French Jesuits in the Chinese Empire was linked to the establishment of the Compagnie de la Chine, a trading concern that benefited greatly from imperial favor. An important reason for Portugal's decline was the exploitation of its colonies by the Spanish, who ruled the kingdom from 1580 to 1640. The Spanish favored their own trading company in Manila at the expense of Portuguese commercial concerns in Macao. Early in the seventeenth century, Francesco Carletti (1573–1636), a Florentine merchant and slave trader, claimed that Jesuit missionaries served as intermediaries in the purchase of "the finest Blue and White porcelain," and in addition secured five "very large and beautiful jars" that he had purchased for export to Europe. More surprising is the

assistance the Jesuits rendered the British East India Company, traveling on its ships, serving as translators, and otherwise aiding the firm's endeavors in China. In return, the Fathers were permitted to ship items home and even to travel free on company ships between Europe and East Asia.[5] It is no surprise that the distinctions between conversion and commerce were not always transparent and that they go unmentioned in Jesuit publications about the China mission.

Although the Society of Jesus played a role, still not fully understood, in the China trade in the interest of both Catholic and Protestant enterprises, the Jesuits' involvement in both the cultural exchange between East Asia and Europe and the development of chinoiserie can more readily be assessed. To read how these phenomena actually worked, however, requires, as the art historian Thomas DaCosta Kaufmann has observed, a broad approach to global cultural exchange and a refusal to assume that culture was centered in Europe and diffused from there to East Asia, at the periphery.[6] Hybridity was essential to Asian-European cultural transfer, and chinoiserie could have developed only if artists had access to genuine Chinese works of art as visual resources. More significant, the Asian models were a touchstone of authenticity, however much the meaning of that term changed during the two centuries under consideration here. The allogamous quality of chinoiserie demands an approach different from the one that traditional notions of artistic influence can provide, and a willingness to examine how Chinese art may have been influenced by both European art and chinoiserie. Visual hybridity resulting from artistic cross-fertilization between East Asia and the West is most clearly evident in European, Chinese, and Japanese porcelain, and the commercial dynamics of this prized artistic medium suggest why the decoration of porcelain developed as it did.

Massive disruptions in the production of Chinese porcelain, for both domestic consumption and export, accompanied the collapse of the Ming dynasty and the more than three decades of civil war that followed,

especially in southern China, where the largest kilns were located. To pick up the slack, the Arita (Imari) manufactory in Japan produced Chinese-style vessels, which reached Europe primarily by way of Manila in the Spanish Philippines and the Dutch East Indies port of Batavia (modern Jakarta) on the island of Java. Japanese porcelain produced in imitation of Chinese wares caused considerable confusion in Europe, and Western inventories do not always specify whether an object listed was of Chinese or Japanese manufacture. Even after the Manchu victory in the War of the Three Feudatories (1673–81), the last gasp of Ming loyalism in southern China, piratical interference with shipping, above all by the Zheng network headquartered on the island of Taiwan (then called Formosa in Europe), still caused major problems in exports. When the Kangxi emperor finally conquered the island in the early 1680s, relatively unfettered trade with Europe resumed.

The commerce in porcelain emerged from these seventeenth-century disruptions much changed from what it had been under the late Ming. Private enterprise encroached aggressively on the monopolies of European trading companies, and the conduits for the Japanese trade remained open, largely beyond sovereign control. This development increased the amount of porcelain going to the West and helped develop new types of vessels with more varied decorative schemes, especially those articulated with human figures. By the 1680s, competition with the French and British companies and private traders (often employees of the companies in question) was so debilitating that the Dutch East India Company decided to cut back on its trade in porcelain in favor of silks and spices. In 1688 the directors in Amsterdam asked for "the new inventions and of such kinds that have never been here, also garnitures and tea wares, but no dishes or such things."[7] The popularity of porcelain garnitures (figure 14) as focal points of European interior decoration spurred demand for large jars, urns, and vases, and the vastly increased consumption of tea (also imported

14. Garniture of five vases, porcelain painted in underglaze blue, Jingdezhen production, ca. 1690. Los Angeles, J. Paul Getty Museum.

from Asia), particularly in northern Europe, led to the importation of the appropriate vessels from which to drink it. Queen Mary II of England (reigned 1689–94) set up a porcelain cabinet at Hampton Court Palace, near London, that was packed with Asian and other ceramic objects. Her obsession with such porcelain and its Netherlandish ceramic imitation, Delftware, began while she was living in the United Provinces; she was the wife of the Dutch Stadtholder William of Orange, later King William III of England (reigned 1689–1702).

Europeans during the seventeenth century regarded porcelain as a decorative rarity, and in the private sphere accumulating it was a mark of status. China "closets" began to appear in many domestic settings, and numerous sconces, brackets, and shelves were mounted on walls to display it, in addition to its privileged position atop cabinets, commodes, and highboys. Choice works of Asian porcelain (or European imitations) soon began to appear in still-life paintings, especially in the Netherlands and France, where they played a part in exoticizing the traditional theme of *vanitas*. A blue-and-white porcelain chocolate pot features prominently on the table in *Girl Interrupted While Playing Music* (figures 15a and 15b), circa 1660, by Johannes Vermeer (1632–1675). As the historian Christiaan Jörg has noted,

15a-b. Johannes Vermeer, *Girl
Interrupted while Playing Music*, oil
on canvas, ca. 1660. Madrid,
Thyssen-Bornemisza Museum.
Right: Detail.

the Dutch East India Company imported more than 3.2 million pieces of East Asian porcelain before 1682, but from 1729 to 1734 alone, the number exceeded 4.5 million objects, a staggering number that documents, surprisingly, a vast increase in demand at a time when Europeans had finally figured out how to produce and market hard-paste porcelain that rivaled Chinese production in quality and beauty.[8] The increase is explained largely by the seemingly inexhaustible demand for objects associated with serving and drinking tea, coffee, and chocolate. Thus not only did the popularity of Asian porcelain increase, even after the introduction of high-quality Western wares, but its ubiquity in even bourgeois households must also have influenced its reception and the evaluation of its decorative details. Comparison of the figural decoration of Asian vessels with that of their European counterparts was in all likelihood common by the beginning of the eighteenth century.

+ + + +

The intense efforts of the Catholic courts and private concerns in Holland and England to master the production of hard-paste porcelain were in part a quest for prestige and profits, but they were also implicated in contemporary trade issues, especially mercantilism. The growth of the global empires of European maritime powers fostered the invention of a trading system in which manufactured goods were exported in return for such raw materials as cotton, chocolate, sugar, pepper, nutmeg, tobacco, furs, indigo, precious metals, and other colonial commodities. In this Eurocentric commercial configuration East Asia was problematic. Trade with Japan was increasingly limited after about 1620, being confined to the port of Nagasaki on the southeastern tip of the island of Kyushu, and China had little inclination to exchange its luxury items for European wares. Silver was more precious to the Chinese than gold, and the overwhelming demand for porcelain and other items began to drain European reserves, even

of those nations like Spain and Portugal that controlled extensive silver mines in their colonies. Chinese goods were essential to Western markets, but the colonial mercantilist model was unworkable in East Asian commerce. The pronounced trade imbalance that resulted drained bullion to an extent that alarmed many European rulers.[9] Thus the manic efforts to produce hard-paste porcelain in Europe made sense politically and commercially.

It was not always necessary to go to China to obtain Chinese goods. During a global trading voyage in the 1690s, a wealthy Neapolitan adventurer, Giovanni Francesco Gemelli Careri (1651–1725), wrote about the large colony of Chinese merchants who lived in Manila, capital of the Spanish Philippines. In 1695 he visited Beijing, where he had extensive contact with the Jesuit missionaries resident there and became familiar with Chinese trading practices. Gemelli Careri estimated that some three thousand Chinese were living in Manila; their business there was to sell porcelain, silk, lacquer, and other goods to European traders. Although they were sometimes persecuted and had to pay tribute annually to the king of Spain for permission to live in his colony and conduct business there, they were able to work outside the much more onerous Qing imperial restrictions and higher taxes, so that the profits they reaped were much larger.[10] In addition, the very low esteem in which merchants were held in China, an attitude fostered by traditional Confucian disdain for the pursuit of money, was not a factor for those Chinese traders living abroad. A similar situation was found in the somewhat smaller Chinese trading colony based in the Dutch colony of Batavia in the East Indies (modern Indonesia). Because numerous Europeans, in addition to the indigenous people, lived in the Philippines and the East Indies, Western merchants were able to trade European manufactured goods for Chinese products. The cities of Manila and Batavia were in the trading colonies closest to China, and one wonders why other, similar, opportunities for reciprocal trade were not pursued more assiduously.

The French were latecomers to the China trade, but what they lacked in promptness they more than made up for in enthusiasm. Louis XIV was deeply interested in China, as I noted earlier, and many court notables collected Chinese art, especially lacquer, silk, and porcelain. The increasingly close commercial and diplomatic contacts between France and Siam (modern Thailand) intensified interest in the luxury products of East and Southeast Asia. With elaborate ceremony in 1686, King Somdet Phra Narai of Siam (reigned 1656–88) sent an embassy to Louis XIV at Versailles, headed by his ambassador Kosa Pan (died 1700), bearing presents that included an impressive assemblage of Chinese, Japanese, and Siamese porcelain, tapestry, silk, lacquer panels, furniture, and silver ornaments for the French monarch and his courtiers. The gift included fifteen hundred pieces of porcelain. Important notables also received presents from the Siamese monarch, further stimulating the collecting impulse among the aristocracy.

French merchants had long noted the copious amounts of Chinese porcelain and lacquer furniture in Bangkok, the Siamese capital, and Somdet Phra Narai's gifts confirmed such reports.[11] When Louis XIV approved the commercial venture to China of the ship *Amphitrite* in 1698, he sent to the Kangxi emperor and his courtiers extravagant presents, including mirrors (a French specialty), brocade, tapestries, and portraits of French worthies, doubtless including at least one of King Louis. The French monarch must have been impressed by the lavishness of the Siamese gifts and would reasonably have assumed that such was the custom in Asia. When the *Amphitrite* returned to France, it brought a trove of gifts from Kangxi that also included works of art. The ship's manifest mentions a vendible cargo of lacquer panels, furniture, porcelain, silk, and Chinese paintings of unspecified type that were most likely scrolls.[12] The actual number of "rolled paintings" is not given, but the shipment included seventeen boxes of lacquer panels, twenty-one crates of lacquer cabinets, sixteen bureaus, and nine cases of small tables. Tea, silk, and porcelain were the largest categories of goods imported

on the French frigate.[13] The presence of "rolled paintings" as well as works of material culture among Kangxi's presents and in the cargo offered for sale at the port cities of Nantes and Rouen is further evidence of European familiarity with Chinese art, though the lack of specific descriptions and the apparent loss or misidentification of the works themselves are frustrating.

Documentary sources for European trade with East Asia, however, provide some indirect evidence of the considerable knowledge of Chinese paintings in the West. An account of a trip to China by an officer of the British East India Company is a case in point. Although the voyage took place in 1747–48, the memoir of the journey was published only in 1762. The English official wrote: "As we passed along the coast of China, I thought it the finest prospect I had ever seen. When I saw their lofty pagodas or steeples, fortifications, houses, and burying places, everything green and carrying the appearance of plenty, it confirmed the ideas I had formed of them in Europe, from Chinese paintings."[14] In all likelihood, the author was referring to authentic Chinese scroll paintings and woodblock prints. He certainly could not have acquired such perceptions from works of eighteenth-century chinoiserie. I make no claim that the officer's observations are characteristic of the period—indeed, I believe quite the opposite—but his citation of paintings, remarkably, as responsible for his notions of China's actual appearance may indicate a more sophisticated knowledge of Chinese art in ancien régime Europe than has generally been supposed.

The *Amphitrite* venture was far from the only trading expedition sent from Europe to China in hopes of exchanging Western wares for Eastern ones. In 1719 the English merchant ship *Carnarvon* returned from China with 28,824 blue-and-white coffee cups and saucers, 85,409 teacups and saucers, and 12,214 chocolate cups as well as smaller quantities of "painted" wares such as dessert plates, milk pots, and slop basins. The value of the cargo, however, depended largely on tea, its most valuable single component. By the early eighteenth century, Chinese and European markets were so inter-

connected that potters at Jingdezhen began to fire blue-and-white wares based on models supplied by Western merchants, creating genuine export porcelain, because the vessels produced were types unknown in China. Tea and table services could also be manufactured, left plain, and shipped to Europe so that Western artists could decorate them with coats of arms and other elements suited to their European clientele. Although Jingdezhen had long imitated foreign models, often Japanese or Korean ones, export production became a vital part of its business only in the early eighteenth century. After the introduction of European hard-paste porcelain at Meissen around 1710, the demand for large Chinese decorative pieces such as bowls, urns, and figural sculpture slowly decreased, but the large orders for services that required many smaller pieces (which were more cost efficient to transport) more than made up the difference. Tens of thousands of such services could be included in a single shipment. European designs for export porcelain at Jingdezhen, moreover, also influenced the empire's domestic consumption. Chinese elites began to collect vessels with Western-inspired designs. A Chinese taste for what the art historian Kristina Kleutghen has called occidenterie was hardly limited to porcelain; it included painted screens, watercolors on silk, and woodblock prints, among other specimens of Western visual culture. As she has demonstrated, enthusiasm about Chinese occidenterie was not limited to Qing court elites but was widely disseminated and more broadly influential than has previously been recognized.[15] A fine porcelain bowl with an image of Venus bathing, preserved in the Seattle Art Museum (figure 16), is a characteristic example of Chinese occidenterie from the Qing imperial collections.

+ + | |

Accessible and authoritative examples of works of art served the needs of artists wishing to engage the visual culture of a different society. The presence in Europe of Chinese art and in China of European designs for export

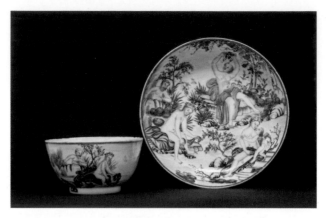

16. Porcelain bowl with Venus bathing, Jingdezhen production, mid-eighteenth century. Seattle, Seattle Art Museum.

porcelain was essential to the development of chinoiserie as well as to the Western-themed porcelain that had a much more limited market in the East. Some Italian cities by 1600 could boast assemblages of Chinese paintings, including works in collections with at least some public access in Verona, Milan, and papal Bologna. Count Baldini in Piacenza owned two Chinese hand scrolls, with over two hundred pictures on silk; his collection was dispersed in 1725.[16] It is likely that most of the Chinese scroll paintings available to European artists were landscapes, but because almost all these works have been either lost or dispersed (their provenance usually erased), certainty about the representation of East Asian people, costumes, and leisure activities is elusive, although some of these works of art doubtless included such imagery.

The ground is more secure when it comes to figural components in the decoration of Chinese porcelain. The tall porcelain vases with a blue underglaze and bands that created fields for figures were a major innovation in late Ming and early Qing ceramics. Many of these vessels illustrated scenes from Chinese novels and plays. A blue underglaze porcelain vase preserved in

Chinoiserie and Chinese Art

the Victoria and Albert Museum narrates scenes from the popular novel *The West Chamber* (figures 17a and 17b).[17] The makers of early Qing porcelain consciously emulated these late Ming vessels and introduced quadrangular vases that created larger fields for narrative depiction. Such items were immensely popular in Europe and were imitated extensively in chinoiserie. On the numerous banded narrative porcelain vessels made in China, the figures are characteristically represented in human proportions and are appropriately gendered in their costume and coiffure. Architectural elements, when they appear, are rational and solid, if exotic, and the rock gardens, trees, birds, insects, and other decorative elements in no way anticipate the flimsy, insubstantial, and frivolous characteristics of chinoiserie during the Enlightenment. The great quantities of Chinese porcelain introduced into Europe during the Kangxi reign could not but lead to Western artists' copying decorative motifs from East Asian originals; such visual outsourcing necessarily had a profound impact on the development of chinoiserie.[18]

Three examples of Saxon porcelain from the early eighteenth century may serve as case studies for European artists' direct borrowing of decorative motifs found in Chinese originals. A large two-handled faience vase dated circa 1712, produced at the factory of Peter Engebrecht in Dresden, is preserved in the Arnhold collection in New York (figures 18a and 18b). A little over a foot tall, the vase has repeating floral designs on its base and in its lower register, and its lip has similar forms connecting oval landscape vignettes. In its central field, figures grouped in a garden enjoy a picnic, the women slender and elegant but normally proportioned, and their faces characterized by Chinese features that are not exaggerated.[19]

Such floral and human decorations clearly follow Chinese prototypes, as do the figures, garden, and buildings seen on two Meissen bottle vases with covers of about 1725, preserved in the same collection. The necks of the bottles are decorated with figures in a landscape with distant buildings, and the

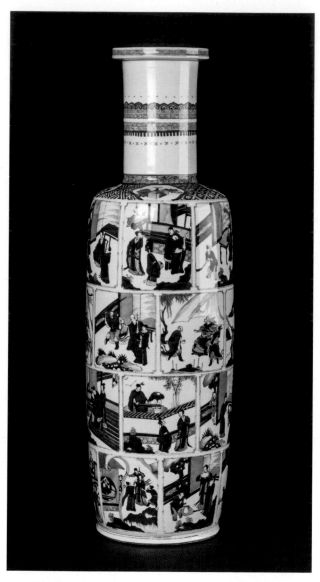

17a. Porcelain vase with scenes from the novel *The West Chamber*, porcelain painted in underglaze blue, Jingdezhen production, late seventeenth century. London, Victoria and Albert Museum.

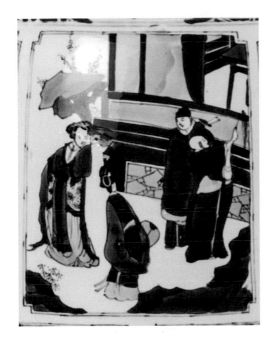

17b. Detail of porcelain vase with scenes from the novel *The West Chamber* (*opposite page*).

vessels' rounded bodies form the major decorative field. One of the pair shows men in a garden with some buildings in the distance.[20] Male bodies in the decoration are naturalistically proportioned and the architecture is Chinese inspired, thus exotic, but not flimsy. As in myriad examples of European chinoiserie created before the end of the China mission in the 1720s, direct copying or close imitation of East Asian originals is apparent, if not always demonstrable.

By the mid-eighteenth century, however, although Western artists were still consulting Chinese art for motifs, they took far greater liberties with the originals, producing a distorted image of the Other. Chinese naturalism was transformed into chinoiserie's caprice, whimsy, and feminine "decadence." Louis-Henri, Prince de Condé (1692–1740), supported on his estate at Chantilly a few kilometers north of Paris an establishment that produced

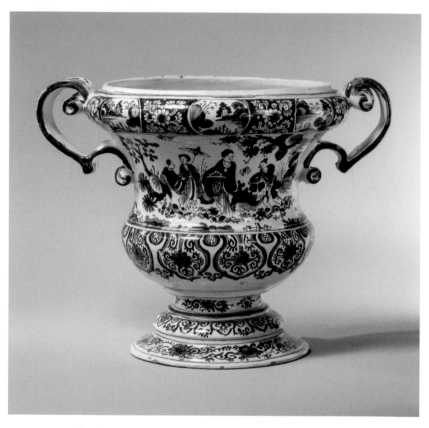

18a. Peter Engebrecht, two-handled vase, faience, Dresden, ca. 1712. New York, Arnhold Collection.

chinoiserie porcelain, lacquer, and textiles. Condé employed Jean-Antoine Fraisse (ca. 1680–ca. 1739) to supply decorative designs for the manufactories. In 1735 Fraisse executed a dozen image-laden albums entitled *Livre de desseins chinois*, and many of these prints may have been intended to serve as models for the decoration of fabric, lacquer, and porcelain. As the art historian Susan Miller has indicated, the foldout format of some of

Chinoiserie and Chinese Art

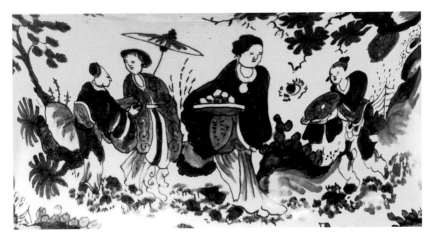

18b. Detail of two-handled vase (*opposite page*).

Fraisse's designs indicates careful study of Chinese and Japanese scroll paintings.[21] Although there is little doubt that Fraisse worked closely with original works of art, especially Chinese woodblock prints and both Chinese and Japanese porcelain, the images as transferred to actual objects indicate an almost wholly imaginary chinoiserie all but unrelated to the naturalism of East Asian art.[22] A pair of soft-paste Chantilly porcelain and enamel potpourri pots with gilt bronze mounts (figure 19), preserved in the J. Paul Getty Museum, are characteristic of mid-eighteenth-century chinoiserie's trivialization of Chinese subjects. Their images, based on East Asian depictions of the Buddhist god of good fortune Budai (Hotei in Japanese), show smiling monks with long earlobes, each seated with a potpourri pot in place of the cloth sack (or *pu'tai*, the source of his name) with which monks are usually shown in Chinese art. Budai is a whimsically paradoxical figure in Chinese and Japanese art, but here he is trivialized as an accessory for potpourri, and the tradition he represents is demeaned, albeit elegantly.

19. Chantilly manufactory, potpourri pots with Budai, soft-paste porcelain and enamel, 1740s. Los Angeles, J. Paul Getty Museum.

Eighteenth-century Europeans referred to these figures as *magots*, a French word translated as "grotesque" or "stocky figure" in a specifically East Asian context. It also means "ape." Chinese Budai figurines were highly collectible in Europe during the seventeenth century, but only later did they become objects of comic derision. *Magots*, which were ubiquitous objects in a variety of European settings, may well be the quintessential visualization of "bad China" during the Enlightenment. Diderot complained in the *Encyclopédie* that *magots* "had chased from our apartments ornaments of a much better taste," adding, "This reign is that of the *magots*."[23] A Dutch Delftware wig stand, produced in the 1660s, attests to the relative commonness in baroque orientalist chinoiserie of decorating ordinary utilitarian objects with Chinese figures, but in this object's decoration the figures are believable Chinese people, not divinities. Relatively few examples exist that can be dated before the early eighteenth century of the figures of East Asian deities (excepting Budai) used as ornaments for chinoiserie bric-a-brac—at least figures understood to be divinities.

Chinoiserie and Chinese Art

Chantilly was only one of the French factories in the age of Louis XV that used chinoiserie to trivialize China. In 1740 a manufactory was founded on royal property at Vincennes, just east of the capital, to produce soft-paste porcelain. Philibert Orry (1689–1747), *contrôleur général* of finances, supported its endeavors, primarily to help stem the flow of specie from France to China and to the Meissen porcelain factory in the Electorate of Saxony. Five years later, Vincennes was given a royal monopoly to produce hard-paste "porcelain of the Saxon type, gilded and painted with human figures." The monopoly gave to Sèvres (where the factory moved from Vincennes in 1756, possibly to be closer to Versailles) a great advantage over Chantilly, which was limited by royal statute to a five-color palette and soft paste.[24] Although chinoiserie decoration was applied to a relatively small number of objects produced at Sèvres, the "human figures" for the most part represented Chinese people with physiognomy distorted and gender ambiguous, participating in pastimes that many in the West perceived as feminine. Such imagery paid little or no attention to issues of rank and dignity, as they were understood in China and depicted in Chinese art and visual culture.

Two elephant vases, produced circa 1761 for Madame de Pompadour (1721–1764), a major patron of the establishment, and preserved in the Walters Art Gallery in Baltimore (figure 20), are characteristic of mid-eighteenth-century Sèvres chinoiserie. Fired in soft paste, painted with enamel, and set on gilded bronze bases, the vases are about twelve inches high. The middle sections contain a recessed field decorated with Chinese figures, one with a garden setting and the other, a balcony. The compositions seem fragile and unstable; the woman towers over the male physically. Female elegance, seen to advantage in the faience two-handled vase from Dresden (see figure 18a), here is transformed into impossible attenuation, and the normal Asian features of the figures of the earlier vessel are exaggerated in the Sèvres potpourri vases, so much so that the eyes virtually disappear

20. Sèvres manufactory, potpourri [elephant] vases with chinoiserie figures, ca. 1761. Baltimore, Walters Art Museum.

into the women's tiny heads. French rococo genre scenes also have people behaving frivolously (or licentiously, something almost never seen in chinoiserie, because its intention, in part, was to emasculate the Other), and gender differences were not always distinctly imaged, but rarely to the degree seen in most eighteenth-century chinoiserie representations of East Asians. Depictions of Europeans in this manner are limited to confectionary peasants; upper-class individuals are represented with their gender and social status intact. Moreover, prominent Western artists almost never distorted elite European bodies for comic or dehumanizing effect, unless they were working explicitly in the fields of political and social caricature or pornography.

+ + + +

This chapter documents the widespread availability of original works of Chinese art in Europe in the seventeenth and eighteenth centuries. Artists of chinoiserie had long been engaged with East Asian imagery, looking for

Chinoiserie and Chinese Art

authenticity and a positive exoticism. At the dawn of the Enlightenment in the second quarter of the eighteenth century, however, Asian visual materials were used increasingly as points of departure for caricatural images of a frivolous, feminine, and decayed China that suited altered Western ideas about the Eastern empire. The remainder of the chapter interrogates this shift, attributing it in part to the end of the China mission and the realization that the "Celestial Empire" would never be Christian and would never consider Christian Europe its equal.

It is useful here to scrutinize the impact of East Asian visual culture on Roman chinoiserie, viewed in a specifically papal context. The unhappy outcome of the controversy over the Chinese rites and the expulsion of most of the Christian missionaries did not end all connections between Qing China and the Roman Catholic Church. Ironically, in ancien régime Rome global visual culture came into even greater focus as an avenue of communication and an instrument of politics.

Although, as I have mentioned, diplomatic presents from the Chinese emperors and works of art brought back to Rome by missionaries formed the bulk of the papal collections of East Asian art, the range of objects and the contexts in which they were deployed matter as much as the objects themselves. In 1585, Pope Gregory XIII Buoncompagni (reigned 1572–85) received an embassy from Japan. Among the gifts presented to him were large painted screens executed by the celebrated Kano school.[25] Although they were documented in the Vatican Palace during the pontificate of Benedict XIV, I have been unable to trace them. Beginning about 1635, the Jesuit polymath Athanasius Kircher (1601–1680) began sorting the vast trove of East Asian objects brought to Rome by veterans of the China mission, including some of them in his influential text *China illustrata*. Works of art brought to the papal city by Father Johannes Gruber (1613–1680) were particularly helpful in illustrating Kircher's book. *Lady in an Interior Holding a Bird* (figure 21), a characteristic image, is an outstanding visual example of the hybridity of East-West

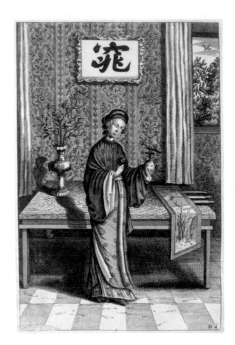

21. Anonymous, *Lady in an Interior Holding a Bird ["Very Pretty"]*, engraving, 1665, from Athanasius Kircher, *China illustrata*.

cultural exchange. The image is labeled by the framed Chinese character for "quiet and elegant," which can be read as describing the subject, but the interior in which the lovely woman stands is Europeanized. She has been plucked from a Chinese painting of an elegant female, a beauty, an old genre in China that was reinterpreted in images that became as immensely popular in Europe during the second half of the seventeenth century as they were in China. She stands before a table on which a landscape scroll painting is displayed, artistically but incorrectly, as Michael Sullivan has observed.[26]

By 1700 the papacy understood which diplomatic presents would be well received in Beijing. When Clement XI sent the Mezzabarba embassy to the Kangxi emperor in 1719 to try once again to persuade him to accept the papal

Chinoiserie and Chinese Art

position in the Chinese Rites Controversy, he included an array of gifts both for the ruler and for prominent members of the imperial court. Among these gifts was a portrait of the pontiff by Pier Leone Ghezzi (1674–1755), most likely a copy of Clement's 1701 coronation portrait. The Albani pope also presented the Kangxi emperor with a large pendulum clock made by the Roman craftsman Pietro Vanstripo; 126 illustrations of birds by Fiorenzo Vanni; an ornate gilt copper casket by the famous metal artist Ermenegildo Hamerani (1683–1756) that was bedizened with coral, silver, and gemstones; and two hundred pounds of chocolate. The pope's most important gifts were musical instruments, long a mainstay of Church diplomacy in China. A composite keyboard instrument valued at 300 *scudi* was the single most expensive item of the lot. The total cost of the presents was 1,855.46 *scudi*—a considerable expenditure.[27] For the same amount of money, Pope Clement could have commissioned major Roman artists to paint four oil-on-canvas altarpieces or to make one large marble sculpture. Despite the severe strains in diplomatic relations between the papacy and the Chinese empire, costly presents were exchanged throughout the eighteenth century, although not at the same pace as in the previous 150 years. In 1720 Kangxi returned Clement XI's courtesy by sending a grand lacquer screen decorated with landscape views of Chinese houses, lakes, hills, trees, and boats. Seven years later the Yongzheng emperor presented Benedict XIII with an assortment of plates, lacquered dishes, caskets, tables, chests, and small leather boxes.[28] The presence of superb examples of Chinese luxury craftsmanship and art in the papal capital did much to spur interest in the developing chinoiserie mode. In its stylistic development from the late sixteenth to the end of the eighteenth century, Roman interest in chinoiserie followed a course similar to those in other Catholic capitals.

Among the eighteenth-century popes who appreciated and promoted Roman chinoiserie, Benedict XIV deserves pride of place. In 1741, less than a year after his accession, he commissioned a small Gallery of Chinese Ladies

to house his collection of Chinese paintings of beautiful women. The gallery, constructed at the papal retreat at Castelgandolfo, a small village outside the city, was a rectangular arcade with seven openings allowing views of the Roman Campagna. One entered the gallery through a small antechamber furnished with chairs and small tables in black-and-gold lacquer. The fourteen paintings were grouped in seven pairs to echo the arches in the arcade. Executed in tempera on paper and probably dating to the early decades of the Settecento, these Chinese paintings are now preserved in the Vatican Museums. The seven pairs of images were enhanced by imitation lacquer panels decorated with chinoiserie flowers and birds on a gold ground, works most likely of Roman manufacture. The physiognomy, body type, and clothing of all fourteen figures are remarkably similar, and their veiled hands indicate high rank.

The architectural historian M. A. De Angelis has recovered this little-studied papal project, but important questions about these paintings of Chinese ladies remain. How the pictures came to Rome or into papal possession is not known. They may have formed part of the Yongzheng emperor's diplomatic gift to Benedict XIII in 1727, and they resemble the Qing monarch's celebrated paintings of twelve court beauties. It is almost impossible to imagine that the ascetic Dominican pontiff would have kept such a secular present, however, and had he been the original recipient, he would doubtless either have placed the paintings in storage or given them to one of his favorites. It is also possible that the court Jesuits in Beijing presented them to the Orsini pontiff. I have found no evidence indicating how Benedict XIV came into possession of the paintings, but given the fact that he, like Benedict XIII, almost always immediately passed on the presents he received to someone else, it seems likely that he found them in the papal collections and decided to use them in his private pleasure gallery at Castelgandolfo. The project was executed on a shoestring budget because papal finances were in

a parlous state in 1741, and most of the project's components were assembled from works already in Benedict's possession, with a few items like the faux-lacquer panels acquired inexpensively on the Roman market.[29]

The "Chinese Ladies," like Kircher's *Lady in an Interior Holding a Bird*, fit well into an established category of European images devoted to notable beauties of a particular era. The "Court Beauties" portraits by Sir Peter Lely (1618-1680) and a subsequent series by Sir Godfrey Kneller (1646-1723) are well-known examples of the genre. The Venetian painter Rosalba Carriera (1675-1757) also executed a high-profile series of pastel portraits of celebrity beauties for the king of Poland at about the same time that Benedict XIV set up his gallery at Castelgandolfo. In each of these series of paintings the physical appearance of the females is remarkably similar. The Lely and Kneller "beauties" are virtually interchangeable to modern eyes, subtle differences in their posture, coiffure, and costume notwithstanding. Carriera's portraits are a bit more diverse, but only in comparison with their English counterparts. I suspect, however, that the painters' contemporaries would not have agreed, and it is possible that Chinese viewers of the Castelgandolfo images would have seen more variety in them than Westerners did. But the underlying premise behind all these images is the same: that a widely accepted notion of female beauty is in play, specific to the time and place. The portraits of the Chinese ladies are exotic, not because of their beauty, refinement, or elegance, but because of their clothing, coiffure, and East Asian facial features.

One can imagine the sympathetic Benedict XIV during his annual *villeggiatura* (an autumnal vacation of about six weeks, usually spent at a suburban villa or a country house), lounging with friends in his pretty little Gallery of Chinese Ladies, contemplating the peaceful countryside around Castelgandolfo, but his interest in Asian art did not end with his holidays. He was the first pontiff to display East Asian porcelain systematically, and he

was proud of his collection and knowledge of the medium. Boasting in a letter of January 12, 1746, to his friend Marchesa Camilla Caprara Bentivoglio Doglioli that he had organized an impressive gallery filled with East Asian porcelain at the pontifical palace on the Quirinal Hill, Benedict claimed, "There is not another prince who has one like it."[30] So proud was he of his Chinese and Japanese porcelain collection that he commissioned twenty triangulated gilt wood pedestals with his coat of arms on which to display the vessels, though they are known only from a reference in an inventory.[31] A description of the celebrated Caffeaus (coffee house) Benedict built in the Quirinal Palace gardens behind the pontifical palace in 1741–44 is equally intriguing. It notes the small pavilion and its large paintings by famous Roman artists such as Agostino Masucci (1691–1758) and Pompeo Girolamo Batoni (1708–1787), stating that it was also decorated with "Chinese curiosities and other rarities."[32] What these objects could have been is anyone's guess, but they were likely to have been pieces of East Asian porcelain, *magots*, and small lacquer panels. Finally, the pope underscored his sophistication as a connoisseur of Chinese and Japanese porcelain in a letter to the Lambertini family's agent in Bologna, Filippo Maria Mazzi. After receiving some porcelain as a present, he sent it to his nephew's family, observing that "in Bologna, no one knows the difference between porcelain from Japan and majolica from Faenza."[33] Many members of the ecclesiastical hierarchy and the Roman nobility shared Benedict XIV's enthusiasm for East Asian art. When the Jesuit painter Matteo Ripa was expelled from China, having refused to declare that he would follow Matteo Ricci's policy of accommodation in the question of the Chinese rites, he returned to Rome with many Chinese works of art. Ripa had introduced copperplate engraving to China and produced large numbers of prints of the imperial gardens, landscapes, and maps. He brought many of his prints back to Europe and offered them as presents to notables. In addition to prints, he also gave gifts of porcelain, painted fans, silk, Chinese books, and antique coins. Among the recipients of his largesse

were two important cardinals—Fabrizio Paolucci (1651–1726), who was given a large number of maps and a Chinese fan, and Cardinal Giuseppe Renato Imperiali (1651–1737), who received a porcelain bowl.[34] Filippo Antonio Gualtieri (1660–1728) was another prominent Roman cardinal who collected East Asian art on a notable scale. Inventories of his collection and notes on its disposition in Palazzo Manfroni indicate three rooms dedicated to Chinese works of art. One contained "many vases, tapestries, Chinese bowls, and works in lacquer." The second displayed a "quantity of Chinese idols, stone carvings [soapstone?], vases, and other curiosities of China, with some beautiful pictures from that country." A "quantity of porcelains" adorned the third chamber.[35]

Other Roman cardinals were also involved in collecting and displaying East Asian art. Gaspare Carpegna (1625–1714) had one of Rome's most impressive private collections, with a wide variety of objects, especially medals and coins, and in addition possessed a considerable number of works of Japanese and Chinese porcelain. The collections were kept together until 1743, when Benedict XIV purchased the lot to prevent some of the prize pieces from being sold abroad, presenting everything to the Vatican Library. Later the same year, however, he raided the Carpegna collections for several pieces of East Asian porcelain, probably for use in the interior decoration of the Quirinal Caffeaus.[36]

The Lambertini pontiff and the cardinals mentioned here were not the only Roman aristocrats who enjoyed displaying Chinese and Japanese art. The Villa Patrizi, owned by Cardinal Silvio Valenti Gonzaga (1690–1756), and both the Palazzo Colonna di Sciarra and the imposing Palazzo Colonna that belonged to the family of Cardinal Girolamo Colonna (1708–1763) had Chinese theme rooms that displayed porcelain, lacquer furniture, and silk. Pope Clement XIV, the pontiff who abolished the Society of Jesus, commissioned grand gilt wood pedestals like those of Benedict XIV to serve as display mounts for six enormous Chinese vases that still survive in the Quirinal

Palace. East Asian luxury objects were so popular in Rome that many local craftsmen specialized in reproducing Asian originals and in making chinoiseries. The king of Sardinia, Vittorio Amedeo II (reigned 1714–30), even instructed his architect Filippo Juvarra (1678–1736) to acquire a large number of lacquer panels on the Roman art market to be used for the Chinese Tea Room in the Royal Palace in Turin.[37] Ironically, the Eternal City and other Italian capitals were filled with Chinese and chinoiserie works of art at precisely the time when decisions against the Chinese rites made by Settecento popes rendered the China mission moribund.

+ + + +

Although Enlightenment Rome was enthusiastic about East Asian art, the city was not exempt from the negative view of China that dominated mid-eighteenth-century European chinoiserie. The disparagement of China in Roman chinoiserie is seen most clearly in the designs for ephemeral works related to the public spectacles so ubiquitous in ancien régime Rome and that received widespread attention. The prints made after the ephemeral structures *(macchine)* were distributed throughout Europe. During the Carnival festivities in 1735, the art and architecture students at the French Academy in Rome orchestrated a procession whose theme was "Chinese masquerade." It was staged in honor of Louis XV's ambassador to the Holy See, the duc de Saint-Aignan (1684–1776). A print by Jean-Baptiste Marie Pierre (1714–1789) gives an idea of the parade float's appearance (figure 22).

The "barge," as it was called, is filled with students from the French Academy in Rome wearing voluminous robes and cone-shaped sun hats. The float is shown passing Trajan's column. Louis XV's *pensionnaires* (the designation for students receiving a royal stipend, or pension, to pursue their art and architectural studies in Rome for four years) sport long, thin false moustaches. The float is filled to overflowing, and other students trail along, playing musical instruments or carrying long-handled feather fans. Seated

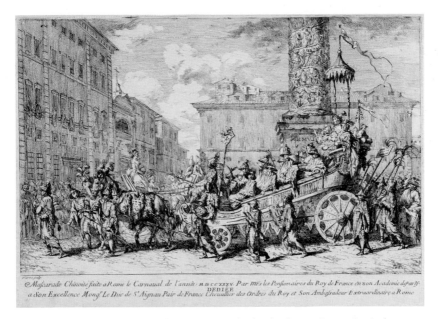

Pierre fully

Mascarade Chinoise faite à Rome le Carnaual de l'année M.D.CCXXXV. Par MMes les Pensionnaires du Roy de France en son Academie depart.
DEDIEE
a Son Excellence Mongr Le Duc de St Aignan Pair de France Chevallier des Ordres du Roy et Son Ambassadeur Extraordinaire a Rome

22. Jean-Baptiste Marie Pierre, *Chinese Masquerade Float for the 1735 Roman Carnival*, engraving, 1735. Los Angeles, J. Paul Getty Museum.

dignitaries covered by an absurd little baldachin supported on impossibly high and thin poles occupy the float's aft section. Carnival in Rome was a traditional time for masquerade and mummery, but the French art students' mime distinctly trivialized and feminized Chinese men. Similar festivities with Turkish themes, in contrast, represent the Other to emphasize virility and military prowess—a phenomenon seen to advantage in a series of thirty-two etchings by Joseph-Marie Vien (1716–1809) of French Academy *pensionnaires* in Turkish costume in another Roman Carnival celebration, the "Caravan to the Sultan in Mecca"—one of them the *Aga of the Janissaries* (figure 23).[38]

A print by the papal architect Paolo Posi (1708–1776), a highly mediated recording of a papier-mâché fireworks platform erected in Piazza Farnese for

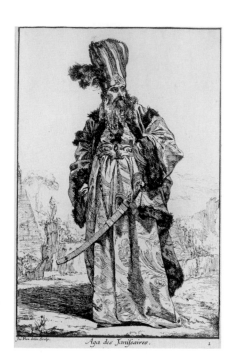

23. Joseph-Marie Vien, *Aga of the Janissaries: A Pensionnaire of the French Academy in Rome in Turkish Costume*, engraving, 1748. Los Angeles, Getty Research Institute, 1465-670.

Aga des Janissaires.

the Chinea festival of 1758 (figure 24), even more explicitly documents "bad China," although the festival, despite its name, had nothing to do with the Manchu empire. The Chinea was an important ephemeral event visualizing the feudal obeisance of the kingdom of Naples to the papacy. It was celebrated with elaborate *macchine,* fireworks, public dancing, wine, and food, all culminating in the presentation of a gift, popularly called the Chinea, that consisted of money and the white horse that carried it into Saint Peter's Square. The general source for Posi's 1758 fireworks platform was the so-called Porcelain Pagoda of Nanjing, illustrated by Athanasius Kircher in *China illustrata* and famous throughout Europe. The description of the *macchina* in the Roman newspaper *Chracas* is worth quoting. It notes that Posi's structure was inspired by:

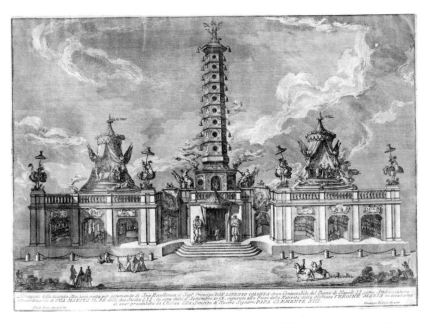

24. Paolo Posi, *Chinoiserie Fireworks Stand for the 1758 Roman Chinea*, engraving, 1758. Los Angeles, J Paul Getty Museum.

that Tower near Nanking in China so greatly celebrated by Travellers, and called the porcelain tower around which a Market was created, or a Fair in the custom of that country. The Tower was octagonal in form, entirely painted like lovely porcelain, and had a winged Dragon at its summit, the symbol of that Imperial land; and from each of the nine stories, becoming narrower as they rose, some small gilded bells stuck out, poised so that with every slightest breeze they rang out in joyful, though dissonant tunes. Flanking the Tower on either side were two sophisticated buildings, the lower part of which was divided into various stores and workshops, some full of Porcelain and some kinds of lacquered objects that are produced for trade in those countries, and others fitted out for the most suitable use of Porcelain, while the upper part extended into a broad loggia with balustrades shaped in the Chinese fashion, and in the middle of these two loggia stood a pretty pavilion in the same style,

for the entertainment of the Mandarins, with ostriches ridden by men and Chinese ladies in the corners, their umbrellas opened against the sun.[39]

Posi almost certainly had access to publications about China that illustrated accurately not only the Nanjing pagoda but many other Chinese buildings as well. The print, although it most likely exaggerates the platform's caprice and flimsiness, is important to scholars as the only extant visual record of the ephemeral structure's general appearance. One may well doubt whether men dressed in a vaguely Chinese fashion actually rode ostriches during the Roman Chinea festival; their inclusion in the print may indirectly refer to the architectural ornamentation of the Porcelain Pagoda that various sources described as including fantastic animals and figures on its door reliefs. It is certain, however, that ostrich rodeos were not a leisure activity in China, as Posi and his fellow Romans surely knew. Nor was the dragon that crowns the structure in the print a feature of the Nanjing pagoda. Mid-eighteenth-century Roman chinoiserie, like that in other parts of Italy, Spain, France, and Catholic Germany, also ridiculed Qing China. With hopes of converting the "Celestial Empire" to Catholicism dashed, such a deployment of visual culture to put China in its place was logical, perhaps inevitable.

+ + + +

The transformation of European chinoiserie from an artistic vehicle for "good China," during the reign of Louis XIV, to an ambitious cultural program of visual feminization and trivialization of "bad China," under Louis XV, was more pronounced in France than in other European countries, possibly because China's reputation had been so high during the reign of Louis XIV. Indeed, Sinophilia in Catholic Europe reached its zenith during the reign of the Sun King. Louis was familiar with a number of Jesuit publications about China, above all Juan Gonzàlez de Mendoza's *History of the Great Kingdom of China*, which was originally published in Rome in 1586 with papal financial

support. It appeared in a French translation published in Paris two years later, and was reprinted at intervals throughout the seventeenth century, translated into all the major European languages. During his long reign the monarch supported the publication of other Jesuit Sinological texts, including those of Louis-Daniel Le Comte (1655-1728) and Joachim Bouvet. Le Comte and Bouvet's various texts emphasized the sophistication of Chinese culture, imperial toleration of Christianity, and the flattering similarities between Louis XIV and the Kangxi emperor, claiming that the Qing monarch's realm was primed for conversion to the "true" faith.[40] Jesuit texts were the primary source of information about East Asia available in France; only with the voyage of the *Amphitrite*, in 1698-1700, was direct commercial contact with China established.

The publications of the Society of Jesus that inspired widespread enthusiasm for China were complemented by visits to the Versailles court by Jesuit fathers who had served in the China mission. On September 15, 1684, the king gave an audience to the Jesuit missionary Philippe Couplet (1623-1693) and his Chinese convert companion Michael Shen Fuzong. Couplet presented his sovereign with "a number of Chinese paintings and curios," in which Louis showed considerable interest. The following day they were asked to dine at the royal table, where the king asked them both many questions. Louis XIV requested that Shen demonstrate the use of chopsticks, and the monarch was so delighted that for the benefit of the clerics he ordered that all the fountains in the Versailles gardens be turned on—an extraordinary mark of distinction for such humble visitors. In addition to the books, maps, and scientific instruments Couplet received from many individuals to take back to Beijing, King Louis dispatched useful objects for the mission and presents for the Kangxi emperor. The most important outcome of Couplet's visit was Louis XIV's decision to send six French Jesuits to the Chinese court.[41] Joachim Bouvet, a philosopher and mathematician mentioned in chapter 1 as a leading light of the Figurist movement, was among the French

Jesuits dispatched to Beijing in 1685. He made a deep impression on Kangxi, who kept him at court. As a gesture of imperial appreciation, he sent Bouvet home in 1699 with presents for Louis XIV and a directive to recruit additional missionaries, above all those who would be useful to imperial scientific endeavors. That same year Bouvet published in Paris his influential book *Histoire de l'Empereur de la Chine presentée au Roy* (The Life of the Chinese Emperor Presented to the King) to encourage further royal interest in the China mission. Bouvet's book was essentially a puff piece, flattering royal efforts to promote missionary work in the Chinese empire and trumpeting Louis's prominent role in the history of Catholic global evangelization. It also reiterated the Jesuit claim that Kangxi was likely to become a Christian in the near future. Bouvet's embassy to Versailles was a great success, and he returned to Beijing with even more gifts for Kangxi, including another small but talented contingent of Jesuits noted for scientific knowledge.[42] The Kangxi emperor certainly knew how to play the diplomatic game with Louis XIV to his advantage.

In 1687, during the heyday of Jesuit influence in French Sinology and aristocratic enthusiasm for everything Chinese, a book was published in Paris that planted the seeds of skepticism regarding Jesuit claims about China. *Confucius Sinarum Philosophus sive Scientia Sinensis Latine exposita* (Confucius, Philosopher of the Chinese, or Chinese Science Set out in Latin), whose coauthors were Prospero Intorcetta, the Fleming François de Rougemont (1624–1676), Philippe Couplet, and a number of other Jesuits, was dedicated to Louis XIV. As Nicholas Dew has astutely observed, *Confucius Sinarum* is no work of neutral scholarship but should be evaluated in the context of Louis XIV's revocation of the Edict of Nantes in 1685 and the renewal of state persecution of the French Protestant minority (the Huguenots), which many attributed to Jesuit influence. The revocation ended almost a century of religious tolerance in France, at least of minorities identified as Christian. The coauthors go to considerable lengths to compare Louis and Kangxi as sup-

porters of scholarship and as enthusiastic extirpators of heresy (a characterization that was wholly imaginary in the case of the Qing monarch). Convinced Figurists, these Jesuits also claimed that Confucian moral teaching was evidence of an early Christian tradition in China. Few openly questioned the Jesuit motives of *Confucius Sinarum* at the time of its publication, but by the early eighteenth century many suggested that the Jesuits were distorting the Chinese textual sources for their own purposes and wondered aloud if any of the Society of Jesus's assertions about China could be believed. Sinology in France was implicated in Christian ecclesiastical politics from at least the last quarter of the seventeenth century.[43]

Chinamania during the Sun King's reign was widely dispersed in France by the final decades of the seventeenth century. Chinese history, politics, administration, philosophy, art, and architecture were frequent topics of conversation among the private Parisian court and urban elite, and books about the empire were consumed with remarkably intense interest. If the most common ideas about China can be teased from the prefaces of such publications, most informed French people had a high opinion of China and its inhabitants. Many texts acknowledged that China was the most beautiful and prosperous nation on the planet. It was admired for its physical immensity, its ancient culture, the sagacity of its laws, and the enviable quality of its art and architecture, especially its material culture. The magnificence and antiquity of China's public and imperial buildings were highly praised, in stark contrast with eighteenth-century descriptions and depictions of Chinese architecture that characterized it as insubstantial and decadent. The only Chinese art universally disparaged was painting.[44] A vast network of collectors, who assembled East Asian works of art and material culture on a scale unmatched anywhere in Catholic Europe, furnishes additional evidence of the increased French interest in Sinology. As the art historian Hugh Honour has pointed out, such collections "had an associative value readily appreciated by a court which reveled in allegory and thrived on symbolism.

For however strange and unclassical, Chinese art was recognized as being the product of a mighty empire."[45] By the end of the Orléanist Regency (1715–23) that preceded the reign of the Sun King's great-grandson, Louis XV, such "associative value" had an entirely different, negative valence.

Among the numerous monuments of French Chinamania assembled or constructed at Versailles during the reign of Louis XIV, the most expensive and ambitious was the celebrated Porcelain Trianon, built in 1670–71 for the king's mistress, Françoise-Athénaïs de Rochecouart de Mortmart, Marquise de Montespan (1641-1707). Inspired by the Porcelain Pagoda of Nanjing, considered an architectural marvel in the West, the chinoiserie garden pavilion was designed by the royal architect Louis Le Vau (1612-1670) and constructed by others after his death. Unlike its nine-story Chinese counterpart, the Porcelain Trianon had only one story and distinctly baroque "bones." The structure's mansard roof was articulated with faience plaques at the corners, and the central pavilion had four small dependencies. In keeping with the porcelain theme, the primary color scheme was blue and white, relieved by bits of yellow and gold. Delftware and faience from the manufactory at Nevers in Burgundy were used throughout the building, as was stucco painted blue and white. Gilded lead vases adorned the building's exterior, and the ceiling of the interior was decorated with stylized flowers. The pavilion's floor plan indicates three main rooms—a central salon flanked by the Chamber of Diana and the Chamber of Cupids, the latter space provided with chinoiserie lacquer furniture. Lacquer was popular among the Versailles elite, so that its use in Montespan's pleasure pavilion is no surprise. By 1687, however, the entire structure was badly decayed, French winters being especially unkind to the faience and Delftware tiles, and Louis ordered it razed.[46] The dedication of two of the three interior salons to Diana and cupids, coupled with the fundamentally classical design of the building, underscores the project's essentially European character. It could be argued that the Porcelain Trianon's superficial engagement with China is a meta-

phor for the imperfect knowledge of the Qing Empire among early modern Europeans.

In addition to the Porcelain Trianon, the set of chinoiserie tapestries entitled *The Life of the Emperor of China* should also be considered in the context of late seventeenth-century French Chinamania. Two of the narratives from the series will be considered in detail in the chapter that follows, in relation to a second set of tapestries with the same theme produced at the manufactory at Beauvais during the 1740s. The royal tapestry works at Beauvais, in Picardy northwest of Paris, also produced the first set of *The Life of the Emperor of China*, for Louis-Auguste de Bourbon, duc du Maine (1670–1736), the legitimated natural son of Louis XIV and Madame de Montespan. The royal duke's interest in China had been piqued when he was still a teenager, probably by Couplet's visit to court, where Maine presented the king's Jesuit guests with an unspecified scientific instrument for use in Beijing. Maine's meeting with Couplet in 1684, followed the next year by the state visit of the Siamese ambassadors to Beauvais, may have inspired him to commission the *Emperor of China* series.

The iconography of the tapestries derived largely from Jesuit publications like those of Kircher and Mendoza, supplemented by images from *Die Gesantschaft der Ost-Indischen Geselschaft in den Vereinigten Niederländern an den tartarischen Cham und nunmehr auch sinischen Keyser* (An Embassy from the East-India Company of the United Provinces, to the Grand Tartar Cham, Emperor of China), by Johan Nieuhof (1618–1672), published in Amsterdam in 1669 and quickly translated into many other languages, including French. Nieuhof's book, with its extensive program of illustrations, was arguably the most influential non-Jesuit text about China published before the eighteenth century.[47] The imagery used in the Beauvais tapestries relies on book illustrations of Chinese buildings, costumes, insignia of rank, furniture, and other objects. Greater liberty was taken with the Chinese originals in representing the imperial throne, boats, plants, and animals. Coconuts and

pineapples appear in two of the tapestries, inspired by Kircher's illustrations of these tropical fruits, the latter of which became a staple on the dining tables of prosperous Europeans during the Enlightenment.

The Jesuit connection to the duke of Maine's tapestries is seen most clearly in *The Astronomers* (figure 25). This intriguing narrative depicts prominent members of the Jesuit mission in Beijing, most likely including Schall von Bell and Ferdinand Verbiest, in company with a figure often identified as the Kangxi emperor (he resembles the likeness of Kangxi in *The Emperor on a Journey,* another tapestry from the series), although he stands while Verbiest sits, and he wears a rank badge. It may be that the monarch stood as a sign of respect to Verbiest's age, but it is also possible that the standing worthy is only a court official. The group is depicted examining astronomical instruments and a globe in an elegant garden pavilion. In the background, one sees substantial buildings, including a pagoda, all suggesting an imperial complex. Everyone understood that the possibility of converting the empire depended on the emperor's goodwill and active support, and the Jesuits were appropriately incorporated into the scene as imperial intimates. The missionaries are dressed in court costume. The scientific instruments that inform the narrative's subject are carefully studied and based on actual models.[48] Any Western viewer would intuitively recognize the distinctions of rank, the calculated informality, and the aura of authority surrounding Kangxi. The only concessions to chinoiserie exoticism are the elaborate yard birds, real and manmade, atop the pavilion, along with the unfamiliar but impressive architecture. *The Astronomers* presents a flattering view of court life in China while drawing attention to the importance of the Jesuits there in supporting Catholic efforts to convert the Qing empire.

Ephemeral events at the Versailles court also embraced the prevailing Chinamania. By the 1660s, the Chinese had taken their place among the Ottomans, Persians, Moors, and other "exotic" folk as subjects for themed masques and theatrical performances. During the Carnival celebrations of

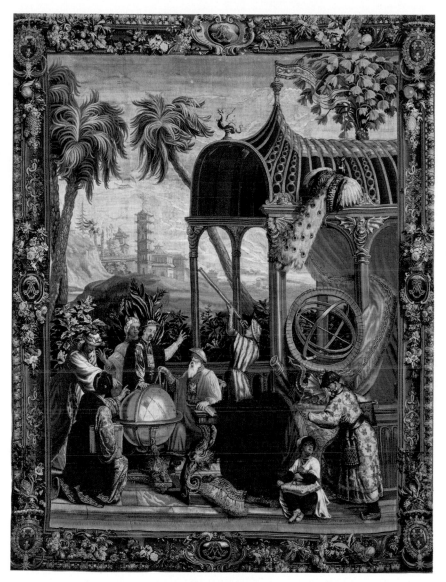

25. Jean-Baptiste Monnoyer, Guy-Louis Vernansal, et al., *The Astronomers,* from *Life of the Emperor of China,* Beauvais tapestry, ca. 1710. Los Angeles, J. Paul Getty Museum.

1667, King Louis appeared at a ball in a costume "half Persian, half Chinese" and probably unrelated to either to Persia or China except in the imagination of his sartorial advisors. In 1699, however, the duchess of Burgundy (Marie Adélaide of Savoy, 1685–1712, later the mother of Louis XV) asked the Jesuit Le Comte, who had recently returned from the China mission, for help in designing a credible costume for a chinoiserie masque, a request that indicates a vastly enhanced knowledge of China and a concomitant demand for greater authenticity. Events like the chinoiserie masque took place with increasing frequency during the last three decades of the Sun King's reign, and the *Mercure de France* and other publications lavished attention on them. The terms used to describe them in these texts are *amusant, galante*, and *fantastique*, among other adjectives, but almost never do the words *bizarre* or *grotesque* appear. Such derogatory language would hardly have been appropriate to describe court events in which the king took part, sometimes mumming as the Chinese emperor.

On January 7, 1700, the day after the Feast of the Epiphany, which marks the beginning of the Carnival season, a musical masque entitled *Le Roy de la Chine* was staged at the royal hunting lodge, the Château de Marly. The king's guest list for outings at Marly was much smaller and more select than at Versailles, and the competition for invitations was fierce. The *Mercure* reported: "The King was there, carried in a litter and preceded by about thirty Chinese [presumably people dressed in Chinese costume], with many singers and musicians playing instruments." The journal goes on to mention a *grotesque* dance, but it is unclear why it was so described.[49] Louis played the title role in *Le Roy de la Chine*; as Scott has observed, the masque and the Other merge in a role-playing performance that signifies elite social status.[50] Had the monarch not viewed his Chinese counterpart as an exotic equal, or at least as a near-equal fellow monarch, such signification would have been either demeaning to him or unintelligible to its audience. French court masques were excellent opportunities for the nobility to jostle for prominence, thus

the duchess of Burgundy's desire to appear in a costume as authentic as possible at Madame de Pontchartrain's chinoiserie masque. The duke of Burgundy (Louis de France, 1682–1712, future father of Louis XV) was even more interested in sartorial authenticity for his masque costume. He appeared as a Chinese mandarin in garb designed by Jean Louis Berain (1637–1711), and prints of this and similar costume ensembles may have influenced some of the chinoiserie figures in Antoine Watteau's designs for the paintings at the Château de La Muette. So much social consequence was at stake that the hosts of chinoiserie masques deployed as props such valuable objects as folding silk screens, porcelain, lacquer furniture, and other items from their collections.[51] Chinoiserie was serious business in Louis XIV's France, though it would not long remain so after his death in 1715.

+ + + +

Of all the Asian objects so avidly collected in seventeenth-century France, porcelain pieces were the most valued and among the most expensive. Inspired in part by the celebrated porcelain holdings of Augustus the Strong, Elector of Saxony and king of Poland, Louis XIV and leading court nobles began to amass collections of their own, but even the most ambitious among them could not equal those in Dresden. A major challenge to historians seeking to reconstruct the porcelain collections assembled at Versailles and elsewhere in France during the Sun King's reign is that specific objects can only rarely be identified with certainty. Those with a reliable provenance were often enhanced by the addition of elaborate gilded metal mounts created by French craftsmen, a stratagem intended to emphasize rarity and enhance visual impact.[52] Royal inventories from the reign of Louis XIV list thousands of pieces of porcelain in several of the royal châteaux, including Versailles, Marly, Fontainebleau, and Saint-Germain-en-Laye. The entries are usually vague or utterly silent about the provenance and even the authenticity of these objects.

King Louis XIV doubtless inherited some porcelain from his Spanish Hapsburg mother, Anne of Austria (reigned as regent 1643–51), an enthusiastic collector of Chinese luxury items, especially fabric. In addition, it is likely that his mother's closest advisor and confidant, the Italian cardinal Jules Mazarin (born Giulio Raimondo Mazarini, 1602–1661), the royal minister who is credited with introducing *"le goût chinois"* to the French court, also left some of his important porcelain works to the young monarch, who both trusted and admired him. Finally, it is likely that the French royal collection benefited from the Parisian sale of the porcelains of the notorious Barbara Palmer, duchess of Cleveland (1640–1709), in 1678, a newsworthy event recorded in the *Mercure*, though this benefit cannot be documented. Her long, flagrant affair with King Charles II of England (reigned 1660–85), Louis XIV's first cousin, resulted in the birth of five acknowledged royal bastards and shocked even an aristocratic Europe long inured to upper-class sexual scandals. The *Mercure*'s description of Cleveland's possessions nonetheless gives some insight into the contemporary taste for porcelain: "Some of them [pieces of porcelain] were remarkable for their depictions . . . and for the variety of their colors. The rarest were provided with gold or silver gilt mounts and decorated in several places with the same material."[53] The number and quality of the porcelains inherited by the Sun King paled in comparison with the thousands of objects he added to the royal collections, either by purchase or as diplomatic gifts from courtiers, other European rulers, and such Asian rulers as the king of Siam and the Kangxi emperor.

The most influential assemblage of East Asian porcelain at Versailles after the king's belonged to his only legitimate son, Louis de France, known as Monseigneur the Grand Dauphin (1661–1711). In his apartments he displayed large quantities of blue-and-white Chinese vessels in elegant lacquer cabinets designed by the royal *ébéniste*, André-Charles Boulle (1642–1732). Monseigneur's rank entitled him to a considerable present from the king of Siam

in 1685 that included eighty-four pieces of porcelain, a mobile silver crab, and a Chinese sculptural lion in an unidentified medium, possibly porcelain. When the Grand Dauphin died, his heir, the duke of Burgundy, who died from smallpox the following year, sold his father's porcelains to Louis Marie, duc d'Aumont (1691–1723). When d'Aumont's son, Louis Marie Augustin (1709–1782) died, his collection was sold to satisfy his creditors. Such was its celebrity that it was still identified as having belonged to the Grand Dauphin.[54] Unfortunately, the collection was scattered and it is now impossible to reconstruct. The fate of Monseigneur's porcelain cabinet is only one example of the conundrums facing historians attempting to understand how such collections were formed, what their display strategies were, and why they were so highly valued. Although literally tons of objects exist, along with numerous generic descriptions of collections, scholars have only a limited ability to connect one category with the other. Visual evidence of their appearance is limited almost exclusively to prints.

The prominence of collections of East Asian porcelain and other luxury imports in France was echoed throughout Catholic Europe and beyond. Owning such objects enhanced social status and visualized the possessor's participation in activities associated with high rank and sophisticated sensibilities. The objects themselves also served as a form of authentication for collectors, who sought to distinguish their own holdings by their greater brilliance and importance in comparison to those of their social competitors, above all at court. Porcelain maintained its aura of exotic mystery, and its display in politicized settings gave it an enhanced charge. From at least the mid-sixteenth century, the acquisition and display of non-European wonders was an important visual and cultural component of the global colonial enterprise. As the art historian Michael Yonan has pointed out, European possessors of exotic works, by recognizing them as worthy of display and developing a strategy to exhibit them, increased their appreciation as global wonders that the cultures that had created them implicitly could not

have valued adequately or fully understood. This is one of the reasons that many of the best specimens of Chinese porcelain were placed in gilt metal mounts. As in the mercantilist colonial trade model discussed earlier, "inferior" cultures could produce exotic wonders, but only the West could realize their full potential. China is problematic in this context. Europe did not put the Eastern empire on the same inferior footing as those parts of the world subject to colonization. Nevertheless, the "cultural work" of display was in part a deliberate visualization of European superiority.[55] Thus the importance of Chinese porcelain and other media to European collectors and the prestige generated by possessing them must be tempered by the realization that their ownership and display confirmed a hierarchy that subordinated even august China to the West. Baroque orientalism, which promoted Catholic Europe's obsession with "good China," also planted the seed for its deconstruction during the Enlightenment. How this development affected the representation of Chinese bodies in mid-eighteenth-century chinoiserie is the subject of chapter that follows.

Chinoiserie and the Chinese Body

Copious amounts of information about the distant empire of China reached Europe from the beginning of the Catholic mission in the late sixteenth century. Europeans, eager to learn about Chinese religious practices, customs, social conventions, architecture, and topography, were especially keen to know more about the physical appearance of the inhabitants of China, their racial features, clothing, and coiffure. Missionaries helped fill this need by sending back to Europe textual descriptions of what they saw in China, along with a large amount of visual material for Western consumption, both their own depictions and those produced by the indigenous population.

The West had been aware of East Asian "difference" since at least the thirteenth century, but the limited information available was larded with rumors, legends, and misunderstandings. As the mission gained ground in the early decades of the seventeenth century, European audiences had access to increasing quantities of credible eyewitness accounts as well as to considerable numbers of actual Chinese images, fueling an even greater demand for reliable information. What often passed as authentic and accurate observation, however, was in fact a highly mediated fusion of Western

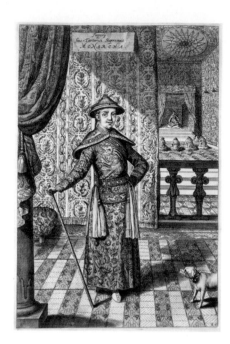

26. Anonymous, *The Shunzhi Emperor*,
engraving, 1667, from Athanasius
Kircher, *China illustrata*.

and East Asian elements. This owed in part to the Jesuits' agenda of empha-
sizing similarities with the Christian West while underplaying disparities
and, in images of the Chinese, promoting the idea that racial differences
were minimal. As the century progressed, however, interest in authenticity
grew, and both Western texts and images depicted minor racial dissimilari-
ties between Europeans and East Asians as a way to bolster the broader range
of similarities, both physical and cultural.

The engraved portrait of the supreme monarch of the Sino-Tartar empire,
probably the Shunzhi emperor (reigned 1644–61), in Kircher's *China illustrata*
is a characteristic fusion of Western and Chinese features in a purportedly
authentic likeness (figure 26); he has predominantly Western features but is
dressed in Manchu court robes. His posture is commanding and authorita-
tive and Kircher's readers would have understood him as a ruler in the Euro-

Chinoiserie and the Chinese Body

pean style.[1] Although the illustrators of Kircher's book may have been on their own in portraying the emperor's physiognomy, they no doubt adapted his costume and headgear from Jesuit descriptions and actual Chinese imagery.

Later seventeenth-century missionary sources are even more detailed and accurate. Father Bouvet's *Portrait Historique de l'Empereur de la Chine* of 1697 includes an engraved bust portrait of the Kangxi emperor and a detailed description of his appearance and personality. Following an already common tendency to compare Kangxi to Louis XIV, Bouvet praised the emperor as learned, just, clement, and well disposed to the Jesuits and their missionary activities. The textual account presents the Qing monarch as an imposing figure of above-average height with an athletic, well-proportioned body. His major facial feature is an aquiline nose, and the scars on his face from smallpox do nothing to diminish his majestic mien. Neither his portrait nor its description gives any hint of weakness or femininity. Like his French counterpart, he was respected for crushing any revolt against his authority, for attending sedulously to even the smallest details of imperial administration, and for defeating the Russians, who attempted to encroach on his dominions (and whose territorial ambitions in eastern Europe and the Ottoman Empire alarmed the French). The Jesuits emphasized his diligent study habits and his attention to scientific and mathematical subjects under their tutelage.[2] Although Bouvet's text and image may be exceptionally encomiastic and obsequious, they offer strong evidence that in the West the Chinese ruler was highly esteemed, to the extent that he could even be compared favorably to the Most Christian King of France without fear of contradiction. After the collapse of the Catholic mission in the eighteenth century, however, such accounts were either disregarded or, more darkly, characterized as Jesuit "intrigues."

Western readers by the 1680s were also familiar with other depictions of Chinese rulers and notables. Unlike the king of Siam, the Kangxi emperor

sent no diplomatic missions to Versailles, but in 1684 the arrival at the French court of Father Couplet with Michael Shen, the celebrity Chinese convert, gave thousands of people the opportunity to see an actual East Asian man. I discuss Shen's own impact on Western notions of authentic Chinese appearance in due course below, but he and Couplet also brought actual portraits of Qing notables and Chinese historical figures to be engraved by Jean-Baptiste Nolin's publishing concern in the rue Saint-Jacques in Paris and distributed throughout Europe; one of them was an idealized representation of Confucius. The China missionaries were always keen to present Confucius as a highly moral philosopher whose ideas were, for the most part, not incompatible with Christianity. Images of Chinese contemporaries included two court ladies and a portrait of the Kangxi emperor.[3] Western interest in such works of art was part of a broader curiosity about the physical appearance of Chinese people. The exaggerated characterization of Chinese bodies in mid-eighteenth-century chinoiserie was still several decades in the future. Baroque exoticism in the engravings produced after the portraits brought by Couplet and Shen was limited largely to details of clothing and hairstyle. Even in contemporary colored engravings, Chinese bodies are as white as those of Europeans.

Westerners, failing to understand the artistic premises of Chinese painting, had little aesthetic appreciation of it, especially portraits, an evaluation that stood in great contrast to European attitudes towards Chinese architecture. What interested them in East Asian representations of East Asian bodies was their usefulness, especially to producers of chinoiserie, as authentic documents and thus accurate visual sources. Although their standing as images of elite status, high culture, and political authority was unquestioned until the era of the Enlightenment, descriptions of Chinese portraits as "primitive," "naïve," and "limited" clearly indicate the Western failure to appreciate the cultural underpinnings of their pictorial conventions. As the art historian Richard Vinograd has pointed out, "the conventional elements

in Chinese portraits reveal their status as constructions of role and identity rather than mere documentations of appearance." In China, portraits of ancestors and contemporaries were informed by a vocabulary of visual conventions based on imagined portraits of notables of the past, "paragons of filial piety, virtuous women, famous poets, literary protagonists, military heroes, and sages from antiquity."[4] Such pictures of historical heroes and celebrities were widely disseminated, so that their conventions were accessible to literate Chinese viewers and could readily be transferred to individuated portraits made for more private use. Portraits of "real" people, whether ceremonial images, such as imperial portraits and depictions of ancestors, or informal representations of family and friends, had limited circulation, with access in most cases restricted to the subjects' official, familial, or social circles. Confucian sensibilities almost always prevailed, precluding expressions of strong emotion or abnormal features and promoting dignity and seriousness of purpose.

Two types of depictions of Chinese bodies made their way to the West: representations of stock characters and more intimate likenesses of individuals. Thus, Western artists and audiences had substantial information about the physical appearance of Chinese people, real and imagined, and about the visual conventions used to portray them in China. The naturalistic rendering of Chinese bodies in baroque orientalism and the purposeful dehumanizing distortions of the eighteenth century, then, cannot be attributed only to artistic whim or to a lack of accurate information.

A possible reason for Europeans' artistic disdain of Chinese portraiture (as opposed to reified abstractions) was the disjuncture between the individuation of the faces and the schematic rendering of the garments and settings. From the late Ming onward, ancestor portraits, which became deeply implicated in the Chinese Rites Controversy, characteristically showed the sitter full-length, seated, and posed in a rigidly frontal iconic manner with immobile facial features. Men and women were shown in the same frontal

pose, with an emphasis on dignity and detachment and a supernal aura adapted from Buddhist and Daoist images.[5] Because Chinese identity was closely connected to individual physiognomy, many portraits have highly clarified faces, rendered illusionistically, whereas bodies are "schematic abstractions," in effect "little more than garment racks" to communicate the rank and status of the person portrayed.[6] Westerners would have had difficulty reconciling such facial specificity with the flattened, schematized costumes and unarticulated backgrounds, usually attributing such "contradictions" to the limited artistic abilities of Chinese portraitists. The only formal parallel in Western European art that I know of was in sixteenth-century Mannerist paintings. One thinks especially of portraits by the German artist Hans Holbein the Younger (1497–1543) of King Henry VIII of England (reigned 1509–47), his family, court aristocrats, and wealthy London merchants.

Western artists adapted the conventions of the Chinese imperial portrait in constructing allegorical and historical narratives in the European manner. On the title page of the 1671 edition of Olfert Dapper's *Tweede en Derde Gesandschap na het Keyserryck van Taysing of China* (Second and Third Embassies to the Empire of Taising or China), a remarkable engraved image represents the enthroned Kangxi emperor in traditional Chinese fashion (figure 27). He is depicted frontally, richly dressed, sitting under a baldachin, and holding a scepter. Suppliants present gifts, including a caged bird. In the background, one sees a pagoda with bells at the ends of the eaves, a detail doubtless acquired from book illustrations of Chinese architecture (see figure 25). Kangxi's posture radiates authority, but the inclusion of figural narratives related to specific events in his reign would have resonated with Europeans familiar with ruler portraits of this type. A Ming loyalist and a figure in a Western-style hat, both in the water, flee the throne, treason and other baleful purposes expressed in their sinister faces and clawed fingers.[7] This particular vignette may refer to Qing efforts to defeat Ming pirates and

27. Anonymous, *The Kangxi Emperor Triumphant over Ming Loyalists and Other Enemies*, engraving, 1671, frontispiece to Olfert Dapper, *Tweede en Derde Gesandschap na het Keyserryck van Taysing of China* (Amsterdam: Jacob van Meurs, 1671). Photo courtesy of Rare Book Collections, University of Maastricht Library.

their Portuguese allies, a process that eventuated in the conquest of the island of Taiwan in 1683. In addition, one of the emperor's soldiers looks up as he is about to cut the long, luxuriant Ming coiffure from a conquered Han Chinese man: refusing to wear the Manchu queue was treason and punishable by death. The engraver who produced the image (only partly understanding the appearance of the Manchu queue) adopted some of its details from works of Chinese art (or other engravings similarly conceived), but the image, as a symbolic narrative of the Kangxi emperor's military victory in the civil war against the Southern Ming, is unmistakably one of rule and would have been legible to informed European viewers.

Chinese portraits and the images of Chinese notables included in Western publications were only one of the sources available to European artists

interested in producing authentic images of East Asian bodies. In the second half of the sixteenth century the little-known Spanish painter Manuel Henriques executed a scene related to the history of the Jesuit mission in Japan: *Saint Francis Xavier Received by the Daimyō of Yamaguchi*, representing the saint meeting the powerful ruler of one of the great courts of feudal Japan. The painter probably based the figures on textual descriptions of the event. The narrative is set in a grand if somewhat vague interior. The richly dressed daimyō is depicted at right, seated on a dais beneath a baldachin. He clasps a scepter and raises an open palm to the Western visitors as a sign of welcome, his red-slippered feet resting on a brocaded footstool. Saint Francis Xavier, a glowing light of sanctity around his head, is dressed in ecclesiastical vestments as if saying Mass. Both European and Japanese attendants witness the audience. As in many Western images of East Asian men, "exotic" elements are relegated largely to details of costume and setting; only a minimal attempt has been made to differentiate the Europeans from the Japanese by portraying their racial features.[8] My point, once again, is that before the middle decades of the eighteenth century, Europeans were not particularly interested in visualizing a racially inferior Asian Other. They saw differences in physiognomy in a relatively neutral way. Skin color was a much more important signifier of "inferior" racial status in the era of baroque orientalism (arguments justifying the enslavement of Africans often being based on the black hue of their skin), and most European accounts described Chinese and Japanese skin color as white. Only when the Chinese body was dehumanized during the Enlightenment were the seeds of the nineteenth-century "yellow peril" planted in the Western consciousness. Until then, Chinese skin color continued to be described in European accounts as white.

Looking back to the time of Matteo Ricci, the later sixteenth century, one sees a remarkable consistency in European accounts of Chinese people, who were almost always characterized as having full round faces, small flat noses, black hair, black eyes, and sparse beards. Chinese skin was white,

with some southern Chinese described as tanned. Westerners were much more fascinated with Chinese coiffure than with skin color, taking note of the elaborate hairdos, especially during the Ming era, and they understood the Qing queue as a signifier of masculinity. Costume was also of interest to Europeans, who learned that Chinese men and women wore long robes with large sleeves in which their hands could be concealed. They changed their clothes with the seasons and their garments to suit the formality of the occasion. The Europeans viewed modesty in dress as a Chinese virtue, especially for women. The ubiquity of men's hats also intrigued Europeans. These accessories were keyed to an individual's status: scholars and officials wore what to Europeans looked like a rectangular hat with wing-like appendages on the back, and most common people wore round hats. The Chinese thought it farouche to appear in public without a hat.[9] Very few observers paid much attention to the different shape of Chinese eyes, remarking only on their dark color. In sum, what Westerners saw later as important racial differences—eye shape and a largely imagined difference in skin color—they scarcely noticed before the eighteenth century.

Although I discussed the importance of imported porcelain to the Western development of chinoiserie in the preceding chapter, additional East Asian examples are relevant in this chapter's account of the images of the Chinese body available to Europeans. Here I consider four vessels, including two pieces produced at the imperial manufactory at Jingdezhen during the late Ming dynasty, one of them a *famille verte* polychrome dish dating from the Transitional Period (the years between the fall of the Ming in 1644 and the definitive establishment of the Manchu Qing dynasty in the early 1680s), and the other a blue-and-white bottle vase manufactured either late in the reign of the Wanli emperor, which ended in 1620, or possibly in the Transitional Period. Although none has a European provenance before the nineteenth century, they are characteristic of hundreds of thousands (if not millions) of porcelain pieces that flooded Europe in the seventeenth and

eighteenth centuries. All four have Chinese male figures as the principal component of their decoration, and their scale, status, dress, and accessories furnish further proof that Europeans had ample visual evidence of actual Chinese bodies. East Asian bodies in Western chinoiserie before the Enlightenment imitate their models more or less faithfully, whereas later those same models were grossly distorted and dehumanized. European artists drew their source material from a range of imported Chinese media, but the ubiquity of porcelain is especially noteworthy as a touchstone of authenticity, a concept differently defined at various times.

A bell-shaped candlestick dating to the middle third of the seventeenth century is characteristic of imperial production under the Chongzhen emperor (reigned 1628–44), the last ruler of the Ming dynasty, who committed suicide as the Manchu invaders occupied Beijing. Its blue-and-white color scheme is typical of Ming porcelain. The lower "bell" section is hollow and the upper part has a tall neck. The larger base is decorated with a narrative image of a mandarin in a garden with attendants, a common subject of late Ming porcelain. The men, tending to portliness in their sumptuous, voluminous robes, are rendered in naturalistic scale. A servant holds an elegant sunshade over his master's head as two other attendants look on deferentially.[10]

The image unambiguously communicates a scene of privilege and status, and there is no possibility of gender confusion. The shape of another late Ming vessel, a blue-and-white porcelain ovoid jar, is typical of works produced under the Chongzhen emperor. It is also articulated with several male figures (figures 28a and 28b). The floral decorations include a peach tree and plum blossoms, both flowers considered highly auspicious in traditional Chinese thought. A multi-figured narrative, most likely illustrating a scene from the popular novel *The Water Margin*, shows a group of five soldiers arresting a bearded, coarse-featured miscreant in a rocky landscape with trees. A magistrate and soldier flanked by attendants stand opposite, apparently prepared to take the prisoner into custody. One of the servants holds a

Chinoiserie and the Chinese Body

28a–b. Ovoid covered jar with scene from *The Water Margin,* porcelain painted in underglaze blue, Jingdezhen production, ca. 1630s. Phoenix, Phoenix Art Museum. *Below:* Detail.

banner proclaiming the official's authority and status. The individuation of the figures' faces and bodies is exceptional—especially those of the insouciant ruffian and the snub-nosed guards—possibly inspired by passages in the novel.[11]

Although this figural composition is more populous and detailed than many visual programs for Ming porcelain, Western audiences would certainly have understood the status of the individuals depicted and would have recognized the image intuitively as a "history painting," that is, an illustration of a story from a literary source, even if they did not know the text in question. Such visual narratives ranked high in European artistic hierarchies, and it would have been difficult to dismiss them as bizarre whimsies or fatuous artifacts of a decadent culture.

Because court patronage had been consistently conservative, the dramatic decrease in imperial patronage of the Jingdezhen porcelain kilns during the final decades of Ming rule had the advantage of creating a spirit of greater innovation. As the art historian Margaret Medley has demonstrated, figures in porcelain decoration became larger in the Transitional Period, and multicolored wares, which made major technical advances in production, complemented the traditional blue-and-white chromatic scheme of much Chinese production, a trend that continued and expanded under the Qing. A *famille verte* dish with four heroic characters from *The Water Margin* is a case in point. The presence of a channeled foot indicates a date not later than 1675, during the War of the Three Feudatories (1673–81), when the Jingdezhen kilns were largely destroyed (and later rebuilt).[12] The heroic warriors exhibit a pronounced martial swagger in the scene where they brandish swords. Their corporeal proportions are solid and rather squat, characteristic of Chinese depictions of the bellicose male body. A similarly heroic but less belligerent narrative is illustrated on a blue-and-white porcelain bottle vase produced early in Kangxi's reign. The top of the vessel's neck has the circular cracked-ice pattern introduced under the early Qing.[13] The major decoration

consists of an emperor and a hermit sage, probably intended to be Shun (who reigned about the twenty-third century BCE) and the wise man Shan Quan, to whom the emperor tried to give his empire. The sage refuses the magnificent gift, pleading the harmonious simplicity of his present circumstances. An attendant holds an elaborate sunshade above the emperor as an attribute of imperial rank. In the background, a groom attends Shun's white horse, accompanied by two guards with capped lances. The contrast in the costumes of the ruler and the sage could not be more pronounced. Shun is dressed in ornate silk robes and a ceremonial hat; the hermit wears only plain trousers and a rustic tunic. The slightly elongated figures are full of dignity and individual character. Both the *famille verte* footed dish and the blue-and-white bottle vase are adorned with figural narratives in which Europeans would have recognized rulers, warriors, servants, and possibly even philosophers. Shun's meeting with Shan Quan may have recalled images of Alexander the Great's encounter with the Greek sage Diogenes, a popular subject in baroque and eighteenth-century European art. Both figural groups would also have been taken seriously as products of a highly advanced civilization.

The European sojourn of Michael Shen Fuzong, a remarkable event mentioned earlier in relation to Shen's visit to Louis XIV at Versailles in company with Father Philippe Couplet, gave a considerable number of Europeans their most tangible evidence of the appearance of a real Chinese person. Many prints, drawings, and paintings of the famous Chinese convert helped spread Shen's celebrity and document his likeness. Although the meeting with the king at Versailles generated publicity for the Jesuit mission in China, the European tour's major visual record is a full-length, life-size portrait of Shen by the English court artist Sir Godfrey Kneller, commissioned by King James II (reigned 1685–88) in 1687 (figure 29).[14] Shen was not the first Chinese convert to Christianity to appear in Europe, but none had ever been the object of so much attention, and certainly none had ever had his portrait painted by

29. Sir Godfrey Kneller, *Portrait of Michael Shen Fuzong* [*"The Chinese Convert"*], oil on canvas, 1687. Windsor Castle, Collection of Her Majesty Queen Elizabeth II.

one of the leading artists of the age. To Catholics, Shen represented the hope of China's conversion, and his visit to England was possible only because the country was then ruled by a Catholic monarch deeply interested in proselytizing non-Catholics. King James was so impressed with Michael Shen that he had Kneller's portrait of him hung in the anteroom to the royal bedchamber.[15] Kneller's *Chinese Convert* is ideated, composed, and presented in the same format as his full-length images of English notables. The only difference is in Shen's facial features—Chinese but not exaggerated—and his dark silk robes and cap. The crucifix he holds helped to normalize him in Catholic European eyes, a detail that may well have been suggested by the pious James II.

While Shen was in England, as a tribute to his great learning and linguistic skills, he was asked to help catalogue the collection of Chinese texts in the Bodleian Library during his visit to the University of Oxford, having been invited there by the English Sinologist Thomas Hyde (1636–1703). Shen also presented several Chinese texts to Oxford and made similar gifts to libraries in France, Flanders, and Italy. In Rome almost a century later, a little-known Chinese priest named Giuseppe Lucio Vu was employed in the Vatican Library as a *scrittore* (roughly, scribe), translating Chinese books and other materials into Latin and Italian until his death in 1763 during the pontificate of Clement XIII Rezzonico (reigned 1758–69). One wonders how many other Chinese convert clerics were similarly employed in the major libraries of Catholic Europe.

As I have demonstrated, European artists interested in producing works of chinoiserie had vast storehouses of authentic visual material at their disposal as well as quantities of textual descriptions by Catholic missionaries, European merchants, and travelers. Both visual objects and written accounts portray the Chinese as inheritors of an ancient and highly developed culture, widely acknowledged to be Europe's equal (in some aspects, its superior). Descriptions of Chinese bodies from the sixteenth to the eighteenth

century downplay racial difference, above all in skin color, and find exotic—and almost always admirable—only details of dress and coiffure. Why, then, was this vast body of visual evidence and textual testimony so grossly distorted or ignored during the middle decades of the eighteenth century, especially in chinoiserie produced in Roman Catholic countries? What could have motivated such a sea change in attitudes toward Chinese civilization and especially the Chinese body?

I believe the destruction of the Jesuit mission to China by the Kangxi and Yongzheng emperors during the 1720s was one likely motivation, as was the mounting frustration over trade imbalances and the lofty, detached, and superior attitude of the Beijing court vis-à-vis the West. This chapter turns now to the visual strategies adopted by eighteenth-century Catholic Europeans to punish China for its rejection of the "true" faith and its haughty refusal to enter into hierarchical competition with the West because it was convinced of its own superiority, a state of mind Europeans could never tolerate. It galled Westerners that the Qing imperial court considered Europeans technologically advanced barbarians who could be useful at times but who remained barbarians nonetheless.

+ + + +

One of the most significant changes in European chinoiserie in the mid-eighteenth century was a pronounced tendency to distort, dehumanize, and make effeminate representations of the Chinese male body. In the early decades of Ricci's evangelization of China, missionaries observed and sometimes commented on the sexual practices of Chinese men, some of which they considered effeminate, abhorrent, or both. The Spanish Jesuit Diego de Pantoja (1571–1618) wrote the first Christian moral treatise critical of Chinese sexual habits common in the late Ming era. Pantoja's *Seven Victories*, first published in Mandarin and then translated into many Western languages, emphasized the Jesuit teaching of victory in salvation, but also reminded

Chinoiserie and the Chinese Body

potential converts of the dangers of the deadly sins. To Pantoja homosexuality was the greatest of these, even though it was not one of the canonical seven, because it purportedly made men effeminate and violated the procreative principle essential to Christian sexual morality. He linked this condemnation to fundamental Chinese philosophical concepts of yin and yang, imperfectly understood as a rigid binary mode, arguing that such a system could not accommodate homosexuality. To remind his readers of divine judgment against same-sex relations, he cited God's horrifying punishment of Sodom and Gomorrah.[16]

Pantoja's chief target was the practice of pederasty, widespread in southern China, above all in the old capital of Nanjing, where many upper-class men took younger ones as catamite lovers—a common practice among the literati and those involved in the theater. Because the goal of most missionary literature intended for Western audiences was to stress Chinese virtue and morality, such writing, by contrast, downplayed or ignored Chinese homosexuality, presenting the Ming empire as a high-minded society worthy of conversion.

Many Europeans considered the engagement of Chinese men in combing, arranging, and perfuming their hair feminine, although they apparently found it endlessly fascinating, to judge by the number of comments it generated. Western men kept their own hair close-cropped, wearing more or less elaborate wigs that their servants combed, arranged, and sometimes powdered before the men put them on. *The History of the Great and Renowned Monarchy of China,* by the Portuguese Jesuit Alvarez Semedo (1585–1658), originally published in Latin in 1642 and appearing in an English translation in 1655, narrates the Manchu conquest of most of Ming China in the early 1640s. According to the author, the continuing resistance of the Ming in southern China was driven more by the men's hope of saving their hair than by a determination to save the dynasty. Martino Martini, a Jesuit historian of China who claimed that hair was equally important to the Ming and Qing

dynasties, asserted that the Qing queue was a sign of Manchu military prowess, unlike the "effeminate" coiffures of the Ming. European men also wore queues, either attached to their wigs or formed from their own hair, bound in back by a black ribbon, well into the eighteenth century, but as the preference for shorter, natural hair increased in the age of Enlightenment, the Chinese queue came to represent submission, effeminacy, and backwardness, a prejudice even more pronounced after 1800.[17] Western observers apparently saw no comparison between their own, shorter queues and those of Qing men, which were braided and worn rather long.

Another practice of Chinese men that the West marked as effeminate in the eighteenth century but that had not been remarked on in gender terms before was the use of sunshades and umbrellas as both a practical accessory and status marker. During the baroque era, servants carrying baldachins or parasols often accompanied Western rulers and high-ranking officials in public, but this practice was largely symbolic, visualizing divine favor for the status quo. The sacral quality of such shielding recalls the use of baldachins and umbrellas to honor sacred relics and holy persons, the most celebrated example being the colossal gilt bronze baldachin over the high altar in Saint Peter's, erected by Pope Urban VIII Barberini (reigned 1623–44) and designed by Gianlorenzo Bernini (1598–1680). However, sunshades were also associated with femininity: a European woman of rank typically used a parasol when out of doors, invariably held above her head by a servant, as in *Portrait of the Marchesa Elena Grimaldi* by the Flemish painter Anthony Van Dyck (1599–1641) of 1623 (figure 30).

Prosperous Chinese men and women had their sunshades held by servants, and ordinary people also used them, usually carrying them without assistance. Matteo Ricci remarked: "On the street a large umbrella to ward off sun and rain is carried by a servant. Poor people carry a small one in their own hand."[18] Because of Ricci's observations, Europeans would readily have understood the ubiquity of servants holding sunshades above the heads of

Chinoiserie and the Chinese Body

30. Anthony Van Dyck, *Portrait of the Marchesa Elena Grimaldi*, oil on canvas, 1623. Washington, D.C., National Gallery of Art.

their betters in the Chinese images available to them in Europe. Many Europeans in the late sixteenth- and seventeenth-centuries may have excused men's use of parasols because of China's climate (though it was certainly no hotter than much of southern Europe), but the potential to gender such objects feminine remained and was exploited in the eighteenth century. Moreover, in much Enlightenment-era chinoiserie imagery, even elite men carry their own sunshades, emphasizing both their effeminacy and the degradation in their social status. In sum, hair and umbrellas are among the objects initially understood in a positive or at least a gender-neutral way that later became almost entirely feminized.

The feminization of the Chinese male body in mid-eighteenth-century chinoiserie went beyond coiffure and personal accessories. Activities, occupations, and clothing were also emasculated. The phenomenon of creating hierarchy by feminizing the Other had an effect on depictions of social class and status, seen especially in European visualizations of "Chinese" genre scenes only remotely tied to actual works of Chinese art. Johann Gregor Höroldt (1696–1775), the leading designer of Meissen porcelain in the mid-eighteenth century, actively propagated the emerging view of China as frivolous, decadent, and effeminate. Höroldt's chinoiserie figures are frequently engaged in leisure activities most Europeans would gender feminine, particularly those associated with the elite classes. His "Chinese" genre scenes depict people fishing, drinking tea, carrying their own umbrellas, chasing butterflies, and pursuing other recreational activities. Upper-class Chinese sometimes are represented fishing in Chinese art, because the fisherman's way of life was considered idyllic and detached in the Confucian sense, but that is not the reason Chinese men appear as fishermen in eighteenth-century chinoiserie. Tea drinking was also a leisure activity often depicted in Chinese images. But in those representations men are represented naturalistically and women, when they appear at all, are subordinated to the men they serve, whereas in eighteenth-century chinoiserie women often are the

Chinoiserie and the Chinese Body

more active participants. Chasing butterflies, which some of Höroldt's men seem to enjoy, in China was an exclusively feminine activity.

Moreover, Höroldt's Chinese figures are often dressed in fanciful costumes in pastel colors that draw more inspiration from the European Commedia dell'Arte than from actual Chinese prototypes. The contrast with the somber silk robes of the Chinese convert in Kneller's portrait could not be more pronounced. Indeed, Chinese clothing had long been lauded for its modesty and decorum, so the switch in chinoiserie images to pink, pale green, and yellow costumes (the latter in China a hue reserved exclusively for the emperor) was a deliberate choice unrelated to authentic Chinese garments. Although Höroldt studied Chinese woodblock engravings and works of East Asian porcelain carefully, he brought to chinoiserie design at Meissen an extraordinary degree of artistic license.[19] The nervous, highly attenuated style he employed for figures is only partly a stylistic choice—it also fit perfectly into the broader Enlightenment project of portraying Chinese males as indolent, effeminate, and physically weaker than Europeans.

A small porcelain tankard with silver mounts manufactured circa 1725 is a characteristic example of Höroldt's chinoiserie (figure 31). There is a continuous narrative genre scene on a grass ground that goes all the way around the vessel. A Chinese scholar, mounted on an elegant horse, richly dressed, and wearing a cap, carries a stick over his shoulder, a cloth laden with fruit tied to it. A servant holding a harmless-looking halberd walks before him, while another, remarkably emaciated, servant looks on. Large birds and oversized insects fly above, adding to the sense of unreality.[20] About five years later, a tureen cover made at Meissen that was influenced by Höroldt's style shows hyperelegant Chinese men arranging flowers in vases while another man prepares tea.[21] In Chinese art, youthful male servants often make and serve tea or wine and sometimes arrange beautiful objects for their master's delectation, but distinctions of rank are clear. Such activities, however, never encompassed flower arranging, which was an explicitly

31. Johann Gregor Höroldt (attributed to), tankard, Meissen porcelain, ca. 1725. Jacksonville, Cummer Gallery of Art and Gardens.

feminine activity. On neither the tankard nor the tureen cover was the Chinese male body depicted naturalistically, and on both pieces the men themselves engage in activities most Europeans would have considered feminine. Chinese art rarely if ever represented men in the extremely thin, elegant manner that East Asian art characteristically reserved for women of leisure, often called "thin lizzies" in the West.

The historian Steven Parissien has suggested that the European obsession with East Asian porcelain was "predicated on the concept of Asia as a romantic, amusing and, most significantly, passive and unthreatening stereotype." He has claimed that with the collapse of the Ming, China was a civilization in decline, "politically neutered" by dynastic struggle in a way that made its people and art suitable motifs for Western interior decoration.[22] This highly problematic line of reasoning, however, reflects the stereotypes of an earlier generation of Western scholars. Most Western and all Jesuit sources discuss

Chinoiserie and the Chinese Body

the Manchu as a warlike people, and it is hard to reconcile the admiration for the Kangxi emperor and his frequent comparison to Louis XIV with the notion of a "politically neutered" Chinese empire. According to Parissien, the European view of China during the Enlightenment was based on the notion that it had become a decadent, frivolous, and ephemeral society after the fall of the Ming dynasty. He characterizes China, moreover, as "emphatically unwarlike" and notes "the psychological demilitarizing of the East" in the imagination of Europeans.[23] In reality, owing to distance and lack of interest, Qing China posed no military threat to either Europe or even European colonies in the Philippines and the Dutch East Indies, and the empire's disinclination to foster its own maritime trade after the mid-fifteenth century made even naval conflicts with the Western powers highly unlikely. The Qing empire was highly aggressive in its armed conflicts with rebel groups on its borders, however, and exercised effective control of Burma, Tibet, Mongolia, Korea, and Indochina (modern Laos, Vietnam, and Cambodia), a fact well known to Europeans, so the notion of a passive and unwarlike eighteenth-century China is untenable. Denis Diderot may have best represented the Enlightenment view of China in considering it backward, passive, tranquil, and "less avid for novelties than the spirit of the West."[24] This assessment was inaccurate, but was an early step in Europe's condemnation of China as mired in tradition and incapable of technological progress, major pretexts for colonialist intervention in the nineteenth century. Such an attitude marks a sea change from the European admiration of Chinese political administration, history, philosophy, architecture, and even porcelain production that dominated Sinology in the late sixteenth and seventeenth centuries.

+ + + +

The transformation of China in European visual culture from an exotic but powerful and cultivated empire to a rickety, decadent, and effeminate one can be documented in many artistic media. Two tapestry series dedicated to

the activities of the Chinese emperor, one dating from the 1680s and the other from the 1740s, provide a rare opportunity to see this change embodied in objects produced at the same manufactory, Beauvais, and for similar patrons, court aristocrats. The first *Life of the Emperor of China* tapestry set, commissioned by the duc du Maine, includes *The Astronomers* (see figure 25), an image discussed briefly in chapter 2 in relation to the Jesuit scholars at the Kangxi emperor's court. The figures in the tapestry are probably Verbiest, Schall von Bell, and the emperor himself, as well as other learned attendants, in an elegant garden pavilion, where they are surrounded by scientific instruments related to astronomy and cartography, two Jesuit specialties. The missionaries are dressed as mandarins, and palatial Chinese architecture is visible in the background. Except for details of costume and setting, the scene evidences little overt exoticism, and the dignified figures, both European and Chinese, are shown equally engaged in scientific study.[25] All the tapestries of the first series present Chinese court life as refined, civilized, learned, and different from the life of European courts only in details, not in essentials.

The prominence of the Jesuit scientists in *The Astronomers* indicates the indirect role of the Society of Jesus in creating the tapestry series. The French court followed missionary efforts in China very closely. The first set of tapestries in the *Tenture chinoise* series was executed about 1685–89, and the cartoons were loomed several times until 1731, by which date they were worn beyond use. Iconographical details in them were gleaned from a wide variety of visual and textual sources, including Jesuit publications by Martini, Kircher, and others as well as Protestant illustrated texts such as those of Johan Nieuhof and Olfert Dapper (ca. 1635–1689). Kircher's *China illustrata* was especially important for the series, because it considered "ethnology, geography, geology, zoology and botany" and contained illustrations of Chinese people "in their native dress living after their own manner surrounded by the most charming landscapes."[26]

Chinoiserie and the Chinese Body

The duc du Maine's *Life of the Emperor of China* was a highly collaborative initiative. The primary designer was most likely Guy-Louis Vernansal (1648–1729), a member of the Académie Royale who specialized in enlarging existing paintings. As Edith A. Standen, a historian of the decorative arts, has pointed out, that particular ability was crucial to the process of transferring cartoons to fabric in tapestry design. The participation in the project of two flower painters, Jean-Baptiste Monnoyer (1636–1699) and his son-in-law Jean-Baptiste Belin de Fontenay (1653–1715), is no surprise, because flowers and other flora feature prominently in most of the scenes.[27]

Audience of the Emperor of China is one of the principal narratives in the first Beauvais series (figures 32a and 32b). The tapestry exists in at least fifteen versions. It shows the emperor seated on an elaborate throne that is crowned with peacock feathers (symbols of clear-sightedness) and covered with a luxurious Near Eastern rug. He wears a turban-like headdress and gorgeous robes, and his face has only a slight Asian cast. The porcelain vessels at right are Chinese, of the type familiar to Western artists, but the patterns in the textiles seen in the image bear no apparent relation to East Asian prototypes. The elephant behind the throne, given the size of its ears, is most likely African; Nieuhof claims that such elephants were bred in China.[28] The Qing emperors did indeed keep elephants that they received as tribute from vassal rulers in Southeast Asia, especially Burma. The tapestry's composition is adapted from the frontispiece of Nieuhof's influential book on his travels in China, *Die Gesantschaft der Ost-Indischen Geselschaft in den Vereinigten Niederländern an den tartarischen Cham und nunmehr auch sinischen Keyser* (An Embassy from the East-India Company of the United Provinces, to the Grand Tartar Cham, Emperor of China). *Audience of the Emperor of China* unambiguously visualizes imperial power and glory in a narrative format easily comprehensible to European audiences. Three suppliants at the lower right koutou to the monarch, and at the lower left a woman, presumably the empress, is brought into the scene in a small conveyance pulled by servants. She has

32a. Jean-Baptiste Monnoyer, Guy-Louis Vernansal, et al., *Audience of the Emperor of China*, tapestry, ca. 1700–1710. New York, Metropolitan Museum of Art.

decidedly European features, and looks in fact as if she had been borrowed from a painting by the Venetian painter Paolo Veronese (1528–1588). The costumes, accessories, and setting are engagingly exotic, and racial differences are minimal. *Audience of the Emperor of China* shares with the other tapestries in the series a hybrid approach to Asian subject matter, mixing South Asian and East Asian elements freely while maintaining the loose thematic association with the Kangxi emperor's court in Beijing. Such hybridity may have resulted because the artists who produced the Chinese series decided, likely for reasons of economy and ease, to repeat some elements (albeit with notable variations) of a set of Indian tapestries they had made at the Gobelins manufactory in 1687.[29] In any event, the popularity of the Beauvais *Life of the Emperor of China* tapestries surpassed that of its Indian counterpart, and the tapestries themselves affirm the baroque orientalist idea of China as an

Chinoiserie and the Chinese Body

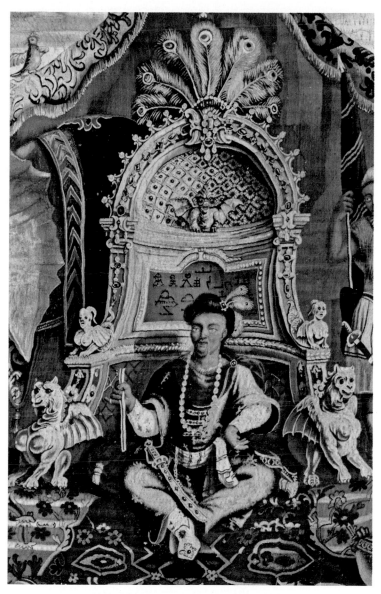

32b. Detail of *Audience of the Emperor of China* (*opposite page*).

exotic but an essentially equal counterpart to France that dominated Western thinking during the reign of Louis XIV.

The wear and tear on the Beauvais *Life of the Emperor of China* canvas cartoons eventually rendered them useless as models for the weavers, strong evidence of their popularity, and a new set of cartoons was ordered from the prominent painter François Boucher (1703–1770). His nine paintings were produced in 1742 and were used for the six-unit set of scale cartoons executed by Jean-Joseph Dumons, called Dumons de Tulle (1687–1779). The Boucher images are utterly different from the first set. As the art historian Perrin Stein has observed, such a high-profile commission would have necessitated research, and the artist consulted a number of popular Sinological texts, including those of Pieter van der Aa (1659–1733), Arnoldus Montanus (ca. 1625–1683), Nieuhof, Bouvet, and Kircher.[30] As a collector of Chinese art, especially porcelain vessels, *magots,* and folding silk screens, the painter doubtless also scrutinized objects in his possession. Boucher used his research, however, only for an occasional motif in the tapestry cartoons. In fact, visual research had a far greater impact on his exotic hunt scenes and turqueries than on his chinoiseries. Drawings sent from Beijing by the Jesuit artist Jean-Denis Attiret (1702–1768), who later became famous as an expert on Chinese gardens and influenced landscape design in Europe, were the ostensible models for the tapestries, but they had little visual impact on the artist's cartoons.[31] Boucher's designs for the second version of *The Life of the Emperor of China* are arguably an artistic invention embodying a whimsical visualization of China largely unconcerned with authenticity, the issue that drove much chinoiserie imagery before the mid-eighteenth century.

Even a cursory comparison of the *Audience of the Emperor of China* from the original Beauvais set with Boucher's tapestry design of the same subject underscores the profound shift in attitudes about China from the late seventeenth century to the Enlightenment (figures 33a and 33b). The celebration of a glorious if remote ruler has changed to an image of an emperor as a play-

thing for the court ladies, who decorate his hat with ribbons. Boucher's monarch, though he occupies the center of the composition, is hardly its focus. A sense of disorder and the random piling up of lush accessories take center stage. Numerous servants and courtiers are scattered across the foreground, but many seem to be ignoring the imperial presence. Although several koutou, their obeisance is lost in the *beau désordre* of porcelain vessels, elaborate umbrellas, fabrics, insubstantial draped pavilions, and even pieces of lacquered furniture. A delicate, coy lady, perhaps the emperor's consort, sits cozily at his feet, though nothing other than her position in the composition suggests exalted rank. The clutter and confusion speak volumes about contemporary notions of the Chinese court as mired in luxury, decadent, feeble, and, above all, feminine. One may easily imagine Vernansal and Monnoyer's Chinese emperor rising to go on a hunt or to war, but Boucher's doll-like *magot* monarch seems permanently seated, incapable of action. European ideas about divine right monarchy were predicated on the effective and active masculinity of the royal body, a political tenet the first version of *Audience of the Emperor of China* in no way countermands. The women in Boucher's painting, however, treat the monarch as a plaything. The courtiers who form a compositional pale at the foot of the dais prevent his emergence from the feminine web that ensnares him, even if he had the energy and volition to move. He seems impotent in every sense of the word.

The imperial court in Beijing, predictably, misunderstood the painter's sacrifice of authenticity to visualize a feminized, perverse, and nonthreatening China. The Qianlong emperor had erected European pavilions in his Garden of Perfect Brightness (Yuanming Yuan) at Beijing, in part to house the many European objects presented to him by Louis XIV, Louis XV, various Roman pontiffs, and other rulers. Unfortunately, almost all these diplomatic presents and the buildings that housed them were destroyed by the Anglo-French army during the Second Opium War (1856–60). Among the objects Qianlong displayed at Yuanming Yuan was a set of the Boucher chinoiserie

33a. François Boucher, *Audience of the Emperor of China,* oil on canvas, 1742. Besançon, Musée des Beaux-Arts.

tapestries produced at Beauvais, a gift from Louis XV. It is more than a little ironic that the Chinese monarch believed them to represent the court at Versailles, so little did they resemble anything with which he was familiar.[32] What the French king was thinking in sending such a potentially problematic gift to the Qianlong emperor is anyone's guess.

+ + + +

Boucher's image of the ruler of the world's largest empire in *Audience of the Emperor of China* resembles the *magot* figurines seen everywhere in eighteenth-century elite (and not-so-elite) interiors. Many of these objects were made of either stoneware *(terre des Indes)* or porcelain, and the *magots* included elderly men, small children, beggars, porters, and generic Asian deities. The *magots* often sit on stools or outcroppings of rock or else ride buffalo, tigers, or dragons, recalling the Chinese men astride ostriches in Paolo Posi's print of the

Chinoiserie and the Chinese Body

33b. Detail of *Audience of the Emperor of China* (*opposite page*).

Roman Chinea festival of 1758 (see figure 24). The most popular *magots* were the grimacing fat and deformed seated figures many found amusing. They could be either freestanding or incorporated into clocks, sconces, mirrors, potpourri pots, or even furniture. Many French cultural critics derided *magots* as expensive bagatelles of bad taste. Above all, collectors of *magots* were mocked in literature and the theater for their obsession with "feminized absurdities" capable of seducing their susceptible devotees, especially women.

Serious collecting of *magots* and pagods began in France during the last decades of the reign of Louis XIV, when they were usually viewed as charming curiosities, but by the 1730s they had taken on a decidedly negative connotation. In the *Encyclopédie*, Diderot associated such objects with religious superstition and disparaged as "idolaters" the Asians who purportedly worshipped them. Other dictionaries defamed such bric-a-brac and those who created and

"adored" them, and by the midcentury, the word *magot* was also used to define a small, grimacing monkey of the type increasingly found in rococo chinoiserie decoration. Surely the association of traditional East Asian pagods (which, far from being "adored" or "worshipped" in China, were seen as friendly, light-hearted spirits of good omen) with cavorting, leering monkeys was not a coincidence.[33] Despite criticism by prominent intellectuals like Diderot, the figurines known as *magots* and pagods were avidly collected and frequently displayed in European interiors. They were a major feature of rococo chinoiserie, reaching the apex of their popularity in the 1740s and 1750s. Some of the figurines nodded their heads and even stuck out their tongues, further emphasizing their "grotesque character." Evidence suggests that *magots* and pagods served as decorative elements in a variety of mediums, including textiles, wall hangings, lacquer panels, and other luxury objects. Louis XV's celebrated mistress Jeanne-Antoinette Poisson, Marquise de Pompadour (1721-1764), owned a *secrétaire* covered in lacquered pagods, and her favorite painter, François Boucher, also collected them.[34] The artist occasionally incorporated grotesque simian *magots* and pagods into his chinoiserie paintings and drawings. A red-chalk drawing of the late 1740s or early 1750s, *The Element of Fire* (figure 34), is a well-known example of the trend. The work shows a dehumanized, mantis-like Chinese man holding a simple pot from which he pours tea for the squatting soldier (who looks more like an oafish peasant) who has brought wood for the stove. A prominent *magot* sits on a shelf at the top of the composition. This red-chalk drawing, one of a series of four Boucher chinoiserie studies devoted to the elements, is unfortunately the only one that survives.[35]

The painter also included distorted, grotesque Chinese figures in a series of designs dedicated to *The Five Senses Represented by Different Chinese Pastimes*, produced in collaboration with the engraver and publisher Gabriel Huquier (1695-1772), who published them in 1740. It was most likely Huquier who made Boucher aware of the growing commercial market for chinoiserie design and its potential for profit. He also provided the painter with chinoiserie

34. François Boucher, *The Element of Fire*, red chalk on paper, ca. 1740. New York, Metropolitan Museum of Art.

imagery, having pirated Jean-Antoine Fraisse's *Livre de desseins chinois* of 1735 and published its illustrations throughout the 1740s, the years of his closest collaboration with Boucher. In the *Five Senses*, Chinese men, mostly *magot* types, bang on gongs, laugh, eat huge melons, and engage in other comical or farcical activities. As Stein has observed, their antics echo those of the monkeys found in contemporary *singeries*, meaning "monkey tricks," and referring to images of monkeys behaving like humans.[36]

Chinoiserie and singerie, rarely mixed before the rococo era, kept frequent company in the middle decades of the eighteenth century. A similar image by Christophe Huet (1700–1759), dated about 1750 and also in the Bibliothèque Nationale, shows a seated simian playing a musical instrument, accompanied by two Chinese boys, one on each side (figure 35). The youth at left jangles a string of tiny bells, while his counterpart at right plays a percussion instrument that looks like a tambourine. All three figures are encased in a quadrangular, decorative floral pergola. The monkey, clearly the most important of the trio, sits cross-legged atop a grisaille cartouche. Indeed, the young boys seem to be suspended from wires in the manner of marionettes, further emphasizing their inferior status.

The decorative association of Chinese figures and monkeys in rococo chinoiserie is also seen in more ambitious pictorial undertakings. The Château de Champs-sur-Marne—built between 1703 and 1707 and remodeled in the late 1740s, when Huet added numerous exotic images—is one of the finest surviving examples of rococo singerie decoration. The château's largest chamber, designated the Chinese drawing room, is adorned with wood panels on which male and female Chinese figures are painted, and a cabinet in an adjacent bedroom is decorated with monochrome blue chinoiserie pastorals. Huet painted monkeys and Chinese and Turkish figures on the wood panels. The Chinese figures predominate. They are depicted fishing, playing woodwind instruments, smoking, digging in a garden, and watering plants. Two are shown transporting a small orange tree on a stretcher; another feeds a caged

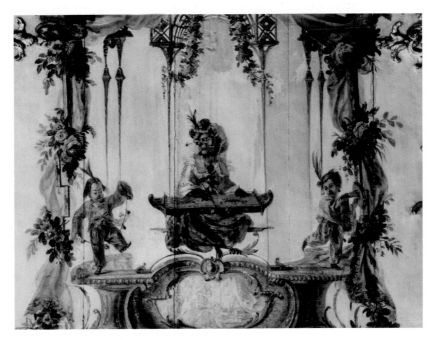

35. Christophe Huet, *Chinoiserie with Monkeys*, colored drawing, ca. 1745–52. Paris, Bibliothèque Nationale.

bird. Although a few wear sun hats, most are bareheaded and shaved, except for a minuscule Qing queue. A typical Chinese figure from the château's pictorial program is shown seated like a monkey, burning incense before an obese seated Buddha figure that looks suspiciously like a *magot* (figure 36). The *faux* "idol" also has a shaved head with a tiny queue, something no East Asian representation of Buddha would ever include.

Fewer Turkish men are depicted, but they are more actively employed in masculine pursuits. In one scene, two mounted Turks armed with spears hunt an ostrich (figure 37). The ubiquitous monkeys in the Champs-sur-Marne decorations literally ape and often mock the Chinese figures, but not the Turks.[37] China was a distant empire, correctly believed to be largely

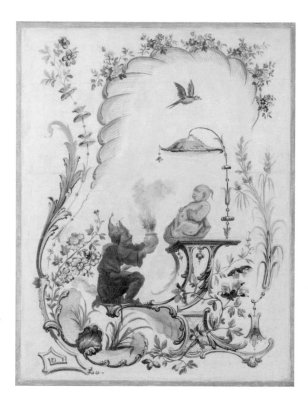

36. Christophe Huet, *Chinese Man Burning Incense before an Image of Buddha,* oil on wood, late 1740s. Champs-sur-Marne, Château de Champs-sur-Marne.

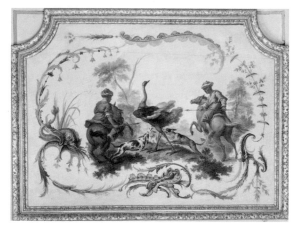

37. Christophe Huet, *Turks Hunting an Ostrich,* oil on wood, late 1740s. Champs-sur-Marne, Château de Champs-sur-Marne.

indifferent to European attempts at evangelization, trade, and cultural exchange. The Sublime Porte (a designation for the Ottoman Turkish empire, derived from a prominent architectural feature of the sultan's palace in Constantinople), by contrast, was a traditional French ally in the struggle against the Austrian Hapsburgs. Huet, at the Château of Champs-sur-Marne, visualized differences in perception based on political considerations. In sum, even in a rococo exoticist context, a clear visual distinction was made between the martial Turks and the feminized, simian Chinese.

The association of monkeys and Chinese men is even more obvious in a design by Jean-Baptiste Pillement (1728–1808). In 1798 the artist published *Nouvelle suite de cahiers arabesques chinois à l'usage des dessinateurs et des peintres* (New Set of Notebooks of Chinese Arabesques for Use by Draftsmen and Painters), basing his work on chinoiserie arabesques he had produced during the 1750s. The later images, however, tend to be more visually complex, busier in detail, and smaller in size. Many of these colored etchings show Chinese men in extremely tenuous tree houses, doing nothing. One design even depicts a junk "floating" on a rocky path in a garden.[38] Indeed, what could be more absurd and otiose than a grounded ship? For the present discussion, it is *Chinese Men Conversing with Monkeys in a Tree House* that encapsulates the rampant dehumanization of East Asians in much of the chinoiserie imagery produced during the Enlightenment. Pillement made little attempt to differentiate the activities of the men and the monkeys; they all seem idle and nonsensical. The men's crouching postures call attention to their simian character, and in this instance they even live in the trees. Does such an image differ much from the "Chinaman" with a sloping forehead and prognathic jaw of nineteenth-century Yellow Peril Imagery?

+ + + +

In the initial stages of French rococo imagery, representations of the Chinese male body, leisure activities associated with social status, costumes specific

to class, badges of rank, gendered coiffure, and objects like pagods connected to Chinese spirituality were neither dehumanizing nor feminizing, characteristics imposed on the chinoiserie of the middle and later decades of the eighteenth century. Thus it is not simply "rococo" to depict feminized, impotent, and dehumanized Chinese bodies in works of art. The initial rococo continuity with the immediate baroque orientalist past owed partly, I believe, to the continuing presence of missionaries in China, many of them French, and the widespread hope that the Qing empire might still be converted to Roman Catholicism.

Antoine Watteau's designs for the chinoiserie decorations at the Château de la Muette, executed about 1712–14, help to make the case. Although the paintings had vanished by 1754, their general appearance is recorded in the thirty Watteau plates in *Diverses figures chinoises et tartares* (Various Chinese and Tartar [Manchu] Figures), engraved by Boucher and Edme Jeaurat (1688–1738), among others, and published by the wealthy connoisseur and collector Jean de Jullienne (1686–1766). They include *Geng, or Chinese Physician* (figure 38) and the well-known *Chinese Divinity*, a female figure seated on a four-stepped throne and worshipped by prostrate devotees.[39] The Chinese physician is seated and wears capacious draperies that cover an ample body that has both bulk and corporeal presence. Neither of Watteau's images suggests the etiolated, feminized male body characteristic of Boucher's later representations of Chinese men.

The engravings of the chinoiserie at La Muette are characterized by their "Frenchness," an aesthetic quality usually attributed to "cultural blindness." As Katie Scott has indicated, however, Watteau was far from uninformed about China. Moreover, the Siamese embassy to Versailles in 1686 had created a sensation, as had Michael Shen's sojourn at the Bourbon court two years earlier. The artist interpreted East Asian sources, not out of cultural blindness, but with a desire to create visual ambiguity between the French and Chinese, similar to the class mixing and hazy sartorial distinctions that

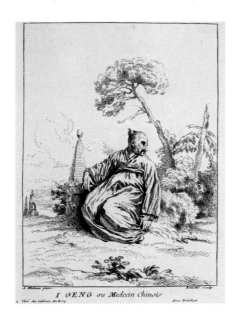

38. François Boucher, after Antoine Watteau, *Geng [Chinese Physician]*, engraving, 1731. Private collection.

prevailed in contemporary *forain* theatrical performances or in Commedia dell'Arte skits. Had Watteau intended any mockery, it would have been aimed at the Chinamania that still gripped France in the last years of the Sun King's reign.[40] The comic qualities of Watteau's La Muette designs were a product of elite notions of raillery that helped codify early eighteenth-century class behavior. In contrast to ridicule, which was highly negative and could frequently be vicious, raillery was benevolent and comprehensible, promoting a gentle self-mocking that fostered elite social cohesion. Above all, raillery in Watteau's chinoiserie was an aspect of positive wit and privileged leisure.[41] Like Watteau, whose La Muette images he helped engrave, François Boucher, in his chinoiserie, was also deeply informed by works of Chinese art and Sinological texts. Boucher's version, however, consistently visualized China as a ridiculous realm peopled by effeminate emperors and doll-like court ladies whose anatomy related to that of humans tangentially

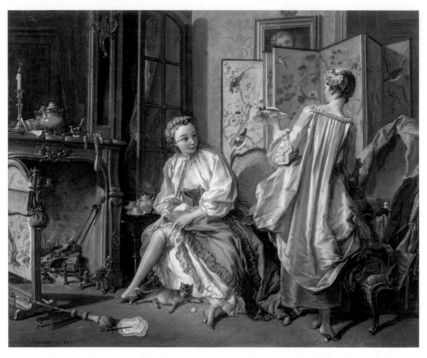

39a–d. François Boucher, *Lady Fastening Her Garter*, oil on canvas, 1742. Madrid, Museo Thyssen-Bornemisza. *Opposite page*: Details of *Lady Fastening Her Garter*.

at best and at worst, monstrously. Many of Boucher's chinoiseries were produced to be engraved, and "updated" versions of earlier book illustrations were doubtless profitable to both the painter and the publishers.[42] The artist's studio was packed with East Asian works of art and European chinoiserie objects, including quantities of porcelain and lacquer, though it is hardly surprising that none can be directly related to surviving objects. They may have served as points of reference for chinoiserie accessories that appear in a number of Boucher's genre paintings. In *Lady Fastening Her Garter* of 1742 (figures 39a, 39b, 39c, and 39d), Boucher included a painted silk folding screen, a blue-and-white porcelain lidded urn, cups, and saucers. As Stein

Chinoiserie and the Chinese Body

has argued, many of these objects must have been acquired from the prominent art dealer Edme-François Gersaint (1694–1750), who renamed his establishment À la Pagode in 1740 to indicate the type of luxury goods he sold.[43] Boucher was commissioned to design Gersaint's new trade card, which combines a grimacing *magot* and a lacquered cabinet with shells, coral, musical instruments, and other collectible oddities and curiosities. As in *The Life of*

the Emperor of China tapestry cartoons, the artist avoided treating Chinese artifacts as authentic, choosing instead to produce absurd and risible effects. The mania for collecting *magots* and pagods peaked in the middle decades of Louis XV's reign, in part because these objects presented Chinese "monks" as either bizarre or barbarous. Thus, Boucher could transform the Immortal Dongfang Shuo carrying a peach branch (a symbol of long life) into a laughably pedantic Chinese botanist, and Guanyin, bodhisattva of compassion, who was revered in China, into a commonplace "Chinese" peasant.[44] By about 1740, the issue of authenticity in chinoiserie was no longer relevant, and the visualization of the Chinese as utterly Other was complete.

+ + + +

The shift in Enlightenment attitudes from "good China" to "bad China" peaked in the middle decades of the eighteenth century. Before the Enlightenment, many European observers had remarked on the impressive architectural profile of China, commenting on buildings that had stood for centuries, especially in the two major urban centers, Beijing and Nanjing. Bridges, pagodas, temples, public buildings, and city walls were praised as impressive and enduring symbols of an advanced civilization. The famous Great Wall awed (and continues to amaze) many Western viewers, even though some questioned its military efficacy. By the 1730s, however, Europeans increasingly viewed Chinese architecture as insubstantial and impermanent, a few notable monuments like the Great Wall and the Nanjing pagoda notwithstanding.[45] And Catholic Europe began to mock what it earlier had considered major accomplishments of the Chinese empire in architecture and the sciences and contributions to global civilization. Chinoiserie artists contributed significantly to the perception of China as a feckless culture in full decline, using its venerable architecture as a visual metaphor for a decadent polity beyond hope of renewal. The pavilion in Boucher's *Chinese Fishing Scene* presents a typical example of a negative Enlightenment era visualization of

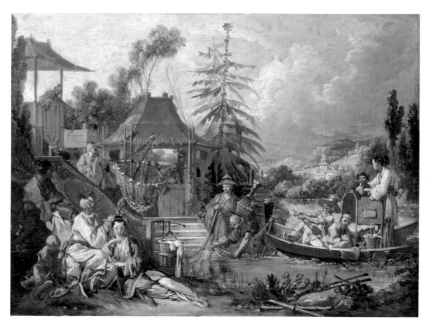

40. François Boucher, *Chinese Fishing Scene*, oil on canvas, 1742. Besançon, Musée des Beaux-Arts.

Chinese vernacular architecture (figure 40). The flimsy structure represented in it would collapse at the first gust of wind. By extension, so would the Qing empire.

The Chinese built environment was increasingly depicted as ephemeral and insubstantial, and attacks on an exemplary China long promoted by the Society of Jesus accompanied such representations. Many of the leading French *philosophes* were decidedly Sinophobic and disparaged both Chinese art and science, Voltaire being a notable exception. In his political treatise *L'Esprit des lois* of 1748, the baron de Montesquieu (Charles-Louis de Secondat, 1689–1755) pilloried imperial China as a backward despotism, an idea picked up in several texts by Denis Diderot. Although Jean-Jacques Rousseau

(1712–1778) admired what he perceived to be the benign paternalism of the Chinese government, he belittled China's art, architecture, science, and intellectual culture. In company with other critics of China, many scholars and intellectuals based their Sinophobic notions on negative evaluations found in such publications as the French translation of George Anson's *Voyage round the World in the Years 1740–1744*, a text filled with unflattering descriptions of the dishonesty, rapacity, and double-dealing of Chinese merchants and imperial officials. Diderot claimed such accounts proved the moral degeneracy of the East Asian character. It is perhaps revealing that he privileged a Protestant merchant text rather than the Jesuit publications that had dominated Sinology in earlier periods.[46] In the era of Enlightenment, a fundamentally flawed civilization such as China was considered incapable of embracing progressive ideas, above all in the scientific arena.

Jean-Baptiste Pillement's well-known *Chinese Astronomer* embodies many of the assumptions that epitomized Catholic European attitudes toward China during the Enlightenment (figure 41). As Hugh Honour has eloquently observed, Pillement's chinoiseries are set in structures and decorative constructs that "seem to have been spun by some exotic, yet innocuous, eastern spider."[47] Pillement painted the *Chinese Astronomer* as a cartoon for tapestry weavers in Lyon, the leading center in France for the production of silk. The scientist peers myopically through a telescope, caged in a decorative frame. He resembles the "thin lizzie" Chinese female beauties popular in Europe in the seventeenth century, so called because of their attenuated bodies and small, jewel-like heads, and from a European perspective he looks decidedly feminine, in both physique and dress. The telescope is depicted carefully, but it was widely known that missionaries, popes, and kings had been sending such Western astronomical instruments to China for almost two centuries. To continue Honour's innocuous "eastern spider" metaphor, the astronomer appears harmless, decorative, and silly. The floral and avian borders permit no actual observation of the heavens, so the

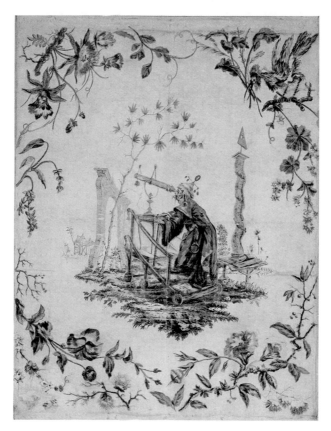

41. Jean-Baptiste Pillement, *The Chinese Astronomer,* colored
engraving, ca. 1765. New York, Cooper Hewitt Museum.

astronomer's efforts, like Chinese science in general, are an exercise in
futility.

+ + + +

To underscore the political, economic, and intellectual reasons for the dra-
matic transformation in the Western view of China and the Chinese and the

devolution in chinoiserie from the "good" to the "bad China" model, it may be helpful to consider how the Chinese depicted Europeans. China's first experience with Western images of Westerners probably came from religious art, which many admired for its technical virtuosity, illusionism, and naturalism, although others found it repugnant. The late Ming Buddhist reformer Yunqi Zhuhong (1535–1615) advocated the destruction of images of heretical and "deceitful" deities, among which he probably included Christian figures, as the art historian Craig Clunas has documented. Zhuhong's enemy Matteo Ricci objected to the vulgar pictorial parodies by Chinese artists who depicted Portuguese men in Macao in feminized short tunics, twirling rosary beads and attending worship services with women.[48] To my knowledge, very few of these works of art have been identified.

By the middle years of the Kangxi emperor's reign, the porcelain manufactories at Jingdezhen, as well as those outside Canton, possessed a large number of Western prints, which they used as visual sources for ceramic decoration. A Chinese Imari-style plate in the Musée Guimet in Paris made in the late 1720s shows a European couple strolling in a garden—elegant, beautifully dressed, and well proportioned.[49] There seems to have been little interest in China, during these years at least, in parodic depictions of Westerners. There was a domestic market for occidentalizing porcelain, though most of it was produced for export to the West.[50] The presence of European artists in Beijing, especially the Jesuit Giuseppe Castiglione (called Lang Shining in China), also stirred Chinese interest in Western art and European bodies. The Qianlong emperor's portraits of his favorite mistress, the so-called Fragrant Concubine (possibly Rong Fei, 1734–1788), sometimes present her in a Western manner and sometimes in Western dress.[51] *The Fragrant Concubine as an Arcadian Shepherdess*, most likely dating from the 1750s and possibly executed by Castiglione or another European artist, depicts the Uighur imperial favorite seated in an idyllic garden, simply dressed and wearing a straw hat. Her right hand rests on the handle of a bas-

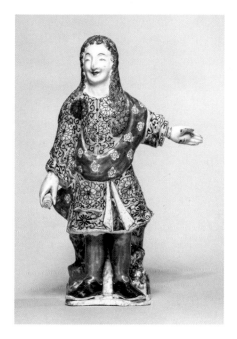

42. Anonymous, *Louis XIV, famille verte* porcelain, Jingdezhen production, early eighteenth century. Baltimore, Walters Art Gallery.

ket of flowers she has gathered, and in the other hand she holds an arcadian staff, an item found in numerous European portraits that is the main objec‑ tified attribute of an arcadian (as opposed to a real) shepherd. She gazes intently and unabashedly at the spectator, exuding elegance and secure in the knowledge of her privileged position at the Qianlong emperor's court.

The most remarkable adaptation of Western clothing and leisure activities to Chinese art, however, can be seen in an unprecedented series of portraits of the Yongzheng emperor dressed as a European monarch. An album in the Palace Museum in Beijing preserves fourteen leaves showing Yongzheng, var‑ iously costumed, engaged in different activities. As the art historian Wu Hung has argued, only the emperor could have commissioned them. No previous Chinese rulers had ever been depicted in such a manner, and it is likely that Qing curiosity about European masquerades in fancy dress was responsible

for the portraits, though to my knowledge no such entertainments have been documented at the Beijing court during this era. One of the portraits shows Yongzheng, holding a trident and confronting a tiger in a cave while wearing a big curly wig, a frock coat, and silk stockings. Another depicts him in a three-quarters view bust portrait, wearing an elaborate peruke and a casually tied cravat. After decades of image exchange between China and Europe, the Qing elite was probably familiar with European fancy-dress portraits.[52] Western artworks doubtless inspired the *famille verte* porcelain portrait of Louis XIV, produced at Jingdezhen early in the eighteenth century (figure 42). Yongzheng also had himself portrayed in the costume of a Buddhist monk and of a Mongol cavalryman, so the European guises were not the only ones represented in the series. The album illustrations' portrayal of the emperor as an individual precludes any gentle mockery or ridicule of European dress or, by extension, Europeans. Nonetheless, the portraits indicate an absence of malice toward the European body, in stark contrast to European visualizations of the Chinese during the Enlightenment.

Chinoiserie and the Chinese Body

Chinoiserie and the Enlightenment

Chinoiserie initially visualized China as an Edenic, luxurious, timeless, clement, and refined civilization, arguably Europe's equal in everything except religion. East Asian people, architecture, material culture, and scientific and technological achievements were represented admiringly, their exotic elements evocative and stimulating, not the pretext to visualize an alien, inferior Other. The increased knowledge of East Asia introduced by both Jesuits and merchants begged comparisons of East to West, and China entered into a range of European debates, including speculation about the earth's age, natural versus revealed religion, and meritocracy versus aristocratic governance, among others.[1] By the second quarter of the eighteenth century, favorable comparisons had become much less frequent, and by the early 1800s China's differences—social, racial, philosophical, economic— dominated Sinological discourse. Western religious and intellectual interests in East Asia were always strongest in the Roman Catholic countries, especially Italy, France, and parts of Germany, the British and the Dutch being keener to engage in commerce than in conversion. The discipline of Sinology was first developed and best promoted in Catholic scholarship. When the Kangxi, Yongzheng, and Qianlong emperors suppressed Christian

missionary activities in the Qing Empire in the 1720s and 1730s, in response to the papal condemnation of the Chinese rites, the West swiftly expressed its embittered response. Chinoiserie was only one arena in which the Catholic West transformed China into the decadent, effeminate despotism that dominated European thought for the next 150 years.

Despite the vindictive Western reaction to the imperial decision to quash conversion efforts and almost all missionary activities in the East, China made a considerable, though often unacknowledged, contribution to the Enlightenment. Intellectual and social critics of the privileges of birth in the appointment of officials of the state and Church knew that governmental preferment based on birth (except in the imperial family) was largely unknown in China, where examinations determined the occupants of almost all public offices. Many European reformers lamented the privileged position of the Catholic Church in state and society, aware that in China even the emperor allowed foreign missionaries to attempt to convert his subjects, religious tolerance being, for the most part, a necessity in so large and confessionally diverse an empire. Vaccination against smallpox, still controversial in Catholic Europe owing to the Church's opposition, had been commonplace in China for more than two centuries, as it had been in the Ottoman Empire. To progressives, European medicine seemed remarkably backward in comparison.

In the decades before proselytizing in China ended, Louis XIV established a census in his realm to quantify population, primarily as a means of increasing tax yields, an innovation in France but a long-practiced policy of the Chinese imperial administration. Both Louis XV and the Holy Roman Emperor Joseph II (reigned 1765–90) participated in an imperial Chinese vernal tradition of turning the first plow as a ritual act in support of a good harvest.[2] After the rejection of the "true" faith, however, what galled Catholic Europe more than anything else was that "China was the first example of a disciplined, rich, and powerful state which owed nothing to Christianity."[3]

For different reasons, both the Church and the Enlightenment rejected a paradigmatic China. Such an august and powerful entity outside European control simply could not be tolerated. The West's only recourse until the nineteenth century was largely limited to cultural and artistic denigration.

The artistic degradation of China is obvious in the visualization of the Chinese male body in chinoiserie. Despite copious sources of authentic Chinese imagery available in Europe in a variety of forms, the move from a normative depiction of Chinese men to the effeminate, weak, and mantis-like bodies seen in much eighteenth-century chinoiserie was partly a cultural response to the empire's rejection of Christianity. The fact that this change was a cultural and political one, as opposed to merely an aesthetic choice in direct opposition to Chinese ideas about the representation of masculinity, is suggested in an Englishman's journal entry. Henry Ellis, one of the commissioners who in 1816 accompanied the ill-fated Amherst embassy to the court of the Jiaqing emperor (reigned 1796–1820), noted during a visit to a Chinese temple (which he called a *miao*) that "the principal objects of adoration were two figures standing in a recess. . . . The male figures were short and thick; this may therefore be considered the Chinese standard of beauty, man being usually disposed to attribute his notions of perfection to the forms under which the Deity is portrayed."[4] There is no reason to suppose that Ellis's idea was novel to Europeans of his era; thus, it stands to reason that eighteenth- and early nineteenth-century Westerners deliberately distorted Chinese male bodies for their own purposes.

One of the many ironies of the Enlightenment was that it refused to accept the value of even the Chinese Empire's progressive achievements. In the anti-China philosophical discourse of the mid-eighteenth century, the Jesuits, long-standing champions of the East, were targets as easy as China itself. The necessity of discrediting the Society of Jesus and the obscurantist, antiprogressive ideas it supposedly promoted also made the degradation of China de rigueur. But even for those anticlericals who were uninterested in

the conversion of the Qing Empire, the trade imbalance with the East was seen as a threat to the financial stability of the Catholic monarchies and flew in the face of emerging physiocratic ideas on trade, commercial treaties, and the wealth of nations. In particular, the mania for collecting porcelain and lacquer, wearing Chinese silk, and drinking tea increasingly came to be associated with the power of women in the marketplace and in taste formation, and many believed that this development could only be detrimental to the body politic. The Enlightenment wished to promote a society of active male citizenry based on rationalism, self-sufficiency, and progress, ideas it struggled unsuccessfully to define. In the final analysis, an unassimilated, distant Asian empire had no place in the new world order of the Enlightenment.

INTRODUCTION

1. H. Belevitch-Stankevitch, *Le goût chinois en France au temps de Louis XIV* (orig. pub. Paris: Jouve, 1910; Geneva: Slatkine Reprints, 1970), 243–44.

2. Gottfried Wilhelm Leibniz, quoted in Jacques Gernet, *A History of Chinese Civilization*, 2nd ed., trans. J. R. Foster and Charles Hartman (Cambridge: Cambridge University Press, 1982), 523–24. See also David E. Mungello, *Leibniz and Confucianism: The Search for Accord* (Honolulu: University of Hawaii Press, 1977).

3. The original text reads: "Se di questo regno non si può dire che i filosofi sono Re, almeno con verità si dirà che i Re sono governati da filosofi." Quoted in Michela Fontana, *Matteo Ricci: Gesuita scienziato umanista in Cina* (Rome: De Luca Editori, 2010), 19.

4. The exceptionalist argument still found adherents in the first half of the eighteenth century, above all in Jean-Baptiste Du Halde, whose *Description de l'Empire de la Chine* was published in Paris in 1735. An English translation appeared in London in 1741. Although literary figures like Voltaire found much to admire in China, mostly as a positive foil for the shortcomings of ancien régime France, most shared Denis Diderot's more captious views. Voltaire addressed the Chinese Rites Controversy (discussed in detail in chapter 1) in his celebrated work *Le Siècle de Louis XIV* (1751), condemning the Church and castigating its

narrow-mindedness. A small group of philosophes and savants shared Voltaire's enthusiasm for China, notably Henri-Léonard Jean Baptiste Bertin (1720–1792), who was responsible both for funding, until his death, the continuing activities of the French Jesuits at the Beijing court and for financially supporting French authors who wrote about China in positive terms. Diderot's Sinophobia extended to both Chinese art and European chinoiserie. See Huguette Cohen, "Diderot and the Image of China in Eighteenth-Century France," *Studies on Voltaire and the Eighteenth Century* 242 (1986): 219–20. For Bertin's Sinophilia, collecting activities, and encouragement of trade with East Asia, see Constance Bienaimé and Patrick Michel, "Portrait du singulier Monsieur Bertin, ministre investi dans les affaires de la Chine," in *La Chine à Versailles: Art et diplomatie au XVIIIe siècle*, ed. Marie-Laure de Rochebrune, exhibition catalogue (Paris: Somogy Éditions d'Art, 2014), 151–57.

5. Nicholas Dew, *Orientalism in Louis XIV's France* (Oxford: Oxford University Press, 2009), 3–7.

6. The ramifications of this decrease in credibility have been examined in an English context by Stacey Sloboda, "Picturing China: William Alexander and the Visual Language of Chinoiserie," *British Art Journal* 9, no. 4 (2002): 28–36.

7. Paraphrased from Raymond Dawson, *The Chinese Chameleon: An Analysis of European Conceptions of Chinese Civilization* (London: Oxford University Press, 1967), 109–10. The author claims that the rise of chinoiserie was a European reaction to the formal aesthetic of classicism rather than the expression of a wish to engage Chinese art and civilization. Overwhelming evidence to the contrary suggests that such an assertion is erroneous. One of the fallacies of the discipline of art history is the notion that artistic choices alone are responsible for stylistic development, the underlying assumption of which is that artists live in isolation from the societies in which they live and work.

8. Hugh Honour, *Chinoiserie: The Vision of Cathay* (London: John Murray, 1962). Although in many ways dated, this publication is still useful for its examination of an impressive range of objects and places related to chinoiserie.

9. For a good introduction to the topic, see Wang Fang-yu, "Book Illustration in Late Ming and Early Qing China," in *Chinese Rare Books in American Collections,* ed. Sören Edgren, exhibition catalogue (New York: China Institute in America, 1985), 31–43, with additional bibliography.

1. Francesco Morena makes this important point in his *Chinoiserie: The Evolution of the Oriental Style in Italy from the 14th to the 19th Century,* trans. Eve Leckey (Florence: Centro Di, 2009), 18–21. The Yuan encouraged Nestorian Christians to move to China, and Roman Catholic slaves had been brought there after Mongol campaigns in Central Europe. See Nicolas Standaert, ed., *Handbook of Christianity in China,* vol. 1, *635–1800* (Leiden: Brill, 2001), 59–76.

2. Morena, *Chinoiserie,* 221–22. *China illustrata,* Father Athanasius Kircher's work of 1667, mentioned in the introduction, was the magisterial text in the Catholic world well into the eighteenth century.

3. D. E. Mungello, *The Great Encounter of China and the West, 1500–1800,* 2nd ed. (Lanham, MD: Rowman and Littlefield, 2005), 81–82. Jesuit missionaries benefited from the attitudes of many elite Chinese, who considered even those with "barbarian" origins civilized if they adopted traditional Chinese values and culture. This was one reason that Ricci and his brothers went to great pains to learn Chinese, to study Confucian texts, and generally to "blend in." Donning the silk garments of the literati and imperial officials (mandarins) was a visible compliment to Chinese traditions. See John D. Langlois, "Chinese Culturalism and the Yüan Analogy: Seventeenth-Century Perspectives," *Harvard Journal of Asiatic Studies* 40, no. 2 (1980): 364–65.

4. An example of negative press about China is Diego de Pantoja's *Relación de la entrada de algunos padres de la Compañía de Jesús en la China,* published in Seville in 1605. Pantoja was appalled by what he considered the immorality and rapacity of the court eunuchs, provincial administrators, and the military. His text, moreover, usefully documents Chinese interest in such papal gifts as clocks, maps, paintings, and other Western objects. Donald F. Lach and Edwin J. van Kley, *Asia in the Making of Europe* (Chicago: University of Chicago Press, 1993), 564–65.

5. Albert Chan, "Late Ming Society and the Jesuit Missionaries," in *East Meets West: The Jesuits in China, 1582–1773,* eds. Charles E. Ronan and Bonnie B. C. Oh (Chicago: Loyola University Press, 1988), 161–63. For a useful survey of the visual culture of the Jesuit missions in China, see Gauvin Alexander Bailey, *Art on the Jesuit Missions in Asia and Latin America, 1542–1773* (Toronto: University of Toronto Press, 1999), 82–111, with additional bibliography.

6. The Elector of Saxony's Chinese soapstone collection is examined in Maureen Cassidy-Geiger, "Changing Attitudes towards Ethnographic Material: Re-Discovering the Soapstone Collection of Augustus the Strong," *Abhandlungen und Berichte des Staatlichen Museums für Völkerkunde Dresden: Forschungsstelle* 48 (1994): 26–31, with illustrations. Augustus was also king of Poland.

7. Lach and Kley, *Asia in the Making of Europe*, 566–69. The widely influential Jesuit publications that ignore non-Confucian Chinese spirituality include Nicholas Trigault's *De christiana expeditione apud Sinas* (Concerning the Christian Mission to China) of 1615; *Imperio de la China*, published by Alvarez Semedo in 1642; and Martino Martini's 1655 volume *Novus atlas sinensis* (New Chinese Atlas), published in Amsterdam.

8. Julia B. Curtis, "Markets, Motifs, and Seventeenth-Century Porcelain from Jingdezhen," in *The Porcelains of Jingdezhen*, ed. Rosemary E. Scott (London: School of Oriental and African Studies, 1993), 123–32, with additional bibliography.

9. Jacques Gernet, "A propos des contacts entre la Chine et l'Europe aux XVIIe et XVIIIe siècles," *Acta Asiatica* 23, no. 1 (1972): 83–90.

10. See Standaert, *Handbook of Christianity*, 1:893–95.

11. Edwin J. V. Kley, "Europe's 'Discovery' of China and the Writing of World History," *American Historical Review* 76, no. 2 (1971): 362–64.

12. Arnold H. Rowbotham, "Jesuit Figurists and Eighteenth-Century Religion," *Journal of the History of Ideas* 17, no. 4 (1956): 478–85. Figurism is related to an idea of acculturation that glosses over cultural differences between two societies in order to stress commonalities. The ideas of one are "figured" in the other, if in different ways. For the broader European debate on historical dating and the flood of Noah, see C. P. E. Nothaft, "Noah's Calendar: The Chronology of the Flood Narrative and the History of Astronomy in Sixteenth- and Seventeenth-Century Scholarship," *Journal of the Warburg and Courtauld Institutes* 74 (2011): 191–211.

13. Kley, "Europe's 'Discovery' of China," 363–64.

14. Voltaire, quoted in ibid., 374–75.

15. Joseph Dehergne, "La mission de Pékin à la veille de la condemnation des rites: Études d'histoire missionnaire," *Neue Zeitschrift für Missionswissenschaft* 9 (1953): 91–95.

16. Fontana, *Matteo Ricci*, 17–19. Ricci's Chinese name was Li Madou.

17. Frederic Wakeman, *The Great Enterprise: The Manchu Reconstruction of Imperial Order in Seventeenth-Century China* (Berkeley: University of California Press, 1985), 2:1005–6.

18. Theodore E. Treutlein, "Jesuit Missions in China during the Last Years of K'ang-hsi," *Pacific Historical Review* 10, no. 4 (1941): 435–43.

19. The Jesuits encouraged the idea of a French trading expedition to China, believing that the display of consumer commodities would aid their efforts by demonstrating the advanced state of French civilization. The four-hundred-ton frigate *Amphitrite* went to trade in China in 1698, returning in 1700 with a cargo of furniture, porcelain, silk, paper, fans, painted screens, tea, and other goods. Sales in Nantes, Rouen, and Paris were brisk and profitable, but a second venture two years later was much less successful. Chinese trade in the context of rococo chinoiserie has been examined in Katie Scott, "Playing Games with Otherness: Watteau's Chinese Cabinet at the Château de la Muette," *Journal of the Warburg and Courtauld Institutes* 66 (2003): 189–248, with additional bibliography. I discuss Michael Shen Fuzong's visit to Europe in detail in chapter 3.

20. Gernet, *History of Chinese Civilization*, 490–91. Nerchinsk was followed in 1727 by another Sino-Russian treaty negotiated by the Yongzheng emperor, again with the invaluable assistance of Jesuit translators.

21. F. W. Mote, *Imperial China 900–1800*, 3rd ed. (Cambridge, MA: Harvard University Press, 2003), 874.

22. Liam Matthew Brockey, *Journey to the East: The Jesuit Mission to China, 1579–1724* (Cambridge, MA: Harvard University Press, 2007), 166–68.

23. Jonathan Spence, "The Seven Ages of K'ang-hsi [1654–1722]," *Journal of Asian Studies* 26, no. 2 (1967): 207–10.

24. A. D. Wright, *The Counter-Reformation: Catholic Europe and the Non-Christian World* (Aldershot, England: Ashgate, 2005), 120–22.

25. Joseph Brucker, "La mission de Chine de 1722 à 1735: Quelques pages de l'histoire des missionnaires français à Péking au XVIIIe siècle, d'après des documents inédits, par Joseph Brucker, S.J.," *Revue des questions historiques* 29 (April 1, 1881): 495–96. See also Isabelle Landry-Deron, "Les mathématiciens envoyés en Chine par Louis XIV en 1685," *Archive for History of Exact Sciences* 55, no. 5 (2001): 423–63.

26. Quoted in J. J. Heeren, "Father Bouvet's Picture of Emperor K'ang-hsi," *Asia Major* 7 1 (1932): 569-72.

27. Basil Guy, "'Ad majorem Societatis gloriam': Jesuit Perspectives on Chinese Mores in the Seventeenth and Eighteenth Centuries," in *Exoticism in the Enlightenment*, eds. G. S. Rousseau and Roy Porter (Manchester: Manchester University Press, 1990), 72-75. For same-sex practices in China, see especially Bret Hinsch, *Passions of the Cut Sleeve: The Male Homosexual Tradition in China* (Berkeley: University of California Press, 1990), with additional bibliography.

28. Standaert, *Handbook of Christianity*, 1:879-81. For a detailed investigation, see especially David E. Mungello, *Curious Land: Jesuit Accommodation and the Origins of Sinology* (Honolulu: University of Hawaii Press, 1989), with extensive bibliography.

29. George Minamiki, *The Chinese Rites Controversy from Its Beginning to Modern Times* (Chicago: Loyola University Press, 1985). For an overview, see Rodney L. Taylor, *The Religious Dimensions of Confucianism* (Albany: State University of New York Press, 1990).

30. Minamiki, *Chinese Rites Controversy*, 40-62, with additional bibliography.

31. Brockey, *Journey to the East*, 184-87.

32. The Portuguese authorities in Macao were only too eager to detain Tournon, resenting Clement XI's appointment of the legate as vicar apostolic without the approval of the Lisbon court. Francis A. Rouleau, "Maillard de Tournon, Papal Legate at the Court of Peking," *Archivium Historicum Societatis Jesu* 31 a (1962): 264-69.

33. John W. Witek, *Controversial Ideas in China and in Europe: A Biography of Jean-François Foucquet, S.J. (1665-1741)* (Rome: Institutum Historicum, 1982), 132-33. After the *piao* began to be enforced, some provincial missionary establishments were looted or burned, and Chinese converts faced increased persecution by the mandarins, whose hands had been stayed only by the Kangxi emperor's so-called Edict of Toleration. See Brucker, "Mission de Chine," 505-7.

34. Witek, *Controversial Ideas*, 221-26. Among those threatened with expulsion was Bernardino della Chiesa (1664-1721), a Venetian Franciscan who had been consecrated bishop of Beijing by Alexander VIII Ottoboni in 1690. The bishop did not sign the *piao* and died before he could be deported.

35. Wright, *Counter-Reformation*, 112–14.

36. Kangxi, quoted in Heeren, "Father Bouvet's Picture," 569.

37. For an introduction to the activities of missionary artists at the Qing court, see Harrie Vanderstappen, "Chinese Art and the Jesuits in Peking," in *East Meets West: The Jesuits in China, 1582–1773*, eds. Charles E. Ronan and Bonnie B. C. Oh (Chicago: Loyola University Press, 1988), 103–26. For a monographic study of Castiglione's career in Beijing, see Michèle Pirazzoli-T'Serstevens, *Giuseppe Castiglione, 1688–1766: Peintre et architecte à la cour de Chine* (Paris: Thalia Edition, 2007), with additional bibliography.

38. Brockey, *Journey to the East*, 165.

39. Gernet, *History of Chinese Civilization*, 518–21. Alexandre Metello de Sousa (1687–1766), sent by King John V, led the Portuguese embassy of 1727, which had come to ask the emperor to abandon or at least to modify his anti-Christian policies. He was received as a tributary and exempted from performing the koutou, a remarkable imperial concession, but the court Jesuits persuaded him not to bring up religious issues that might make their situation even more difficult. He was able to obtain only a bit of good will for Portuguese trading interests, thereby earning the thanks of Benedict XIII, who was engaged at that time in negotiations with the Portuguese court that ultimately failed to repair the strained relations between Rome and Lisbon that had prevailed under Clement XI. See John E. Wills, *Embassies and Illusions: Dutch and Portuguese Envoys to K'ang-hsi, 1666–1687* (Cambridge, MA: Harvard University Press, 1984), 182–83.

40. For the Kangxi emperor's involvement with Tibetan Buddhism, see Natalie Köhle, "Why Did the Kangxi Emperor Go to Wutai Shan? Patronage, Pilgrimage, and the Place of Tibetan Buddhism at the Early Qing Court," *Late Imperial China* 29, no. 1 (2008): 73–119.

41. Scott, "Playing Games with Otherness," 227–28. I am indebted to Professor Scott's discussion of Watteau's chinoiserie and owe much of my thinking on the subject to her discerning analysis.

CHAPTER 2

1. Francesco Morena, *Chinoiserie: The Evolution of the Oriental Style in Italy from the 14th to the 19th Century*, trans. Eve Leckey (Florence: Centro Di, 2009), 23–24.

2. These examples are discussed in William R. Sargent, "Asia in Europe: Chinese Paintings for the West," in *Encounters: The Meeting of Asia and Europe, 1500–1800*, eds. Anna Jackson and Amin Jaffer, exhibition catalogue (London: Victoria and Albert Museum, 2004), 274–76.

3. Morena, *Chinoiserie*, 221.

4. See Rose Kerr, "Asia in Europe: Porcelain and Enamel for the West," in *Encounters: The Meeting of Asia and Europe, 1500–1800*, eds. Anna Jackson and Amin Jaffer, exhibition catalogue (London: Victoria and Albert Museum, 2004), 222–31.

5. Rosemary E. Scott, "Jesuit Missionaries and the Porcelains of Jingdezhen," in *The Porcelains of Jingdezhen*, ed. Rosemary E. Scott (London: School of Oriental and African Studies, 1993), 233–36.

6. Thomas DaCosta Kaufmann, "Interpreting Cultural Transfer and the Consequences of Markets and Exchange: Reconsidering 'Fumi-e,'" in *Artistic and Cultural Exchanges between Europe and Asia, 1400–1900*, ed. Michael North (Farnham, England: Ashgate, 2010), 138–40. I have benefited greatly from Kauffman's ideas on cultural exchange in an early modern context.

7. Christiaan J. A. Jörg, "Chinese Porcelain for the Dutch Seventeenth Century: Trading Networks and Private Enterprise," in *The Porcelains of Jingdezhen*, ed. Rosemary E. Scott (London: School of Oriental and African Studies, 1993), 194–96. Jörg's invaluable research is based on a magisterial command of the documentary records of the Dutch East India Company.

8. Christiaan J. A, Jörg, *Porcelain and the Dutch China Trade* (The Hague: Martinus Nijhoff, 1982), 148–49.

9. F. W. Mote, *Imperial China 900–1800*, 3rd ed. (Cambridge, MA: Harvard University Press, 2003), 954–55; and Frederic Wakeman, *Great Enterprise: The Manchu Reconstruction of Imperial Order in Seventeenth-Century China*, 2 vols. (Berkeley: University of California Press, 1985), 2:1–8.

10. C. R. Boxer, "Notes on Chinese Abroad in the Late Ming and Early Manchu Periods Compiled from Contemporary European Sources (1500-1750)," *Tien Hsia Monthly* 5 (May 1939): 459–60. An English version of Careri's travel memoir was published in London in 1744 as *A Voyage around the World*.

11. H. Belevitch-Stankevitch, *Le goût chinois en France au temps de Louis XIV*, (Paris: Jouve, 1910; Geneva: Slatkine Reprints, 1970), 29–48.

12. Belevitch-Stankevitch, *Le goût chinois*, 51–71.

13. Philippe Haudrère, et al., *La soie et le canon: France-Chine 1700–1860*, exhibition catalogue (Nantes: Gallimard, 2010), 50–52, with additional bibliography.

14. The text of the East India official (possibly Charles Frederick Noble) is quoted in Sarah Richards, *Eighteenth-Century Ceramics: Products for a Civilised Society* (Manchester: Manchester University Press, 1999), 177–79. The text's editor was J. S. Stavorinus, who was still a child in 1747. For commercial activities in South China during the eighteenth century, see Paul A. Van Dyke, *Merchants of Canton and Macao: Politics and Strategies in Eighteenth-Century Chinese Trade* (Hong Kong: Hong Kong University Press, 2011).

15. For a perceptive discussion of Chinese interest in Westernizing objects produced in China as an alternative to importing actual European objects, see Kristina Kleutghen, "Chinese Occidenterie: The Diversity of 'Western' Objects in Eighteenth-Century China," *Eighteenth-Century Studies* 47, no. 2 (2014): 117–35, with additional bibliography.

16. Michael Sullivan, *The Meeting of Eastern and Western Art* (London: Thames and Hudson, 1973), 92–93. Manfredo Settala (1600–1680), a Lombard *amateur*, also owned several Chinese paintings.

17. See Stacey Pierson, *Chinese Ceramics* (London: Victoria and Albert Museum, 2009), 68–73.

18. Germano Coccolino, *Incontro con le porcellane cinesi di epoca Ch'ing prodotte dai laboratori imperiali e dai forni privati dal periodo K'ang Hsi all'epoca della Repubblica* (Pinerolo, Italy: Alzani Editore, 1998), 33–35.

19. Maureen Cassidy-Geiger, *The Arnhold Collection of Meissen Porcelain, 1710–50* (New York: Frick Collection, 2008), 718.

20. Cassidy-Geiger, *The Arnhold Collection*, 198–99.

21. Susan Miller, "Jean-Antoine Fraisse at Chantilly," *East Asian Library Journal* 9, no. 1 (2000): 80–83. Fraisse's designs influenced the redefinition of midcentury chinoiserie's decorative vocabulary. In actual decoration, as Fraisse moved away from the naturalism of the many East Asian images he had studied, he widened the gap that had existed in earlier periods between Asian art and chinoiserie.

22. Wang Fang-yu, "Book Illustration in Late Ming and Early Qing China," in *Chinese Rare Books in American Collections*, ed. Sören Edgren, exhibition catalogue (New York: China Institute in America, 1985), 31. Like later Ming art, Ming

literature also flourished. Novels, plays, and short stories fueled an explosion in theatrical productions, especially in Nanjing, the most important city in southern China. Most of those texts were illustrated. The approximately 125 plays (not to mention novels) published under the Ming included more than 1,750 woodblock illustrations. Because these often occupied a full page—illustrations in other publications were usually small marginalia—Western artists were easily able to use them as source material.

23. Denis Diderot, *Encyclopédie*, 9:861-62, as quoted in Daniëlle Kisluk-Grosheide, "The Reign of Magots and Pagods," *Metropolitan Museum Journal* 37 (2002): 195-96n40..

24. Tamara Préaud, "Récherches sur les sources iconographiques utilisées par les décorateurs de porcelaine de Vincennes (1740-1756)," *Bulletin de la société de l'histoire de l'art français* (1989): 105.

25. See Oliver Impey, *Chinoiserie: The Impact of Oriental Styles on Western Art and Decoration* (New York: Charles Scribner's Sons, 1977), 78-82.

26. Sullivan, *Meeting of Eastern and Western Art*, 93-94.

27. Maureen Cassidy-Geiger, "From Rome to Beijing: A 1719 Document of Musical and Other Papal Gifts to China," *Studies in the Decorative Arts* 15, no. 1 (2007-8): 178-79. Ghezzi was paid 100 *scudi* for Clement's portrait, the relatively modest sum being a good indication that it was a studio copy. The Vanstripo clock cost 120 *scudi*, and Vanni's birds on paper were acquired for 26 *scudi*. Hamerani's casket, which may have been commissioned for the occasion, was priced at 157 *scudi*. The chocolate cost almost 200 *scudi*.

28. Cassidy-Geiger, "From Rome to Beijing," 179-80. In 1610 Matteo Ricci presented a clavichord to the Wanli emperor.

29. Morena, *Chinoiserie*, 224. See also John W. Witek, "Sent to Lisbon, Paris, and Rome: Jesuit Envoys of the Kangxi Emperor," in *La missione cattolica in Cina tra i secoli XVIII-XIX: Matteo Ripa e il Collegio dei Cinesi*, eds. Michele Fatica and Francesco D'Arelli (Naples: Istituto Universitario Orientale, 1999), 338-40.

30. The original text reads as follows: "avendo accomodato questa galleria di Monte Cavallo [in the Quirinal Palace] con tali vasi di porcellana che non é principe che ne abbia altrettanto," in *Frammenti di lettere inedite di Benedetto XIV pubblicate per le nozze Gabotto-Abrate*, ed. Beniamino Manzone (Brà: Tipografia Stefano Rocca, 1890), 15-16.

31. Alessandra Ghidoli, "Manifattura cinese," in *Il Settecento a Roma*, eds. Anna Lo Bianco and Angela Negro, exhibition catalogue (Milan: Silvana Editoriale, 2005), 276–77.

32. The original text reads "oltre le galanterie Chinesi, ed altre rarità." Francesco de' Ficoroni, *Le vestigia e rarità di Roma antica ricercate, e spiegate: Le singolarità di Roma moderna ricercate, e spiegate* (Rome: Girolamo Mainardi, 1744), 2:59.

33. Benedict XIV–Filippo Maria Mazzi correspondence, MS 4331, 5: fol. 65 recto, May 13, 1750. Bologna: Archivio Storico Biblioteca Universitaria.

34. Adolfo Tamburello, "Per un recupero conoscitivo e patrimoniale delle opere, doni e lasciti di Matteo Ripa e del Collegio dei Cinesi," in *La missione cattolica in Cina tra i secoli XVIII-XIX: Matteo Ripa e il Collegio dei Cinesi*, eds. Michele Fatica and Francesco D'Arelli (Naples: Istituto Universitario Orientali, 1999), 40–56.

35. I thank Maureen Cassidy-Geiger for these archival references, which she recovered in the Staatsarchiv in Dresden. The inventory is in French. See also Ellana Fileri, "Il Cardinale Filippo Antonio Gualtieri (1660–1728): Collezionista e scienziato," in *I Cardinali di Santa Romana Chiesa collezionisti e mecenati*, ed. Marco Gallo (Rome: Edizioni dell'Associazione Culturale Shakespeare and Company, 2001), 2:37–47, with additional bibliography.

36. Giancarlo Altieri, "Gaspare Carpegna, un cardinale 'numismatico,'" in Gallo, *I Cardinali di Santa Romana Chiesa collezionisti e mecenati*, ed. Marco Gallo (Rome: Edizioni dell'Associazione Culturale Shakespeare and Company, 2001), 5:23–24.

37. Morena, *Chinoiserie*, 224–25. Emmanuel Pereira de Sampajo, the Portuguese ambassador to the Holy See, also displayed a large collection of Asian porcelain, lacquer furniture, and other Chinese works of art in his Roman palace. For chinoiserie in northern Italy as a lingua franca of aristocratic society during the ancien régime, see Christopher M. S. Johns, "Chinoiserie in Piedmont: An International Language of Diplomacy and Modernity," in *Torino Britannica: Political and Cultural Crossroads in the Age of the Grand Tour*, eds. Karin E. Wolfe and Paola Bianchi (Cambridge: Cambridge University Press and the British School at Rome, in press).

38. Morena, *Chinoiserie*, 225–26. For Pierre's activities at the French Academy in Rome, see Nicolas Lesur and Olivier Aaron, *Jean-Baptiste Marie Pierre,*

1714-1789: Premier Peintre du Roi (Paris: Arthena, 2008), 24–38. For Vien's Roman turqueries, see Thomas Gaehtgens and Jacques Lugand, *Joseph-Marie Vien, 1716-1809: Peintre du Roi* (Paris: Arthena, 1988), 281–84, and especially Perrin Stein, "Diplomacy, Patronage, and Pedagogy: Etching in the Eternal City," in *Artists and Amateurs: Etching in 18th-Century France*, ed. Perrin Stein, exhibition catalogue (New York: Metropolitan Museum of Art, 2013), 115–20. Vien's prints of his fellow artists in exotic dress include several Turkish men in elaborate costumes, often with swords.

39. Quoted and translated in Gaehtgens and Lugand, *Joseph-Marie Vien*, 226–27.

40. Haudrère et al., *La soie et le canon*, 26–29. Mendoza, an Augustinian monk stationed in Manila, used the testimony of missionaries who had served in China as the source material for his book. Pope Gregory XIII Buoncompagni ordered him to publish the text and paid the costs. For a selection of publications on China available in France during the seventeenth century, see especially Isabelle Landry-Deron, "L'information ancienne sur la Chine," in *La Chine à Versailles: Art et diplomatie au XVIIIe siècle*, ed. Marie-Laure de Rochebrune, exhibition catalogue (Paris: Somogy Éditions d'Art, 2014), 86–93.

41. Theodore Nicholas Foss, "The European Sojourn of Philippe Couplet and Michael Shen Fuzong, 1683–1692," in *Philippe Couplet, S.J. (1623-1693): The Man Who Brought China to Europe*, ed. Jerome Heyndrickx (Nettetal, Germany: Steyler Verlag, 1990), 127–31. The cities Couplet visited on his tour to promote the China mission included Louvain, Ghent, Bruges, Dendermonde, Mechelen (Malines), Brussels, and Paris.

42. J. J. Heeren, "Father Bouvet's Picture of Emperor K'ang-hsi," *Asia Major* 7 (1932): 557–59. From 1708 to 1715 Bouvet was engaged with other Jesuits in a cartographical survey of the Qing Empire.

43. Nicholas Dew, *Orientalism in Louis XIV's France* (Oxford: Oxford University Press, 2009), 207–13. Rougemont, who translated the catechism into Chinese, was a close friend of the famous artist Wu Li, a convert to Catholicism who joined the Jesuit order and performed missionary work in southern China.

44. See Belevitch-Stankevitch, *Le goût chinois*, 174–80.

45. Hugh Honour, *Chinoiserie: The Vision of Cathay* (London: John Murray, 1962), 53–56; the quotation is from 56.

46. See Belevitch-Stankevitch, *Le goût chinois*, 99–112.

47. For an analysis of the illustrations in Nieuhof's text and their importance to the development of chinoiserie in Holland and elsewhere, see especially Dawn Odell, "The Soul of Transactions: Illustration and Johan Nieuhof's Travels to China," in *"Tweelinge eener dragt": Woord en beeld in de Nederlanden (1500–1750)*, eds. Karel Bostoen, Elmer Kolfin, and Paul J. Smith, special printing of *De Seventiende Eeuw* (The Seventeenth Century) 12, no. 3 (2001): 225–42 (Hilversum, Holland: Uitgeverij Verloren, 2001). I thank Professor Odell for providing me with a copy of this informative text. For the duc du Maine's support for the Jesuits in China, see Nathalie Monnet, "Le jeune duc du Maine, protecteur des premières missions françaises en Chine," in *La Chine à Versailles: Art et diplomatie au XVIIIe siècle*, ed. Marie-Laure de Rochebrune, exhibition catalogue (Paris: Somogy Éditions d'Art, 2014), 36 43.

48. See Charissa Bremer-David, *French Tapestries and Textiles in the J. Paul Getty Museum* (Los Angeles: J. Paul Getty Museum, 1997), 90.

49. See Belevitch-Stankevitch, *Le goût chinois*, 170–72.

50. Katie Scott, "Playing Games with Otherness: Watteau's Chinese Cabinet at the Château de la Muette," *Journal of the Warburg and Courtauld Institutes* 66 (2003): 233–34.

51. Scott, "Playing Games with Otherness," 234–36.

52. See Belevitch-Stankevitch, *Le goût chinois*, 141–43.

53. Belevitch-Stankevitch, *Le goût chinois*, 149. The French text reads: "Il y en avait d'amirables par leurs figures . . . et par la diversité de leurs couleurs. Les plus rares étaient montées d'or ou de vermeil doré et garnies diversement de la même matière en plusieurs endroits."

54. Belevitch-Stankevitch, *Le goût chinois*, 81–94. For a group of seven blue-and-white porcelain vessels similar to those in the collection of the Grand Dauphin, with color illustrations, see Stéphane Castelluccio, "Sept vases de Chine en bleu et blanc, equivalents des pièces figurant dans les collections du Grand Dauphin," in *La Chine à Versailles: Art et diplomatie au XVIIIe siècle*, ed. Marie-Laure de Rochebrune, exhibition catalogue (Paris: Somogy Éditions d'Art, 2014), 72–73.

55. Michael E. Yonan, "Igneous Architecture: Porcelain, Natural Philosophy, and the Rococo 'cabinet chinois,'" in *The Cultural Aesthetics of Eighteenth-Century Porcelain*, eds. Alden Cavanaugh and Michael E. Yonan (Farnham, England: Ashgate, 2010), 77–78.

1. Rosemary Crill, "European Depictions of Asians," in *Encounters: The Meeting of Asia and Europe, 1500–1800*, eds. Anna Jackson and Amin Jaffer, exhibition catalogue (London: Victoria and Albert Museum, 2004), 218–19.

2. J. J. Heeren, "Father Bouvet's Picture of Emperor K'ang-hsi," *Asia Major* 7 1 (1932): 560–63.

3. See H. Belevitch-Stankevich, *Le goût chinois en France au temps de Louis XIV* (Paris: Jouve, 1910; Geneva: Slatkine Reprints, 1970), 226–30.

4. Richard Vinograd, *Boundaries of the Self: Chinese Portraits, 1600–1900* (Cambridge: Cambridge University Press, 1992), 1–9, with additional bibliography; for the passages quoted, see 1 and 6.

5. Jan Stuart, "The Face in Life and Death: Mimesis and Chinese Ancestor Portraits," in *Body and Face in Chinese Visual Culture*, eds. Wu Hung and Katherine R. Tsiang (Cambridge, MA: Harvard University Press, 2005), 206–8. The Ming preference for frontal iconic portraiture was inspired in part by traditional Chinese imperial imagery. It was also promoted by an increasing tendency to consider one's ancestors semidivine. The intuition that such was the case helped solidify Christian opposition to the Chinese rites and their associated images.

6. Stuart, "The Face in Life and Death," 209.

7. Patrizia Carioti and Lucia Caterina, *La via della porcellana: La Compagnia Olandese delle Indie Orientali e la Cina* (Trent: Centro Studi Martino Martini, 2010), 108. Dutch merchants, confined to the island of Taiwan, would have looked favorably on the Qing suppression of piracy in the South China Sea. This circumstance may have prompted Dapper's inclusion of the Ming pirates in the portrait of the Kangxi emperor (see figure 28a).

8. Carioti and Caterina, *La via della porcellana*, 98.

9. Donald F. Lach and Edwin J. van Kley, *Asia in the Making of Europe* (Chicago: University of Chicago Press, 1993), 1619–21.

10. Stephen Little, "Chinese Porcelains of the Chongzhen Period (1628–1644)," *Oriental Art* 29, no. 2 (1983): 160–61. Despite a number of innovations in early seventeenth-century porcelain production at Jingdezhen, its manufacture for the domestic market declined notably—largely because of political uncertainties and a crippling decrease in court patronage—and the export of porcelain to Europe became a more important concern.

11. Stephen Little, *Chinese Ceramics of the Transitional Period: 1620-1683*, exhibition catalogue (New York: China Institute in America, 1983), 56-57.

12. Margaret Medley, "Artistic Innovation in a Conservative Craft: Seventeenth-Century Chinese Porcelain," *Arts of Asia* 16 (July–Aug. 1986): 58-68, with additional bibliography. *Famille verte*, "green family" from French, is a designation of Chinese porcelain painted in a color range that includes blue, red, purple, and green. It was especially popular during the Kangxi reign.

13. Little, *Chinese Ceramics*, 112-13.

14. Theodore Nicholas Foss, "The European Sojourn of Philippe Couplet and Michael Shen Fuzong, 1683-1692," in *Philippe Couplet, S.J. (1623-1693): The Man Who Brought China to Europe*, ed. Jerome Heyndrickx (Nettetal, Germany: Steyler Verlag, 1990), 121-24. Shen, the son of a prosperous merchant convert from Nanjing, was in his mid-twenties during his time in Europe. Couplet and Shen brought numerous gifts with them from China, including embroidered altar linens sewn by the prominent female convert Candida Xu (1607-1680), who made them as a present for Couplet's parish church in the city of Mechelen, in Flanders.

15. Foss, "European Sojourn," 136-39.

16. Ann Waltner, "Demerits and Deadly Sins: Jesuit Moral Tracts in Late Ming China," in *Implicit Understandings: Observing, Reporting, and Reflecting on the Encounters between Europeans and Other Peoples in the Early Modern Era*, ed. Stuart B. Schwartz (Cambridge: Cambridge University Press, 1994), 434-35, with additional bibliography.

17. Michael R. Godley, "The End of the Queue: Hair as Symbol in Chinese History," *East Asian History* 8 (Dec. 1994): 60-66.

18. Matteo Ricci, quoted in Willard J. Peterson, "What to Wear? Observation and Participation by Jesuit Missionaries in Late Ming Society," in *Implicit Understandings: Observing, Reporting, and Reflecting on the Encounters between Europeans and Other Peoples in the Early Modern Era*, ed. Stuart B. Schwartz (Cambridge: Cambridge University Press, 1994), 404-5, with additional bibliography. The Jesuit missionaries led by Matteo Ricci, wishing to wear clothing that would signify holy status to the Chinese, initially adopted the garb of Buddhist monks as the closest approximation to clerical garb. After a few years, however, they changed to dark silk robes and hats like those worn by mandarins, merchants, and literati, finally understanding that a sartorial association with Chinese elites would

do more to further their goal of conversion from above, Buddhism at that time being widely associated with the peasantry and the urban poor.

19. Madeleine Jarry, *Chinoiserie: Chinese Influence on European Decorative Art, 17th and 18th Centuries* (New York: Vendome Press, 1981), 104–7. The Chinese sources Höroldt consulted in designing chinoiserie for Meissen porcelain are examined by Maureen Cassidy-Geiger, "Gestochene Quellen für frühe Höroldt-Malereien," *Keramos* 161 (1998): 3–38; and Cassidy-Geiger, "Graphic Sources for Meissen Porcelain: Origins of the Print Collection in the Meissen Archives," *Metropolitan Museum Journal* 31 (1996): 99–126, both with copious bibliography.

20. See Ulrich Pietsch, *Early Meissen Porcelain: The Wark Collection from the Cummer Museum of Art and Gardens*, exhibition catalogue (Jacksonville, FL: Cummer Museum of Art and Gardens, 2011), 150.

21. The tureen cover is illustrated in color in Pietsch, *Early Meissen Porcelain*, 157.

22. Steven Parissien, "European Fantasies of Asia," in *Encounters: The Meeting of Asia and Europe, 1500–1800*, eds. Anna Jackson and Amin Jaffer, exhibition catalogue (London: Victoria and Albert Museum, 2004), 350–53; the quotations are from 350 and 352.

23. Parissien, "European Fantasies," 353.

24. Huguette Cohen, "Diderot and the Image of China in Eighteenth-Century France," *Studies on Voltaire and the Eighteenth Century* 242 (1986): 224. An exception to Diderot's pronounced Sinophobia was his qualified admiration of Confucian morality.

25. Philippe Haudrière et al., *La soie et le canon: France-Chine 1700–1860*, exhibition catalogue (Nantes: Gallimard, 2010), 159. *The Astronomers* is one of six tapestries from the series produced between 1697 and 1705 for Louis-Alexandre de Bourbon, comte de Toulouse (1678–1737), preserved in the J. Paul Getty Museum. The other scenes are *The Collation*, showing the imperial couple enjoying a repast out of doors; *Gathering Pineapples*, showcasing an exotic fruit found increasingly on the dining tables of the European elite; *The Emperor's Progress; Return from the Hunt*, a favorite elite subject of Western audiences; and *The Empress at Tea*. For the Getty tapestries, see especially Charissa Bremer-David, *French Tapestries and Textiles in the J. Paul Getty Museum* (Los Angeles: J. Paul Getty Museum, 1997), 80–84, with additional bibliography. See also Joanna Waley-

Cohen, *The Sextants of Beijing: Global Currents in Chinese History* (New York: W. W. Norton, 1999), especially chaps. 2 and 3.

26. Jarry, *Chinoiserie*, 15–16.

27. Edith A. Standen, "The Story of the Emperor of China: A Beauvais Tapestry Series," *Metropolitan Museum Journal* 11 (1976): 115–16. Vernansal exhibited paintings at the Salons of 1699 and 1704.

28. Standen, "The Story of the Emperor," 103–4.

29. Jarry, *Chinoiserie*, 20–21. The white amber necklace the emperor wears recalls Nieuhof's claim that such objects were reserved for the most exalted members of the court, yet another indication that the iconography of the tapestry set was crafted to underscore its authenticity, a strategy deeply at variance with the conception of the second set, designed by Boucher in the 1740s.

30. Perrin Stein, "Boucher's Chinoiseries: Some New Sources," *Burlington Magazine* 138, no. 1122 (September 1996): 598–604, with additional bibliography. I am deeply grateful to Dr. Stein for sharing her ideas about French rococo chinoiserie and for generously allowing me to consult some of her unpublished work. Arnoldus Montanus's magisterial *Atlas Chinensis* of 1671, published in London, includes engraved illustrations that many Western artists used.

31. Jarry, *Chinoiserie*, 26–32.

32. Michael Sullivan, *The Meeting of Eastern and Western Art* (London: Thames and Hudson, 1973), 66–68.

33. *Magots* and pagods, which increasingly emerged as distinct types in the Enlightenment era, are examined in Daniëlle Kisluk-Grosheide, "The Reign of Magots and Pagods," *Metropolitan Museum Journal* 37 (2002): 177–97, with additional bibliography.

34. Kisluk-Grosheide, "The Reign of Magots and Pagods," 180–82.

35. The drawing is discussed in Jacob Bean, *15th–18th Century French Drawings in the Metropolitan Museum of Art* (New York: Metropolitan Museum of Art, 1986), 36.

36. Perrin Stein makes this important point in an unpublished manuscript.

37. The Huet decorations have been studied in the lavishly illustrated book by Nicole Garnier-Pelle, Anne Forray-Carlier, and Marie-Christine Anselm, *The Monkeys of Christophe Huet: Singeries in French Decorative Arts*, trans. Sharon Grenet (Saint-Rémy-en-l'Eau: Éditions Monelle Hayot, 2010; Los Angeles: J. Paul Getty Museum, 2011), 97–111.

38. See Maria Gordon-Smith, *Pillement* (Kracόw: IRSA, 2006), 281–87, with additional bibliography.

39. See Belevitch-Stankevitch, *Le goût chinois*, 247–50. For Jullienne's activities as an art collector and patron of engravers, see Christoph Martin Vogtherr and Jennifer Tonkovich, eds., *Jean de Jullienne: Collector and Connoisseur*, exhibition catalogue (London: Paul Holberton, 2011).

40. Katie Scott, "Playing Games with Otherness: Watteau's Chinese Cabinet at the Château de la Muette," *Journal of the Warburg and Courtauld Institutes* 66 (2003): 212–15.

41. Scott, "Playing Games with Otherness," 226. Scott's distinction between raillery and ridicule in the context of the chinoiseries at La Muette is crucial to my reading of the imagery.

42. Stein, "Boucher's Chinoiseries," 598–99, with additional bibliography.

43. Stein, unpublished manuscript.

44. Stein, unpublished manuscript.

45. Lach and Kley, *Asia in the Making of Europe*, 1599–1602.

46. Cohen, "Diderot and the Image of China," 230.

47. Honour, *Chinoiserie*, 94–95, with additional illustrations.

48. Craig Clunas discusses these images in his book *Pictures and Visuality in Early Modern China* (Princeton, NJ: Princeton University Press, 1997), 149–52, with additional bibliography.

49. Haudrère et al., *La soie et le canon*, 140. It may be no accident that some of the best examples of Chinese Occidentalizing porcelain are preserved in the imperial collections.

50. Rosemary E. Scott, "Jesuit Missionaries and the Porcelains," in *The Porcelains of Jingdezhen*, ed. Rosemary E. Scott (London: School of Oriental and African Studies, 1993), 252–53. The author argues convincingly that such objects indicate imperial enthusiasm for Western arcadian images.

51. The Fragrant Concubine was supposedly a Uighur noblewoman, presented to the Qianlong emperor by her father, a Qing military vassal ally. Legend has it that her skin exuded a sweet smell, possibly from drinking aromatic teas. For more information on the Fragrant Concubine, see James A. Millward, "A Uyghur Muslim in Qianlong's Court: The Meanings of the Fragrant Concubine," *Journal of Asian Studies* 53, no. 2 (1994): 427–58.

52. Wu Hung, "Emperor's Masquerade: Costume Portraits of Yongzheng and Qianlong," *Orientations* 26 (1995): 30–34.

CONCLUSION

1. Nicolas Standaert, ed., *Handbook of Christianity in China*, vol. 1, *635–1800* (Leiden: Brill, 2001), 1:881–82.

2. See David E. Mungello, *The Great Encounter of China and the West, 1500–1800* (Lanham, MD: Rowman and Littlefield, 2005), 101–2.

3. Jacques Gernet, *A History of Chinese Civilization*, 2nd ed., trans. J. R. Foster and Charles Hartman (Cambridge: Cambridge University Press, 1982), 524–26.

4. In 1815, William Amherst, 1st Earl Amherst (1773–1857), was named Ambassador Extraordinary to China by George, Prince Regent of Great Britain. The following year, Amherst led an embassy to the Jiaqing emperor, hoping for trade concessions for British merchants in the Qing empire and petitioning the Chinese court for some diplomatic concessions. The Amherst embassy was a follow-up to the unsuccessful attempt made by the British government in 1792, when an embassy headed by George Macartney, 1st Earl Macartney (1737–1806), was sent to the Qianlong emperor (Jiaqing's father) with a similar agenda. Although Macartney was politely received, Qianlong refused all his requests. Because of Lord Amherst's refusal to perform the ceremonial koutou, he was denied an imperial audience and sent back to Canton, from whence he returned to England. During the journey to and from Beijing, one of Amherst's party, Henry Ellis, kept a detailed journal that is an invaluable source of information about China and Western reactions to it in the early nineteenth century. Because Ellis had copies of several of the journals published by members of the Macartney embassy, it may be argued that some of his prejudices were based on their accounts. To read the entire passage from which the quotation is drawn, see Henry Ellis, *Journal of the Proceedings of the Late Embassy to China; Comprising a Correct Narrative of the Public Transactions of the Embassy, of the Voyage to and from China, and of the Journey from the Mouth of the Pei-Ho to the Return to Canton, interspersed with Observations upon the Face of the Country, the Polity, Moral Character, and Manners of the Chinese Nation* (London: John Murray, 1817; reprint edition Wilmington, DE: Scholarly Resources, 1973), p. 164.

Altieri, Giancarlo. "Gaspare Carpegna, un cardinale 'numismatico'." In *I Cardinali di Santa Romana Chiesa collezionisti e mecenati*, edited by Marco Gallo. 6 vols, 5:4–24. Rome: Edizioni dell'Associazione Culturale Shakespeare and Company, 2001.

Bailey, Gauvin Alexander. *Art on the Jesuit Missions in Asia and Latin America, 1542–1773*. Toronto: University of Toronto Press, 1999.

———. "Religious Encounters: Christianity in Asia." In *Encounters: The Meeting of Asia and Europe, 1500–1800*, edited by Anna Jackson and Amin Jaffer, 102–23. London: Victoria and Albert Museum, 2004. Exhibition catalogue.

Bartholomew, Terese Tse. *Hidden Meanings in Chinese Art*. San Francisco: Asian Art Museum, 2006.

Bastien, Vincent. "Le goût de la famille royale pour les pièces à décor chinois de la manufacture de Sèvres." In *La Chine à Versailles: Art et diplomatie au XVIIIe siècle*, edited by Marie-Laure de Rochebrune, 224–33. Paris: Somogy Éditions d'Art, 2014. Exhibition catalogue.

Bean, Jacob. *15th–18th Century French Drawings in the Metropolitan Museum of Art*. New York: Metropolitan Museum of Art, 1986.

Belevitch-Stankevitch, H. *Le goût chinois en France au temps de Louis XIV*. Originally published in Paris: Jouve, 1910. Geneva: Slatkine Reprints, 1970.

Bienaimé, Constance, and Patrick Michel. "Portrait du singulier Monsieur Bertin, ministre investi dans les affairs de la Chine." In *La Chine à Versailles: Art et diplomatie au XVIIIe siècle,* edited by Marie-Laure de Rochebrune, 150–57. Paris: Somogy Éditions d'Art, 2014. Exhibition catalogue.

Boxer, Charles R. "Notes on Chinese Abroad in the Late Ming and Early Manchu Periods Compiled from Contemporary European Sources (1500–1750)." *Tien Hsia Monthly* 5 (1939): 447–68.

Bremer-David, Charissa. *French Tapestries and Textiles in the J. Paul Getty Museum.* Los Angeles: J. Paul Getty Museum, 1997.

Brockey, Liam Matthew. *Journey to the East: The Jesuit Mission to China, 1579–1724.* Cambridge, MA: Harvard University Press, 2007.

Brucker, Joseph. "La mission de Chine de 1722 à 1735: Quelques pages de l'histoire des missionnaires français à Péking au XVIIIe siècle, d'après des documents inédits, par Joseph Brucker, S.J." *Revue des questions historiques* 29 (April 1, 1881): 491–532.

Butler, Michael, Margaret Medley, and Stephen Little, eds. *Seventeenth-Century Chinese Porcelain from the Butler Family Collection.* Alexandria, VA: Arts Services International, 1990. Exhibition catalogue.

Carioti, Patrizia, and Lucia Caterina. *La via della porcellana: La Compagnia Olandese delle Indie Orientali e la Cina.* Trent: Centro Studi Martino Martini, 2010.

Cassidy-Geiger, Maureen. *The Arnhold Collection of Meissen Porcelain, 1710–50.* New York: Frick Collection, 2008.

———. "Changing Attitudes towards Ethnographic Material: Re-Discovering the Soapstone Collection of Augustus the Strong." *Abhandlungen und Berichte des Staatlichen Museums für Völkerkunde Dresden: Forschungsstelle* 48 (1994): 7–98.

———. "From Rome to Beijing: A 1719 Document of Musical and Other Papal Gifts to China." *Studies in the Decorative Arts* 1 (2007–8): 178–89.

———. "Gestochene Quellen für frühe Höroldt-Malereien." *Keramos* 161 (1998): 3–38.

———. "Graphic Sources for Meissen Porcelain: Origins of the Print Collection in the Meissen Archives." *Metropolitan Museum Journal* 31 (1996): 99–126.

——. "Rediscovering the Specksteinkabinett of Augustus the Strong and Its Role at Meissen: An Interim Report." *Keramos* 145 (1994): 4–10.

Castelluccio, Stéphane. "Le Roi et la Compagnie française des Indes Orientales." In *La Chine à Versailles: Art et diplomatie au XVIIIe siècle*, edited by Marie-Laure de Rochebrune, 94–99. Paris: Somogy Éditions d'Art, 2014. Exhibition catalogue.

——. "Sept vases de Chine en bleu et blanc, équivalents des pièces figurant dans les collections du Grand Dauphin." In *La Chine à Versailles: Art et diplomatie au XVIIIe siècle*, edited by Marie-Laure de Rochebrune, 70–71. Paris: Somogy Éditions d'Art, 2014. Exhibition catalogue.

Chan, Albert. "Late Ming Society and the Jesuit Missionaries." In *East Meets West: The Jesuits in China, 1582–1773*, edited by Charles E. Ronan and Bonnie B. C. Oh, 153–72. Chicago: Loyola University Press, 1988.

Clunas, Craig. *Pictures and Visuality in Early Modern China*. Princeton, NJ: Princeton University Press, 1997.

Coccolino, Germano. *Incontro con le porcellane cinesi di epoca Ch'ing prodotte dai laboratori imperiali e dai forni privati dal periodo K'ang Hsi all'epoca della Repubblica*. Pinerolo, Italy: Alzani Editore, 1998.

Cohen, Huguette. "Diderot and the Image of China in Eighteenth-Century France." *Studies on Voltaire and the Eighteenth Century* 242 (1986): 219–32.

Coutts, Howard. *The Art of Ceramics: European Ceramic Design 1500–1830*. New Haven: Yale University Press, 2001.

Crill, Rosemary. "European Depictions of Asians." In *Encounters: The Meeting of Asia and Europe, 1500–1800*, edited by Anna Jackson and Amin Jaffer, 218–19. London: Victoria and Albert Museum, 2004. Exhibition catalogue.

Curtis, Julia B. "Markets, Motifs, and Seventeenth-Century Porcelain from Jingdezhen." In *The Porcelains of Jingdezhen*, edited by Rosemary E. Scott, 123–49. London: School of Oriental and African Studies, 1993.

Dapper, Olfert. *Tweede en Derde Gesandschap na het Keyserryk van Taysing of China*. Amsterdam: Jacob van Meurs, 1671.

Dawson, Raymond. *The Chinese Chameleon: An Analysis of European Conceptions of Chinese Civilization*. London: Oxford University Press, 1967.

De Angelis, Maria Antonietta. *Il Palazzo Apostolico di Castel Gandolfo al tempo di Benedetto XIV (1740–1758): Pitture e arredi*. Rome: De Luca Editore, 2008.

Dehergne, Joseph. "La mission de Pékin à la veille de la condemnation des rites: Études d'histoire missionnaire." *Neue Zeitschrift für Missionswissenschaft* 9 (1953): 91–108.

Dew, Nicholas. *Orientalism in Louis XIV's France.* Oxford: Oxford University Press, 2009.

Ebrey, Patricia Buckley. *The Cambridge Illustrated History of China.* Cambridge: Cambridge University Press, 1996.

Ellis, Henry. Journal of the Proceedings of the Late Embassy to China; Comprising a Correct Narrative of the Public Transactions of the Embassy, of the Voyage to and From China, and of the Journey from the Mouth of the Pei-Ho to the Return to Canton, interspersed with Observations upon the Face of the Country, the Polity, Moral Character and Manners of the Chinese Nation. London: John Murray, 1817, Reprint edition Wilmington, DE: Scholarly Resources, 1973.

Ficoroni, Francesco de'. *Le vestigia e rarità di Roma antica ricercate, e spiegate: Le singolarità di Roma moderna ricercate, e spiegate.* 2 vols. Rome: Girolamo Mainardi, 1744.

Fileri, Eliana. "Il Cardinale Filippo Antonio Gualtieri (1660–1728): Collezionista e scienziato" in *I Cardinali di Santa Romana Chiesa collezionisti e mecenati*, edited by Marco Gallo. 6 vols, 2:37–47. Rome: Edizioni dell'Associazione Culturale Shakespeare and Company, 2001.

Fontana, Michela. *Matteo Ricci: Gesuita scienziato umanista in Cina.* Rome: De Luca Editori, 2010.

Foss, Theodore Nicholas. "The European Sojourn of Philippe Couplet and Michael Shen Fuzong, 1683–1692." In *Philippe Couplet, S.J. (1623–1693): The Man Who Brought China to Europe*, edited by Jerome Heyndrickx, 121–42. Nettetal, Germany: Steyler Verlag, 1990.

Gaehtgens, Thomas, and Jacques Lugand. *Joseph-Marie Vien, 1716–1809: Peintre du Roi.* Paris: Arthena, 1988.

Garnier-Pelle, Nicole, Anne Fornay-Carlier, and Marie-Christine Anselm. *The Monkeys of Christophe Huet: Singeries in French Decorative Arts.* Translated by Sharon Grenet. Originally published Saint-Rémy-en-l'Eau: Éditions Monelle Hayot, 2010; Los Angeles: J. Paul Getty Museum, 2011.

Gernet, Jacques. "À propos des contacts entre la Chine et l'Europe aux XVIIe et XVIIIe siècles." *Acta Asiatica* 23 (1972): 78–92.

———. *A History of Chinese Civilization*. 2nd ed. Translated by J.R. Foster and Charles Hartman. Cambridge: Cambridge University Press, 1982.

Ghidoli, Alessandra. "Manifattura cinese." In *Il Settecento a Roma*, edited by Anna Lo Bianco and Angela Negro, 276-77. Milan: Silvana Editoriale, 2005. Exhibition catalogue.

Godley, Michael R. "The End of the Queue: Hair as Symbol in Chinese History." *East Asian History* 8 (Dec. 1994): 53-72.

González-Palacios, Alvar. *Arredi e ornamenti alla corte di Roma 1560-1795*. Milan: Mondadori Electa, 2004.

Gordon-Smith, Maria. "The Influence of Jean Pillement on French and English Decorative Arts, Part One." *Artibus et Historiae* 21 (2000): 171-96.

———. "The Influence of Jean Pillement on French and English Decorative Arts, Part Two: Representative Fields of Influence." *Artibus et Historiae* 21 (2000): 119-63.

———. *Pillement*. Kraców: IRSA, 2006.

Guy, Basil. "'Ad majorem Societatis gloriam': Jesuit Perspectives on Chinese Mores in the Seventeenth and Eighteenth Centuries." In *Exoticism in the Enlightenment*, edited by G.S. Rousseau and Roy Porter, 66-85. Manchester: Manchester University Press, 1990.

Haudrère, Philippe, et al. *La soie et le canon: France-Chine 1700-1860*. Nantes: Gallimard, 2010. Exhibition catalogue.

He, Li, and Michael Knight, eds. *Power and Glory: Court Arts of China's Ming Dynasty*. San Francisco: Asian Art Museum, 2008. Exhibition catalogue.

Heeren, J.J. "Father Bouvet's Picture of Emperor K'ang-hsi." *Asia Major* 7 1 (1932): 556-72.

Hinsch, Bret. *Passions of the Cut Sleeve: The Male Homosexual Tradition in China*. Berkeley: University of California Press, 1990.

Honour, Hugh. *Chinoiserie: The Vision of Cathay*. London: John Murray, 1962.

Impey, Oliver. *Chinoiserie: The Impact of Oriental Styles on Western Art and Decoration*. New York: Charles Scribner's Sons, 1977.

Jarry, Madeleine. *Chinoiserie: Chinese Influence on European Decorative Art, 17th and 18th Centuries*. New York: Vendome Press, 1981.

Johns, Christopher M. S. "Chinoiserie in Piedmont: An International Language of Diplomacy and Modernity." In *Torino Britannica: Political and Cultural Crossroads in the Age of the Grand Tour*, edited by Karin E. Wolfe and Paola

Bianchi. Cambridge: Cambridge University Press and the British School at Rome, in press.

———. *Papal Art and Cultural Politics: Rome in the Age of Clement XI.* Cambridge and New York: Cambridge University Press, 1993.

———. *The Visual Culture of Catholic Enlightenment.* University Park, PA: Penn State University Press, 2014.

Jörg, Christiaan J. A. "Chinese Porcelain for the Dutch in the Seventeenth Century: Trading Networks and Private Enterprise." In *The Porcelains of Jingdezhen,* edited by Rosemary E. Scott, 183–205. London: School of Oriental and African Studies, 1993.

———. *Porcelain and the Dutch China Trade.* The Hague: Martinus Nijhoff, 1982.

Kaufmann, Thomas DaCosta. "Interpreting Cultural Transfer and the Consequences of Markets and Exchange: Reconsidering 'Fumi-e.'" In *Artistic and Cultural Exchanges between Europe and Asia, 1400–1900,* edited by Michael North, 135–61. Farnham, England: Ashgate, 2010.

Keevak, Michael. *The Story of a Stele: China's Nestorian Monument and Its Reception in the West, 1625–1916.* Hong Kong: Hong Kong University Press, 2008.

Kerr, Rose. "Asia in Europe: Porcelain and Enamel for the West." In *Encounters: The Meeting of Asia and Europe, 1500–1800,* edited by Anna Jackson and Amin Jaffer, 222–31. London: Victoria and Albert Museum, 2004. Exhibition catalogue.

Kisluk-Grosheide, Daniëlle. "The Reign of Magots and Pagods." *Metropolitan Museum Journal* 37 (2002): 177–97.

Kleutghen, Kristina. "Chinese Occidenterie: The Diversity of 'Western' Objects in Eighteenth-Century China." *Eighteenth-Century Studies* 47, no. 2 (2014): 117–35.

Kley, Edwin J. V. "Europe's 'Discovery' of China and the Writing of World History." *American Historical Review* 76, no. 2 (1971): 358–85.

Köhle, Natalie. "Why did the Kangxi Emperor go to Wutai Shan? Patronage, Pilgrimage, and the Place of Tibetan Buddhism at the Early Qing Court." *Late Imperial China* 29, no. 1 (2008): 73–119.

Lach, Donald F., and Edwin J. van Kley. *Asia in the Making of Europe.* Chicago: University of Chicago Press, 1993.

Landry-Deron, Isabelle. "Les mathématiciens envoyés en Chine par Louis XIV en 1685." *Archive for History of Exact Sciences*, 55, no. 5 (2001): 423–63.

———. "L'information ancienne sur la Chine." In *La Chine à Versailles: Art et diplomatie au XVIIIe siècle*, edited by Marie-Laure de Rochebrune, 86–93. Paris: Somogy Éditions d'Art, 2014. Exhibition catalogue.

Landweber, Julia. "Celebrating Identity: Charting the History of Turkish Masquerade in Early Modern France. *Romance Studies* 23, no. 3 (Nov. 2005): 175–89.

Langlois, John D. "Chinese Culturalism and the Yüan Analogy: Seventeenth-Century Perspectives." *Harvard Journal of Asiatic Studies* 40, no. 2 (1980): 355–98.

Lesur, Nicolas, and Olivier Aaron. *Jean-Baptiste Marie Pierre, 1714–1789: Premier peintre du roi*. Paris: Arthena, 2008.

Little, Stephen. *Chinese Ceramics of the Transitional Period: 1620–1683*. New York: China Institute in America, 1983. Exhibition catalogue.

———. "Chinese Porcelains of the Chongzhen Period (1628–1644)." *Oriental Art* 29, no. 2 (1983): 159–80.

Manzone, Beniamino, ed. *Frammenti di lettere inedite di Benedetto XIV pubblicate per le nozze Gabotto-Abrate*. Brà: Tipografia Stefano Rocca, 1890.

Medley, Margaret. "Artistic Innovation in a Conservative Craft: Seventeenth-Century Chinese Porcelain." *Arts of Asia* 16 (July–Aug. 1986): 58–68.

Miller, Susan. "Jean-Antoine Fraisse at Chantilly." *East Asian Library Journal* 9, no. 1 (2000): 79–221.

Millward, James A. "A Uyghur Muslim in Qianlong's Court: The Meanings of the Fragrant Concubine." *Journal of Asian Studies* 53, no. 2 (1994): 427–58.

Minamiki, George. *The Chinese Rites Controversy from Its Beginning to Modern Times*. Chicago: Loyola University Press, 1985.

Monnet, Nathalie. "Le jeune duc du Maine, protecteur des premières missions françaises en Chine." In *La Chine à Versailles: Art et diplomatie au XVIIIe siècle*, edited by Marie-Laure de Rochebrune, 36–43. Paris: Somogy Éditions d'Art, 2014. Exhibition catalogue.

Morena, Francesco. *Chinoiserie: The Evolution of the Oriental Style in Italy from the 14th to the 19th Century*. Translated by Eve Leckey. Florence: Centro Di, 2009.

———. *Dalle Indie orientali alla corte di Toscana: Collezioni di arte cinese e giapponese a Palazzo Pitti*. Florence: Giunti Editore, 2005.

Mote, F. W. *Imperial China 900–1800*. 3rd ed. Cambridge, MA: Harvard University Press, 2003.

Mungello, David E. *Curious Land: Jesuit Accommodation and the Origins of Sinology*. Honolulu: University of Hawaii Press, 1989.

———. *The Great Encounter of China and the West, 1500–1800*. Lanham, MD: Rowman and Littlefield, 2005.

———. *Liebniz and Confucianism: The Search for Accord*. Honolulu: University of Hawaii Press, 1977.

Nothaft, C. P. E. "Noah's Calendar: The Chronology of the Flood Narrative and the History of Astronomy in Sixteenth- and Seventeenth-Century Scholarship." *Journal of the Warburg and Courtauld Institutes* 74 (2011): 191–211.

Odell, Dawn. "Porcelain, Print Culture and Mercantile Aesthetics." In *The Cultural Aesthetics of Eighteenth-Century Porcelain*, edited by Alden Cavanaugh and Michael E. Yonan, 141–58. Farnham, England: Ashgate, 2010.

———. "The Soul of Transactions: Illustration and Johan Nieuhof's Travels to China." In *"Tweelinge eener dragt": Woord en beeld in de Nederlanden (1500–1750)*, edited by Karel Bostoen, Elmer Kolfin, and Paul J. Smith, 225–42. Special printing of *De Seventiende Eeuw* (The Seventeenth Century) 12, no. 3 (2001). Hilversum, Holland: Uitgeverij Verloren.

Parissien, Steven. "European Fantasies of Asia." In *Encounters: The Meeting of Asia and Europe, 1500–1800*, edited by Anna Jackson and Amin Jaffer, 348–59. London: Victoria and Albert Museum, 2004. Exhibition catalogue.

Peterson, Willard J. "What to Wear? Observation and Participation by Jesuit Missionaries in Late Ming Society." In *Implicit Understandings: Observing, Reporting, and Reflecting on the Encounters between Europeans and Other Peoples in the Early Modern Era*, edited by Stuart B. Schwartz, 403–21. Cambridge: Cambridge University Press, 1994.

Pierson, Stacey. *Chinese Ceramics*. London: Victoria and Albert Museum, 2009.

Pietsch, Ulrich. *Early Meissen Porcelain: The Wark Collection from the Cummer Museum of Art and Gardens*. Jacksonville, FL: Cummer Museum of Art and Gardens, 2011. Exhibition catalogue.

———, and Claudia Banz, eds. *Triumph of the Blue Swords: Meissen Porcelain for the Aristocracy and Bourgeoisie 1710–1815*. Leipzig: E. A. Seeman Verlag, 2010. Exhibition catalogue.

Pirazzoli-T'Serstevens, Michèle. *Giuseppe Castiglione, 1688–1766: Peintre et architecte à la cour de Chine*. Paris: Thalia Edition, 2007.

Préaud, Tamara. "Recherches sur les sources iconographiques utilisées par les décorateurs de porcelaine de Vincennes (1740–1756)." *Bulletin de la société de l'histoire de l'art français* (1989): 105–15.

Richards, Sarah. *Eighteenth-Century Ceramics: Products for a Civilised Society*. Manchester: Manchester University Press, 1999.

Rochebrune, Marie-Laure de. "Du Trianon de Porcelaine au Cabinet Doré de Marie-Antoinette: La Chine à Versailles." In *La Chine à Versailles: Art et diplomatie au XVIIIe siècle*, edited by Marie-Laure de Rochebrune, 16–33. Paris: Somogy Éditions d'Art, 2014. Exhibition catalogue.

Rouleau, Francis A. "Maillard de Tournon, Papal Legate at the Court of Peking." *Archivium Historicum Societatis Jesu* 31a (1962): 264–332.

Rowbotham, Arnold H. "Jesuit Figurists and Eighteenth-Century Religion." *Journal of the History of Ideas* 17, no. 4 (1956): 471–85.

Sargent, William R. "Asia in Europe: Chinese Paintings for the West." In *Encounters: The Meeting of Asia and Europe, 1500–1800*, edited by Anna Jackson and Amin Jaffer, 272–81. London: Victoria and Albert Museum, 2004. Exhibition catalogue.

Scott, Katie. "Playing Games with Otherness: Watteau's Chinese Cabinet at the Château de la Muette." *Journal of the Warburg and Courtauld Institutes* 66 (2003): 189–248.

Scott, Rosemary E. "Jesuit Missionaries and the Porcelains of Jingdezhen." In *The Porcelains of Jingdezhen*, edited by Rosemary E. Scott, 232–56. London: School of Oriental and African Studies, 1993.

Sloboda, Stacey. "Picturing China: William Alexander and the Visual Language of Chinoiserie." *British Art Journal* 9, no. 2 (2002): 28–36.

Spence, Jonathan. "The Seven Ages of K'ang-hsi [1654–1722]." *Journal of Asian Studies* 26, no. 2 (1967): 205–11.

Standaert, Nicolas, ed. *Handbook of Christianity in China*. Vol. 1, 635–1800. Leiden: Brill, 2001.

Standen, Edith A. "The Story of the Emperor of China: A Beauvais Tapestry Series." *Metropolitan Museum Journal* 11 (1976): 103–17.

Stein, Perrin. "Boucher's Chinoiseries: Some New Sources." *Burlington Magazine* 138, no. 1122 (September 1996): 598–604.

———. "Diplomacy, Patronage, and Pedagogy: Etching in the Eternal City." In *Artists and Amateurs: Etching in 18th-Century France*, edited by Perrin Stein, 102–35. New York: Metropolitan Museum of Art, 2013. Exhibition catalogue.

Stuart, Jan. "The Face in Life and Death: Mimesis and Chinese Ancestor Portraits." In *Body and Face in Chinese Visual Culture*, edited by Wu Hung and Katherine R. Tsiang, 197–228. Cambridge, MA: Harvard University Press, 2005.

———, and Evelyn S. Rawski, *Worshiping the Ancestors: Chinese Commemorative Portraits*. Washington, D.C., and Stanford, CA: Smithsonian Institution and Stanford University Press, 2001.

Sullivan, Michael. *The Meeting of Eastern and Western Art*. London: Thames and Hudson, 1973.

Tamburello, Adolfo. "Per un recupero conoscitivo e patrimoniale delle opere, doni e lasciti di Matteo Ripa e del Collegio dei Cinesi." In *La missione cattolica in Cina tra i secoli XVIII-XIX: Matteo Ripa e il Collegio dei Cinesi*, edited by Michele Fatica and Francesco D'Arelli, 39–59. Naples: Istituto Universitario Orientali, 1999.

Taylor, Rodney L. *The Religious Dimensions of Confucianism*. Albany: State University of New York Press, 1990.

Treutlein, Theodore E. "Jesuit Missions in China during the Last Years of K'ang-hsi." *Pacific Historical Review* 10, no. 4 (1941): 435–46.

Vanderstappen, Harrie. "Chinese Art and the Jesuits in Peking." In *East Meets West: The Jesuits in China, 1582-1773*, edited by Charles E. Ronan and Bonnie B. C. Oh, 103–26. Chicago: Loyola University Press, 1988.

Van Dyke, Paul A. *Merchants of Canton and Macao: Politics and Strategies in Eighteenth-Century Chinese Trade*. Hong Kong: Hong Kong University Press, 2011.

Vinograd, Richard. *Boundaries of the Self: Chinese Portraits, 1600-1900*. Cambridge: Cambridge University Press, 1992.

Vogtherr, Christoph Martin, and Jennifer Tonkovich, eds. *Jean de Jullienne: Collector and Connoisseur*. London: Paul Holberton, 2011. Exhibition catalogue.

Selected Bibliography

Wakeman, Frederic. *The Great Enterprise: The Manchu Reconstruction of Imperial Order in Seventeenth-Century China*. 2 vols. Berkeley: University of California Press, 1985.

Waley-Cohen, Joanna. *The Sextants of Beijing: Global Currents in Chinese History*. New York: W.W. Norton, 1999.

Waltner, Ann. "Demerits and Deadly Sins: Jesuit Moral Tracts in Late Ming China." In *Implicit Understandings: Observing, Reporting, and Reflecting on the Encounters between Europeans and Other Peoples in the Early Modern Era*, edited by Stuart B. Schwartz, 422–48. Cambridge: Cambridge University Press, 1994.

Wang Fang-yu. "Book Illustration in Late Ming and Early Qing China." In *Chinese Rare Books in American Collections*, edited by Sören Edgren, 31–43. New York: China Institute in America, 1985. Exhibition catalogue.

Wei, Tsing-sing Louis. "Les origins des missions catholiques françaises en Chine." *La Revue Nouvelle* 27 (1958): 249–58.

Wei Dong [Jin Weidong]. "Qing Imperial 'Genre Painting': Art as Pictorial Record." *Orientations* 26 (July–Aug. 1995): 18–24.

Wills, John E. *Embassies and Illusions: Dutch and Portuguese Envoys to K'ang-hsi, 1666–1687*. Cambridge, MA: Harvard University Press, 1984.

Witek, John W. *Controversial Ideas in China and in Europe: A Biography of Jean-François Foucquet, S.J. (1665–1741)*. Rome: Institutum Historicum, 1982.

———. "Sent to Lisbon, Paris, and Rome: Jesuit Envoys of the Kangxi Emperor." In *La missione cattolica in Cina tra i secoli XVIII–XIX: Matteo Ricci e il Collegio dei Cinesi*. edited by Michele Fatica and Francesco D'Arelli, 317–40. Naples: Istituto Universitario Orientali, 1999.

Wong, George H.C. "The Anti-Christian Movement in China: Late Ming and Early Ch'ing." *Tsing Hua Journal of Chinese Studies* n.s. 3 (May 1962): 187–222.

Wright, A.D. *The Counter-Reformation: Catholic Europe and the Non-Christian World*. Aldershot, England: Ashgate, 2005.

Wu Hung. "Emperor's Masquerade: Costume Portraits of Yongzheng and Qianlong." *Orientations* 26, no. 7 (1995): 25–41.

Yonan, Michael E. "Igneous Architecture: Porcelain, Natural Philosophy, and the Rococo 'Cabinet Chinois.'" In *The Cultural Aesthetics of Eighteenth-Century Porcelain*, edited by Alden Cavanaugh and Michael E. Yonan, 65–85. Farnham, England: Ashgate, 2010.

ILLUSTRATIONS

1. Pierre Giffart, *Officier de Robe Mandarin [Mandarin Official]*, 1697 *2*

2. Pierre Giffart, *Dame Chinoise Mandarine [Chinese Lady]*, 1697 *2*

3. Map of the province of Beijing, with figures, 1662 *6*

4. Adam Weisweiler, commode *à vantaux*, ca. 1780 *12*

5. Thomas Pitts (attributed to), epergne, 1761 *13*

6. Nestorian stele, seventh century CE *16*

7. Giovanni Battista Gaulli, *Death of Saint Francis Xavier*, 1675 *19*

8. Anonymous, *Portrait of Johann Schall von Bell*, 1667 *26*

9. Anonymous, *Portrait of Father Zhang and Mother Zhao*, late Ming or early Qing *34*

10. Giuseppe Castiglione, *Portraits of Emperor Qianlong, the Empress, and Eleven Imperial Consorts*, 1736–ca. 1770s, detail *39*

11. Edme Jeaurat (after Antoine Watteau), *Bonze des Tartares Mongous ou Mongols*, 1731 *41*

12a. Simone Martini, *Annunciation*, 1333 *44*

12b. Simone Martini, *Annunciation*, 1333, detail *44*

13a. Giovanni Bellini, *Feast of the Gods*, 1514 *47*

13b. Giovanni Bellini, *Feast of the Gods*, 1514, detail *47*

14. Garniture of five vases, Jingdezhen production, ca. 1690 *51*

15a. Johannes Vermeer, *Girl Interrupted while Playing Music*, ca. 1660 *52*

15b. Johannes Vermeer, *Girl Interrupted while Playing Music*, ca. 1660, detail *52*

16. Porcelain bowl with Venus bathing, Jingdezhen production, mid-eighteenth century *58*

17a. Porcelain vase with scenes from the novel *The West Chamber*, Jingdezhen production, late seventeenth century *60*

17b. Porcelain vase with scenes from the novel *The West Chamber*, Jingdezhen production, late seventeenth century, detail *61*

18a. Peter Engebrecht, two-handled vase, ca. 1712 *62*

18b. Peter Engebrecht, two-handled vase, ca. 1712, detail *63*

19. Chantilly manufactory, potpourri pots with Budai, 1740s *64*

20. Sèvres manufactory, potpourri [elephant] vases with chinoiserie figures, ca. 1761 *66*

21. Anonymous, *Lady in an Interior Holding a Bird*, 1665 *68*

22. Jean-Baptiste Marie Pierre, *Chinese Masquerade Float for the 1735 Roman Carnival*, 1735 *75*

23. Joseph-Marie Vien, *Aga of the Janissaries: A Pensionnaire of the French Academy in Rome in Turkish Costume*, 1748 *76*

24. Paolo Posi, *Chinoiserie Fireworks Stand for the 1758 Roman Chinea*, 1758 *77*

25. Jean-Baptiste Monnoyer, Guy-Louis Vernansal, et al., *The Astronomers*, from *Life of the Emperor of China*, ca. 1710 *85*

26. Anonymous, *The Shunzhi Emperor*, 1667 *92*

27. Anonymous, *The Kangxi Emperor Triumphant over Ming Loyalists and Other Enemies*, 1671 *97*

28a. Ovoid covered jar with scene from *The Water Margin*, Jingdezhen production, ca. 1630s *101*

28b. Ovoid covered jar with scene from *The Water Margin*, Jingdezhen production, ca. 1630s, detail *101*

29. Sir Godfrey Kneller, *Portrait of Michael Shen Fuzong ["The Chinese Convert"]*, 1687 *104*

30. Anthony Van Dyck, *Portrait of the Marchesa Elena Grimaldi*, 1623 *109*

31. Johann Gregor Höroldt (attributed to), tankard, ca. 1725 *112*

32a. Jean-Baptiste Monnoyer, Guy-Louis Vernansal, et al., *Audience of the Emperor of China*, ca. 1700–1710 *116*

32b. Jean-Baptiste Monnoyer, Guy-Louis Vernansal, et al., *Audience of the Emperor of China*, ca. 1700–1710, detail *117*

33a. François Boucher, *Audience of the Emperor of China*, 1742 *120*

33b. François Boucher, *Audience of the Emperor of China*, 1742, detail *121*

34. François Boucher, *The Element of Fire*, ca. 1740 *123*

35. Christophe Huet, *Chinoiserie with Monkeys*, ca. 1745–5? *125*

36. Christophe Huet, *Chinese Man Burning Incense before an Image of Buddha*, late 1740s *126*

37. Christophe Huet, *Turks Hunting an Ostrich*, late 1740s *126*

38. François Boucher, after Antoine Watteau, *Geng [Chinese Physician]*, 1731 *129*

39a. François Boucher, *Lady Fastening Her Garter*, 1742 *130*

39b. François Boucher, *Lady Fastening Her Garter*, 1742, detail *131*

39c. François Boucher, *Lady Fastening Her Garter*, 1742, detail *131*

39d. François Boucher, *Lady Fastening Her Garter*, 1742, detail *131*

40. François Boucher, *Chinese Fishing Scene*, 1742 *133*

41. Jean-Baptiste Pillement, *The Chinese Astronomer*, ca. 1765 *135*

42. Anonymous, *Louis XIV*, Jingdezhen production, early eighteenth century *137*

Page numbers in italics indicate illustrations.

Aa, Pieter van der, 118
Africa/Africans, 46, 98
Aga of the Janissaries (Vien), 75, *76*
Alembert, Jean le Rond d,' 25
Alexander the Great, 103
Alexander VIII Ottoboni, Pope, 148n34
Amedeo II, Vittorio, king of Sardinia, 74
Amherst, William, embassy of, 141,
 161n4
Amphitrite (French ship), 55-56, 79, 147n19
ancestor portraits, *34*, 95-96, 156n5
ancestor rites, 33, 35, 140, 156n5
ancien régime, European, 3, 8, 9, 25
Andrea da Perugia, Father, 17
Anne of Austria, 88
Annunciation (Martini), 43, *44*
Anson, George, 134
architecture, Chinese, 4, 9, 81, 91, 139;
 book illustrations of, *85*, 96; depicted
 in porcelain wares, 61; European
 attitudes toward, 94, 113, 132; Great
 Wall, 132; negative Enlightenment

view of, 132-33, *133;* Porcelain
 Pagoda (Nanjing), 76-78, 82, 132;
 Yuanming Yuan (Garden of Perfect
 Brightness), 39, 119
Arita (Imari) manufactory, in Japan, 50,
 136
Arnhold collection (New York), 59
art, Chinese, 12, 56, 81, 110; Budai
 figurines, 63-64; collections in
 Europe, 17, 55; disparaged by
 Enlightenment *philosophes,* 133, 134;
 European art and chinoiserie
 influenced by, 49, 61; Europeans
 depicted in, 136-38, *137;* as product
 of mighty empire, 82; rank and
 dignity depicted in, 65, 96, 111;
 widespread presence in Europe, 45,
 57, 66. *See also* paintings, Chinese;
 woodblock prints
art, European, 58, 97, 100; Alexander the
 Great and Diogenes theme, 103;
 borrowing of Chinese decorative

art, European *(continued)*
motifs, 59; history painting, 102;
influence on Chinese art, 49;
Mannerist paintings, 96; portraiture,
108, *109;* Yuan textiles and, 43
Astronomers, The (Monnoyer, Vernansal, et
al.), 84, *85,* 114, 158n25
astronomy, 25, 31, 84, 114, 134–35
Atlas Chinensis (Montanus), 159n30
Attiret, Jean-Denis, 118
Audience of the Emperor of China (Boucher),
118–19, *120, 121*
Audience of the Emperor of China (Mon-
noyer, Vernansal et al.), 115–16, *116,*
117
Augustinians, 27, 35
Augustus the Strong, Elector of Saxony,
87
Aumont, Louis Marie, duc d,' 89
Aumont, Louis Marie Augustin, duc d,' 89

"bad China," 10, 46, *77,* 132, 136;
feminized/trivialized images of, 78;
magots as visualization of, 64
Baldini, Count, 58
Bangkok, 55
Batavia (Jakarta), 50, 54
Batoni, Pompeo Girolamo, 72
Beauvais, royal tapestry works at, 83, 114
Beijing, French map (1662) of, 5, *6*
Belin de Fontenay, Jean-Baptiste, 115
Bellini, Giovanni, 46, 48
Benedict XI Boccasini, Pope, 43
Benedict XII Fournier, Pope, 17
Benedict XIII Orsini, Pope, 24, 69, 70,
149n39
Benedict XIV Lambertini, Pope, 24, 67,
69–73
Berain, Jean Louis, 87
Bernini, Gianlorenzo, 108

Bertin, Henri-Léonard Jean Baptiste,
144n4
Bible, 17, 22, 23
bodies, Chinese, 4, 94; consistency in
European accounts of, 98–99; images
in late Ming porcelain, 99–100, *101,*
102–3; invention of "yellow peril,"
98, 127; naturalized rendering of, 95;
as schematic abstractions in Chinese
portraits, 96; stock characters, 95. *See
also* men/male body, Chinese
Boniface VIII Caetani, Pope, 17, 43
Bonze des Tartares Mongous ou Mongols
(Jeaurat, after Watteau), 40–41, *41*
Boucher, François, 118–20, 122, 124,
129–30, 159n29; *Audience of the
Emperor of China,* 119, *120, 121; Chinese
Divinity* (after Watteau), 128; *Chinese
Fishing Scene,* 132–33, *133; The Element
of Fire,* 122, *123; The Five Senses
Represented by Different Chinese
Pastimes,* 122, 124; *Geng, or Chinese
Physician* (after Watteau), 128, *129;
Lady Fastening Her Garter,* 130, *130–31*
Boucher, Guillaume, 16
Boulle, André-Charles, 88
Bouvet, Father Joachim, S.J., 1–2, 28, 31,
79–80, 93, 154n42
Breve relatione del regno della Cina [Brief
Account of the Kingdom of China]
(Longobardi), 18
Britain/British empire, 10, 11, 38, 139,
161n4
Brockey, Liam Matthew, 29
Budai [Jap.: Hotei] (Buddhist god of good
fortune), 63, 64, *64*
Buddhism, 21, 37, 136, 157n18; ancestor
portraits and, 96; bonzes (monks), 1,
40, 138; god of good fortune (Chin.:
Budai; Jap.: Hotei), 63, 64, *64;*

peasantry and urban poor associated with, 158n18; Tibetan, 40

Burma, 113, 115

Byzantine Empire, 45

calendar reforms, papal, 30

Cambodia, 113

Cao Guojiu (Daoist Immortal), 21

Careri, Giovanni Francesco, 54, 150n10

Carletti, Francesco, 48

Carnarvon (English merchant ship), 56

Carnival celebrations, 74–75, *75*, 84, 86

Carpegna, Cardinal Gaspare, 73

Carpine, Giovanni da Pian del, 17

Carriera, Rosalba, 71

cartography, 27, 114, 154n42

Cassidy-Geiger, Maureen, 21

Castelgandolfo, Chinese art collection at, 70–71

Castiglione, Giuseppe (Lang Shining), 38, 136

"Cathay," 16

Catholic Church, 25, 67, 140; Chinese converts to, 79, 94, 154n43; European Roman Catholic slaves in Mongol empire, 145n1; as Europe's most precious commodity, 10; Mongol empire and, 17; publications of, 2

Catholic Church, China mission of, 25, 67, 79, 91; collapse of, 4, 38, 40, 74, 93; importance to European art and society, 8; Jesuit dominance of, 30; veterans of, 67, 79; under Yuan dynasty, 17, 18

Catholic courts and elites, 4, 8, 10, 24, 53, 142

"Celestial Empire," 7, 67, 78

Central Asia, 17

Chantilly porcelain, 61–63, *64*, 65

Charles II, king of England, 88

Château de La Muette, Watteau paintings at, 87, 128, 129, 160n41

Chiesa, Bernardino della, 148n34

China: biblical stories accommodated with Chinese history, 22–24; civil service exams, 5; civil war after Ming collapse, 49–50; earliest Christians in, 15; early positive images of, 9; European colonial project and, 8; Europeans depicted in, 136–38, *137*; feminized and decadent depictions of, 4, 7–8, 9, 140; recent emergence as economic and military power, 13; reputation in European consciousness, 42; seen as civilization in decline, 112; situated beyond European control, 3, 7, 10. *See also specific dynasties and emperors*

China illustrata (Kircher), 67, 76, 92–93, *92*, 114

China monumentis, qua sacris qua profanis illustrata [The Monuments of China, Both Sacred and Profane Illustrated] (Kircher), 6–7

Chinese Astronomer, The (Pillement), 134–35, *135*

Chinese Divinity (Boucher, after Watteau), 128

Chinese Fishing Scene (Boucher), 132–33, *133*

Chinese language, 28, 154n43; characters, 22; Christian texts translated into, 17, 106; learned by Jesuit missionaries, 26, 145n3

Chinese Man Burning Incense before an Image of Buddha (Huet), 125, *126*

Chinese Masquerade Float for the 1735 Roman Carnival (Pierre), 74–75, *75*

Chinese Men Conversing with Monkeys in a Tree House (Pillement), 127

Chinese Rites Controversy, 8, 29, 69,
143n4; ancestor portraits and, 95;
Clement XI's bull *Ex illa die* and,
35–38; end of China mission and, 74;
Jesuit tolerance of ancestor rites,
32–33, 35
chinoiserie, 65, 122, 124, 147n19; as
accessories in genre paintings, 130;
authentic versus grotesque depic-
tions in, 3–4; British and Dutch,
10–11; Catholic efforts to convert the
East and, 8; change in Western views
of China and, 4; Chinese art as
influence, 46, 66–67; Enlightenment
and, 139–42; in ephemeral events,
74–75, *75, 77*, 84, 86–87; feminized/
trivialized images of China and, 7, 10,
13, 61, 65; gender in leisure "genre"
scenes, 110–12; Jesuits and, 49; mania
for, 10; porcelain and development
of, 58; positive/naturalistic images of
China and, 30, 59, *60*, 61, *61*; rococo
and, 122, 124; shift in aesthetic of,
8–9, 78, 106, 151n21; *singeries*
("monkey tricks") and, 124–25,
125, 127; tapestries in Porcelain
Trianon, 83
*Chinoiserie Fireworks Stand for the
1758 Roman Chinea* (Posi), 75–78, *77*,
121
Chinoiserie: The Vision of Cathay (Honour),
11, 144n8
Chinoiserie with Monkeys (Huet), *125*
chocolate, 51, 53
Chongzhen emperor, 100
Christianity, 43, 79, 94; Chinese converts
to, 103, 157n14; hopes of converting
Chinese empire to, 3, 8; Kangxi
emperor's view of, 31; parallels with
Confucian philosophy, 18; Qing

emperors' rejection of, 7; sexual
morality of, 107; status of
Christians in China, 27, 29,
148n33; texts translated into
Chinese, 17; as the "true" religion,
79, 140
civilization, 18, 132, 134, 144n7, 147n19;
China as older civilization than
Europe, 22; European paradigm of,
3; positive view of Chinese civiliza-
tion, 139; virility associated
with, 8
civil service exams, 5
class differences, 66, 108, *109*, 110
Clement XI Albani, Pope, 31, 35–38,
68–69, 148n32, 149n39, 152n27
Clement XII Corsini, Pope, 24
Clement XIII Rezzonico, Pope, 105
Clement XIV Ganganelli, Pope, 24, 73
Cleveland, duchess of (Barbara Palmer),
88
clocks, 3, 20, 69, 152n27
clothing, 9, 11, 91, 94; emasculation of,
110; of Jesuit missionaries, 157n18;
Western clothing adapted to Chinese
art, 138–39
Clunas, Craig, 136
coiffure (hairstyle), 94, 97, 99, 107, 128
colonialism/colonization, 7, 8, 90
Colonna, Cardinal Girolamo, 73
Commedia dell'Arte, 111, 129
Compagnie de la Chine, 48
Condé, Louis-Henri, Prince de, 61–62
Confucian philosophy, 18, 20, 110, 145n3;
ancestor rites, 33; Chinese portrai-
ture and, 95; Christianity as threat
to, 29; Diderot's support of Confucian
morality, 158n24; as primary
challenge to Jesuit conversion
plans, 32

Confucius, 23, 94
Confucius Sinarum Philosophus [Confucius, Philosopher of the Chinese] (Intorcetta, Rougement, Couplet, et al.), 80–81
copper plate engraving, 40
Costa, Giuseppe Giovanni da, 38
Couplet, Philippe, 79, 80, 83, 94, 103, 154n41, 157n14

Dame Chinoise Mandarine [Chinese Lady] (Giffart), 2
Daoism, 21, 96
Dapper, Olfert, 96, 114, 156n7
De Angelis, M. A., 70
Death of Saint Francis Xavier (Gaulli), 19
decadence, 4, 9, 21, 61, 113, 119, 140
De christiana expeditione apud Sinas [Concerning the Christian Mission to China] (Trigault), 146n7
Delftware, 51, 64, 82
Description de l'Empire de la Chine (Du Halde), 143n4
Dew, Nicholas, 7, 80
Diderot, Denis, 64, 113, 143n4; magots and pagods disparaged by, 121; Sinophobia of, 25, 133, 134, 144n4, 158n24
Diogenes, 103
Diverses figures chinoises et tartares [Various Chinese and Tartar [Manchu] Figures] (Watteau), 128
Doglioli, Marchesa Camilla Caprara Bentivoglio, 72
Dominicans, 27, 35, 70
Dominus ac Redemptor (papal bull), 24
Dongfang Shuo (Daoist Immortal), 132
Du Halde, Jean-Baptiste, 143n4
Dumons, Jean-Joseph (Dumons de Tulle), 118

Dutch trading empire, 20, 38, 139, 156n7. See also United Provinces (the Netherlands)

East Asia, 7, 9, 46, 48, 116; commerce with Europe, 49; European knowledge of, 2, 139; exchanges with Catholic Europe, 9; Jesuit texts as primary sources of information about, 79; Mongol conquest of, 17; problematic place in European trading system, 53–54
East India Company, British, 49, 56, 151n14
East India Company, Dutch, 50, 53, 115, 150n7
Edict of Nantes, revocation of, 80
Edict of Toleration, 29, 30, 148n33
Egypt, 22, 46
Element of Fire, The (Boucher), 122, 123
Ellis, Henry, 141, 161n4
enamel painting, Western, 39
Encyclopédie (Diderot and d'Alembert, eds.), 25, 64, 121
endpapers, for books, 11
Engebrecht, Peter, 59, 62
England, 51
Enlightenment, 9, 21, 59, 64, 84, 94; caricatured images of China and, 67; chinoiserie and, 139–142; deconstruction of "good China" during, 90; dehumanization of Chinese body during, 98, 127; feminized/trivialized images of Chinese males and, 111; interest in Chinese historical sources, 24; sea change in European attitude toward China and, 113; universal history rejected by, 7
epergne, silver (attrib. Pitts), 11, 13

ephemeral events, 74–78, *75, 76,* 77, 84, 86–87

Esprit des lois, L' (Montesquieu), 133

Este, Duke Alfonso d,' 46, 48

État présent de la Chine en figures, L' [The Present State of China in Images] (Bouvet), 1, *2,* 3

Ethnographical Museum (Dresden), 21

Euclid, 26

Europe, 4, 7, 29, 106; ancien régime in, 3, 56; Catholic and Protestant powers in, 11; Chinese and Eastern art in, 20, 22, 45–46, 58; Chinese art and luxury objects brought to, 5, 10–11, 12; Christianity as "true religion," 10; collapse of mission in China as shock in, 40; commerce with East Asia, 49; Europeans depicted in Chinese art, 136–38, *137;* exchanges with East Asia, 9; knowledge of Chinese history, 22–25; luxury goods from China in, 20, 21–22, 43, 45; maritime global trading system of, 53; masculinity and divine-right monarchy in, 119; Ming Empire as cultural rival of, 18; missionaries' return to, 37, 38; Mongol empire and, 15; papal calendar reforms in, 30; porcelain exports to, 99–100, 156n10; sexual practices in late Ming compared to, 33; Sinophilia in Catholic Europe, 78; visual culture of, 42. *See also* West, the

Evelyn, John, 45

exceptionalism, Chinese, 5–6, 143–44n4

Ex illa die (papal bull), 35–36, 37, 38

fans, Chinese, 11, 72, 73

Feast of the Gods (Bellini), 46, *47,* 48

Ferdinand II of Tyrol, 45

Figurists, 23, 24, 79, 81, 146n12

Five Senses Represented by Different Chinese Pastimes, The (Boucher), 122, 124

flower arranging, 111–12

Fragrant Concubine as an Arcadian Sheperd- ess, The (attrib. Castiglione), 136–37

Fraisse, Jean-Antoine, 62–63, 124, 151n21

France, 1, 7, 38, 51, 78, 139; Carnival masques of Versailles court, 84, 86–87; king of Siam and, 93–94; Ottoman empire as ally of, 127; popes of Avignon and, 45; porcelain manufactured in, 61–66, *64, 66;* tapestry works in, 83–84

Franciscans, 17, 27, 35, 45, 148n34

furniture, 55, 73, 82, 83, 87, 119, 153n37; in cargo of *Amphitrite,* 147n19; *commode à vantaux* (chest of drawers with doors), 11, *12;* Greco-Roman, 3; *magots* as, 121

Gaulli, Giovanni Battista, 19

gender differences, depictions of, 66

Geng, or Chinese Physician (Boucher, after Watteau), 128, *129*

Gerbillon, Jean-François, 28

Germany, 27, 46, 78, 139

Gersaint, Edme-François, 131

Gesantschaft der Ost-Indischen Geselschaft, Die [An Embassy from the East-India Company] (Nieuhof), 83, 115, 155n47

Ghezzi, Pier Leone, 69, 152n27

Giffart, Pierre, 1

Giotto di Bondone, 43, 45

Girl Interrupted while Playing Music (Vermeer), 51, *52*

Gobelins tapestry manufactory, 116

Gonzaga, Cardinal Silvio Valenti, 73

González de Mendoza, Juan, 78, 83, 154n40

"good China," 10, 46, 78, 90, 132, 136
Great Wall, 132
Greece, ancient, 3
Gregory XIII Buoncompagni, Pope, 67, 154n40
Gruber, Father Johannes, 67
Gualtieri, Cardinal Filippo Antonio, 73
Guanyin (bodhisattva), 132

Hamerani, Ermenegildo, 69, 152n27
Henriques, Manuel, 98
Henry VIII, king of England, 96
Histoire de l'Empereur de la Chine presentée au Roy [The History of the Chinese Emperor Presented to the King] (Bouvet), 80
History of the Great and Renowned Monarchy of China (Semedo), 107
History of the Great Kingdom of China (González de Mendoza), 78–79
history painting, 102
Hochstrasser, Julie, 11
Holbein the Younger, Hans, 96
homosexuality, 32, 107
Honour, Hugh, 11, 81–82, 134
Horn, Georg, 23
Höroldt, Johann Gregor, chinoiserie of, 110–11, *112*
Huet, Christophe, 124, 127
Huquier, Gabriel, 122, 124
hybridity, in East-West cultural exchange, 41, 49, 67–68, 116
Hyde, Thomas, 105

Immortals, Daoist, 21, 132
Imperiali, Cardinal Giuseppe Renato, 73
Imperio de la China (Semedo), 146n7
Indochina, 113
Innocent IV Fieschi, Pope, 17
Innocent XII Pignatelli, Pope, 29

Intorcetta, Prospero, 29, 80
Islam, 45
Italy, 27, 46, 58, 78, 139

James II, king of England, 103
Japan, 11, 18, 46; Jesuit mission in, 98; porcelain from, 49, 50, 72; scroll paintings, 63; trade restricted to port of Nagasaki, 53; violent end of Christian mission in, 41–42, 46
Java, 50
Jeaurat, Edme, 40, 128
Jesuits (Society of Jesus), 1, 2, 9, 40, 45, 144n4; abolished by Clement XIV, 24, 73; accommodationist strategy of, 23, 30, 33, 35; arrival of missionaries in China, 3, 18; artists, 38–40, 118, 136; Beijing establishments of, 30–31; "blending in" strategy of, 145n3; Chinese imperial administration and, 5; Chinese Rites Controversy and, 32–33, 35; clothing worn by, 157n18; commerce and, 48–49; depicted in Beauvais tapestries, 84, *85*; European ideas about China shaped by, 21; Figurists, 23, 146n12; French policy in China and, 27–28, 147n19; gifts to Chinese court, 20; in Japan, 98; Kangxi emperor and, 25–30; Louis XIV and, 78; Manchu (Qing) dynasty and, 27, 30, 112–13; papal and Enlightenment attacks on, 24, 141; positive view of China promoted by, 5, 7–10, 18, 20, 32, 92, 141; publications of, 78, 79, 83, 134; sexuality of late Ming and, 106–7; Sino-Russian treaties and, 28–29, 147n20; skepticism toward Jesuit claims about China, 80–81; as translators, 28
Jiaqing emperor, 141, 161n4

Jingdezhen porcelain manufactory, 22, 57, 99, 101, 156n10; destruction and rebuilding of, 102; Europeans depicted in ceramic art, 136–38, *137*
John V, king of Portugal, 36–37, 149n39
Jörg, Christiaan, 11, 51
Joseph II, Holy Roman Emperor, 140
J. Paul Getty Museum, 63, 158n25
Jullienne, Jean de, 128
Juvarra, Filippo, 74

Kangxi emperor, 1, 4, 31–32, 55, 56, 59, 114; Beauvais tapestry series and, 84; Chinese Rites Controversy and, 35–38; Clement XI's gifts to, 68–69, 152n27; command to end missionary activities, 9, 106, 139–40; Decree Concerning Foreigners, 31; edict banning proselytization, 3; Edict of Toleration, 29, 30, 148n33; European diplomatic gifts to, 79; favorable reputation in Europe, 29–30; Jesuit artists and, 39–40; Jesuit hopes for conversion of, 25–28; Louis XIV and, 80, 88, 93; porcelain manufactured in reign of, 102, 157n12; portrait of, 96, *97*; Taiwan (Formosa) conquered by, 50, 97, 156n7; Tibetan Buddhism and, 40
Kangxi Emperor Triumphant Over Ming Loyalists and Other Enemies, The (Anonymous), *97*
Kano school, 67
Kaufmann, Thomas DaCosta, 49
Kircher, Athanasius, 6–7, 67, 71, 76, 92–93, 114, 145n2; Beauvais tapestry imagery and, 83, 84; Boucher paintings and, 118
Kleutghen, Kristina, 57
Kneller, Sir Godfrey, 71, 103, 105, 111

Kögler, Ignaz, 31
Korea, 113
Kosa Pan, 55
Kublai Khan, 15, 17

lacquer, 3, 5–6, 20, 62, 142; Boulle cabinets, 88; Chinese merchants and, 54; French collectors of, 55; furniture, 11, *12*, 55, 73, 87, 119; popularity at Versailles court, 82
Lady Fastening Her Garter (Boucher), 130, *130–31*
Lady in an Interior Holding a Bird ["Very Pretty"] (Anonymous), 67–68, *68*, 71
landscape paintings, Chinese, 45
Laos, 113
Le Comte, Louis-Daniel, 6, 79, 86
Leibniz, Gottfried Wilhelm, 3
Lely, Sir Peter, 71
Le Vau, Louis, 82
Life of the Emperor of China, The (Monnoyer, Vernansal et al., tapestries), 83, *85*, 114, 115, 158n25; *The Astronomers*, 84, *85*, 114, 158n25; *Audience of the Emperor of China*, 115–16, *116*, *117*; Boucher cartoons of, 118–19, *120*, *121*, 131–32; popularity of, 116, 118
Li Teiguai (Daoist Immortal), 21
literati (scholar officials), 9, 18, 145n3, 157n18
Livre de desseins chinois (Fraisse), 62, 124
Longobardi, Niccolò, 18
Louis de France (Monseigneur the Grand Dauphin), 88–89, 155n54
Louis de France, duke of Burgundy, 87, 89
Louis XIV (the Sun King), 1–2, 7, 27–28, 31, 55, 83; Catholic mission in China and, 79; Chinese imperial adminis-tration as influence on, 140; Chinese portrait in porcelain of, *137*, 138; at

costume ball during Carnival, 86;
death of, 87; gifts to Qianlong
emperor, 119; Kangxi emperor and,
80, 88, 93; *magots* and pagods
collected in reign of, 121; porcelain
collections of, 87–88; Shen's visit to,
103; zenith of Sinophilia/Chinamania
in reign of, 78, 81, 82, 129
Louis XV, 65, 74, 78, 82, 86, 87, 122;
Chinese-influenced harvest ritual
and, 140; gifts to Qianlong emperor,
119, 120; *magots* and pagods collected
in reign of, 132
luxury objects, Chinese, 5–6, 20, 45;
global trading system and, 53;
popularity in Rome, 74; in Rome, 69;
at the Versailles court, 28

Macao, trading colony of, 20, 36–37, 48,
136, 148n32
Macartney, George, embassy of, 161n4
magots (grotesque figures), 64, 119,
159n33; Boucher and, 118, 119, 120,
128; Buddha figure resembling, 125,
126; collectors of, 121–22, 132; as
decorative elements, 122
Maine, duc de (Louis-Auguste de
Bourbon), 83, 84, 114
Manchus/Manchu empire, 1, 27, 76;
Christian proselytizing forbidden in,
10; described as warlike by Jesuits,
112–13; struggle with Ming loyalists,
50, 107–8. *See also* Qing empire
mandarins (imperial officials), 87, 114,
145n3, 148n33
Manila, city of, 48, 50, 54, 154n40
Mannerist paintings, 96
maps, 5, *6*, 20, 73
Marie Adélaide of Savoy, duchess of
Burgundy, 86, 87

Marignolli, Giovanni de,' 17
Martini, Martino, 23, 114, 146n7
Martini, Simone, 43
Mary II, queen of England, 51
Masucci, Agostino, 72
mathematics, 25
Mazarin, Cardinal Jules, 88
Mazzi, Filippo Maria, 72
Medley, Margaret, 102
Meissen porcelain, 57, 59, 65, 110,
111–12, *112*
men/male body, Chinese: change in
Western representations of, 5, 141;
compared to monkeys, 125, *126*, 127;
"effeminate" Ming hairstyle, 108;
European men's hairstyle and wigs
compared with, 107, 108; "exotic"
elements limited to costume and
setting, 98; feminized/trivialized
images of, 4, 9, 75, 111, 128; Jesuit
view of Chinese male sexuality,
106–7; late-Ming porcelain depic-
tions, 100, *101*, 102–3; naturalistic
depictions of, 61; Qing/Manchu
queue as signifier of masculinity,
99, 108; sunshades associated with
femininity and, 110
merchants, Chinese, 18, 27, 54, 157n14
merchants, European/Western, 2, 54,
57, 96; knowledge of East Asia
introduced by, 139; Marco Polo's
accounts of China and, 17, 18
Mezzabarba, Carlo Ambrogio, 38, 68
Miller, Susan, 62–63
Ming dynasty/period, 4, 8, 136; ancestor
portraits, 95–96, 156n5; collapse of,
27, 49, 50, 112; establishment of
(1368), 18; literature of, 151–52n22;
male hairstyle of, 107–108; Manchus
resisted by southern Ming, 107; Ming

Ming dynasty/period *(continued)*
loyalists defeated by Kangxi emperor, 96, *97,* 156n7; political crisis of, 21–22; porcelain of, 58, 59, 99–100, *101,* 102–3; Ricci and, 4–5; sexuality in late Ming, 32, 106–7; wariness of foreign adversaries, 20
missionaries, 2, 17, 25, 105, 128; arrival in China, 3; astronomy and, 134; dwindling efforts under Manchus, 27; Jesuit, 20, 145n3; Jesuit tolerance of Chinese rites, 32–33; Nestorian, 15; non-Jesuit rejection of ancestor rites, 33; porcelain trade and, 48; prejudice against Buddhist clergy, 41; residence permits (*piao*) required of, 37, 148nn33–34; rivalries among, 30, 31
Mongol empire, 15–17, 18, 145n1
Mongolia, 113
Monnoyer, Jean-Baptiste, 85, 115, 119
Montanus, Arnoldus, 118, 159n30
Montecorvino, Giovanni da, 17
Montespan, Marquise de (Françoise-Athénaïs de Mortmart), 82, 83
Montesquieu, baron de (Charles-Louis de Secondat), 133
Morena, Francesco, 145n1
Mughal empire, 7
Musée Guimet (Paris), 136

naturalism, in art, 61, 136, 151n21
Nelson-Atkins Museum (Kansas City), 11
neo-Confucian ethics, 20
Nerchinsk, Treaty of (1689), 28, 147n20
Nestorian Christianity, 15, 17, 145n1
Nestorian Stele, in Xian, 15, *16*
Netherlands. *See* Dutch trading empire; United Provinces (the Netherlands)
Nicholas IV Masci, Pope, 17

Nieuhof, Johan, 83, 114, 115, 118, 155n47, 159n29
Noble, Charles Frederick, 151n14
Nolin, Jean-Baptiste, 94
Nouveaux mémoires sur l'état présent de la Chine [New Observations on the Present State of China] (Le Comte), 6
Nouvelle suite de cahier arabesques chinois à l'usage des dessinateurs et des peintres [New Set of Notebooks of Chinese Arabesques for Use by Draftsmen and Painters] (Pillement), 127
Novus atlas sinensis [New Chinese Atlas] (Martini), 146n7

occidenterie (Western-themed Chinese art), 57, 58, *58*
Odell, Dawn, 11
Officier de Robe Mandarin [*Mandarin Official*] (Giffart), *2*
Opium War, First (1839–42), 8
Opium War, Second [Arrow War] (1856–60), 39, 119
orientalism, baroque, 7, 64, 90, 95, 128; China seen as exotic equal to France, 116, 118; racial differences seen in era of, 98
Orry, Philibert, 65
Other/Otherness, 41, 61, 75, 132; emasculation of the Other, 66; hierarchy created through feminization of, 110
Ottoman empire, 7, 84, 93, 127, 140. *See also* Turks, Ottoman

pagods (images of deities), 45, 122, 128, 159n33; collectors of, 121, 132; as decorative elements, 122
paintings, Chinese, 45–46, 68, 70, 79, 94, 151n16; disparaged in Europe,

81; portraits, *34*, 94–98; scroll
paintings, 45, 55–56, 58. *See also* art,
Chinese
Palace Museum, (Beijing), 137
Palazzo Colonna di Sciarra (Rome), 73
Pantoja, Diego de, 106–7, 145n4
Paolucci, Cardinal Fabrizio, 73
paper, 3, 20
Parissien, Steven, 112–13
Pax mongolica (Mongol peace), 15–17
pederasty, 32
Pereira, Tomás, 28
Persian empire, 7, 46, 84
Philippines, Spanish, 50, 54
philosopher-kings, 5, 7
philosophy, Chinese, 113
Pierre, Jean-Baptiste Marie, 74
Pillement, Jean-Baptiste, 127, 134
Pitts, Thomas, 11
Polo, Marco, 16–17, 18
polygamy, 32
Pompadour, Marquise de (Jeanne-Antoi-
nette Poisson), 65, 122
popes/papacy, 8, 69, 119, 134; in Avignon,
43, 45; Chinese Rites Controversy
and, 35, 140; diplomatic missions
to China, 17, 145n4; hostility to
Jesuits, 24
porcelain, 3, 5–6, 20, 87, 113, 120, 142;
Chinese porcelain in Bangkok, 55; in
European paintings, 46, *47*, 48, 51,
52; European production of, 12–13,
65; *famille verte*, 99, 102, 103, *137*, 138,
157n12; figural components in
decoration of, 58–59, *60*, *61*; French
collectors of, 55; garnitures, 50–51,
51; images of Chinese body in,
99–100, *101*, 102–3; importance to
European collectors, 89–90;
increased European demand for, *52*,
53; missionary involvement in
porcelain trade, 48; as most
ubiquitous East Asian art in Europe,
12; occidenterie in, 57, *58*; in papal
collections, 71–72; produced in
Europe, 53, 57, *62*, *63*; reception in
Europe, 46; in royal château
collections of France, 87–89; as status
marker in Europe, 51. *See also*
Jingdezhen porcelain manufactory;
Meissen porcelain
Porcelain Pagoda, in Nanjing, 76–78, 82,
132
Porcelain Trianon, at Versailles, 82–83
pornography, 66
Portrait Historique de l'Empereur de la Chine
(Bouvet), 93
Portrait of Father Zhang and Mother Zhao
(Anonymous), *34*
Portrait of Johann Schall von Bell (Anony-
mous), 25, *26*
Portrait of Marchesa Elena Grimaldi (Van
Dyck), 108, *109*
*Portrait of Michael Shen Fuzong ["The
Chinese Convert"]* (Kneller), *104*, *105*
*Portraits of Emperor Qianlong, the Empress,
and Eleven Imperial Consorts* (Castigli-
one), 39, *39*
Portugal/Portuguese empire, 20, 24,
Chinese artists' depictions of
Portuguese men, 136; contacts with
Qing court, 38; decline of, 48; Ming
pirates allied with, 96–97; *padroado*,
27–28, 37, 48; silver mines in, 54;
Tournon's detention in Macao, 36–37,
148n32
Portuguese College [Church of the South]
(Beijing), 30–31
Posi, Paolo, 76–78, 120–21
prostitution, 32

Protestants/Protestantism, 11, 24, 49, 80, 114, 134

Qianlong emperor, 8, 119–20, 161n4; Castiglione's portrait of, *39;* command to end missionary activities, 9, 40, 139–40; Fragrant Concubine and, 136–37, 160n51
Qing empire, 1, 2, 57, 67, 142; aggressive expansionism of, 113; command to end missionary activities in, 139–40; definitive establishment of, 99; early favor to Catholic missionaries, 25; European hopes for conversion to Catholicism, 128; Europeans viewed by, 106; history of Catholic contact with, 4; imperfect European knowledge of, 83; initial positive Western view of, 3; porcelain of, 58, 59, 102; portraits of notables in, 94; relations with France, 7; restrictions and taxes on merchants, 54; ridiculed in Roman chinoiserie, 78; Russian relations with, 28–29, 147n20. *See also* Manchus/Manchu empire
Quirinal Palace (Rome), 72, 73–74

racial differences, 92, 98, 106, 116
raillery, versus ridicule, 129, 160n41
Relación de la entrada de algunos padres de la Compañía de Jesús en la China (Pantoja), 145n4
Renaissance, 18, 45
Residence of Saint Joseph (Beijing), 31
Ricci, Matteo, 4–5, 9, 18, 37, 98, 145n3; on Chinese artists' depictions of Europeans, 136; clothing worn by missionaries of, 157n18; Kangxi emperor and, 26, 31, 38; sexual practices in late Ming and, 32, 33,

106; on sunshades used in China, 108; tolerance of ancestor rites, 35, 36; Wanli emperor and, 152n28
Ripa, Matteo, 39–40, 72
rococo art, 4, 9, 122, 124, 147n19; ancien régime associated with, 8; "feminized" aesthetics of, 25, 66; initial continuity with baroque orientalism, 127–28; *magots* in, 122. *See also* chinoiserie
Rome: ancient, 3; Chinea festival (1758), 76, 77, 78, 121; "Chinese masquerade" for Carnival (1735), 74–75, *75;* chinoiserie in, 69–73; French Academy in, 74, 76; global visual culture and, 67; portraits of Chinese and Japanese notables in, 45–46; Vatican Library, 73, 105
Rong Fei (the Fragrant Concubine), 136
Rougement, François de, 80, 154n43
Rousseau, Jean-Jacques, 133–34
Roy de la Chine, Le (musical masque for Carnival, 1700), 86
Russia, 28–29, 93, 147n20

Saint-Aignan, duc de, 74
Saint Francis Xavier Received by the Daimyō of Yamaguchi (Henriques), 98
Sampajo, Emmanuel Pereira de, 153n37
Schall von Bell, Johann Adam, 25, *26,* 84, 114
science, 27, 133, 134, 135
Scott, Katie, 41, 86, 128
screens, folding, 11, 118
scroll paintings, Chinese, 45, 55–56, 58
Seattle Art Museum, 57
Semedo, Alvarez, 107, 146n7
Settala, Manfredo, 151n16
Seven Victories (Pantoja), 106
Sèvres chinoiserie, 65–66, *66*

Shan Quan (legendary sage), 103
Shen, Michael (Shen Fuzong), 28, 79, 94, 128, 157n14; European tour of, 103, 105; portrait of, 103, *104*, 105
Shun (legendary emperor), 103
Shunzi emperor, 92–93, *92*
Siam (Thailand), 55, 83, 88–89, 93–94, 128
Siècle de Louis XIV, Le (Voltaire), 143–44n4
silk, 20, 43, 50, 142; Chinese merchants and, 54; folding screens, 87, 118; French collectors of, 55; tapestry weavers of Lyon and, 134; watercolor paintings on, 57
Silk Road, 15
silver: Chinese demand for, 53; in chinoiserie, 11, *13*; currency, 3, 10; mined in Spanish and Portuguese colonies, 54; ornaments, 20
singeries ("monkey tricks"), 124
Sinicae historiae decas prima [History of China, Volume One] (Martini), 23
Sinology, 3, 80, 113; Christian ecclesiastical politics and, 81; developed in Catholic scholarship, 139; Jesuit publications and, 134; origins of, 4, 9; Rome as first seat of, 45
Sinophilia, 5–6, 7, 24, 78, 144n4
Sinophobia, 25, 133, 144n4, 158n24
skin color, 98
Sloboda, Stacey, 11
soapstone carvings, 20–21, 73, 146n6
Somdet Phra Narai, king of Siam, 55
Song dynasty/period, 15
Sousa, Alexandre Metello de, 149n39
South Asia, 20, 46, 48, 116
Spain/Spanish empire, 20, 27, 46, 54, 78
Standen, Edith A., 115
Stein, Perrin, 118, 130–31, 159n30
still-life paintings, European, 51
stoneware (*terre des Indes*), 120

Storia dell'introduzione del Cristianesimo in Cina [History of the Introduction of Christianity into China] (Ricci), 32
Sullivan, Michael, 68

Taiwan (Formosa), 50, 97, 156n7
Tang dynasty/period, 15
tapestries, 83–84, 114–16, 158n25
tea, 3, 20, 53, 55, 110–11, 142
technology, Western, 20, 27
Temple of the North (Beijing), 31
Tenture chinoise (tapestry series), 114
textiles, 62, 122
Tibet, 113
Toghon Temür, Yuan emperor, 17
Toulouse, comte de (Louis-Alexandre de Bourbon), 158n25
Tournon, Charles Thomas Maillard de, 36–37, 148n32
Transitional Period, 99, 102
Treatise on Geometry (Euclid), 26
Tribunal of Mathematics (Beijing), 30
Trigault, Nicholas, 32, 146n7
Turin, Royal Palace, Chinese Tea Room in, 74
Turks, Ottoman: China seen as potential ally against, 45; virile representation in contrast to feminized Chinese men, 75, *76*, 124, 125, *126*, 127. *See also* Ottoman empire
Turks Hunting an Ostrich (Huet), 125, *126*
Tweede en Derde Gesandschap na het Keyserryck van Taysing of China [Second and Third Embassies to the Empire of Taising or China] (Dapper), 96

United Provinces (the Netherlands), 10, 27, 51. *See also* Dutch trading empire
Urban VIII Barberini, Pope, 108

Van Dyck, Anthony, 108, 109
Vanni, Fiorenzo, 69, 152n27
Vanstripo, Pietro, 69, 152n27
Vatican Museums, 70
Verbiest, Ferdinand, 25–26, 84, 114
Vermeer, Johannes, 51, 52
Vernansal, Guy-Louis, 85, 115, 119,
 159n27
Veronese, Paolo, 116
Victoria and Albert Museum, porcelain
 in, 59
Vien, Joseph-Marie, 75, 154n38
Vietnam, 113
Villa Patrizi (Rome), 73
Vinograd, Richard, 94–95
Voltaire (François-Marie Arouet), 24–25,
 133, 143–44n4
Voyage around the World, A (Careri),
 150n10
Voyage around the World in the Years
 1740–1744 (Anson), 134
Vu, Giuseppe Lucio, 105

Walters Art Gallery (Baltimore), 65
Wanli emperor, 22, 26, 99, 152n28
War of the Three Feudatories, 50, 102
Water Margin, The (Chinese novel), 100,
 101, 102
Watteau, Antoine, 40, 41, 42, 87, 128–29
Weisweiler, Adam, commode à vantaux by,
 11, 12
West, the, 45, 48, 113; China subordi-
 nated to, 90; Chinese paintings in,
 46, 56; denigration of China after
 Chinese Rites Controversy, 140; early
 awareness of Chinese "difference,"
91–92; trade imbalance with China,
 3, 7, 10, 142. See also Europe
West Chamber, The (Chinese novel), 59,
 60, 61
William III (William of Orange), king of
 England, 51
women, Chinese, depictions of, 1, 2,
 67–68, 68; in Chinese art, 95;
 Fragrant Concubine, 136–37, 160n51;
 in gallery of papal Castelgandolfo
 retreat, 70, 71; modesty in dress, 99;
 "thin lizzies," 112, 134
women, European, sunshades associated
 with femininity, 108, 109
woodblock prints, 13, 22, 45, 56, 111;
 illustrations in Ming literature,
 152n22; occidenterie and, 57
Wu Hung, 137
Wu Li, 154n43

Xavier, Saint Francis, 18, 19, 98
Xu, Candida, 157n14

yin and yang, philosophy of, 107
Yonan, Michael, 89
Yongzheng emperor, 40, 69, 147n20;
 command to end missionary
 activities, 9, 106, 139–40; diplomatic
 gift to Benedict XIII, 70; dressed as
 European monarch, 137–38
Yuan dynasty/period, 15, 17, 43, 145n1
Yuanming Yuan (Garden of Perfect
 Brightness), 39, 119
Yunqi Zhuhong, 136

Zheng piratical network, 50